The Painting and Teaching of
PHILIP PEARLSTEIN

The Painting and Teaching of
PHILIP PEARLSTEIN

By Jerome Viola

WATSON-GUPTILL PUBLICATIONS/NEW YORK

PICTURE CREDITS

Unless otherwise noted, all works are in the collection of the artist or in private collections, and are reproduced courtesy of the Allan Frumkin Gallery.

Art Institute of Chicago: *Male and Female Models Leaning on Chair,* p 104. The Brooklyn Museum (John B. Woodward Memorial Fund, A. Augustus Healy Fund, Dick S. Ramsay Fund, and Other Restricted Income Funds): *Female Model on Platform Rocker,* p 58. Georgia Museum of Art: *Boulder,* p 58; *Positano 7,* p 29. Grey Art Gallery and Study Center, New York University Art Collection (Gift of Benjamin Weiss): *Roman Ruin,* p 31. The Herbert W. Plimpton Foundation (courtesy of Muldoon Studio-Rose Art Museum): *Female Nude Reclining on Bentwood Love Seat,* p 113. Milwaukee Art Museum Collection (Gift of Friends of Art): *Portrait of the Artist's Daughter,* p 120. Philadelphia Museum of Art: *Two Female Models With Drawing Table,* p 118, Vassar College Art Gallery, Poughkeepsie, New York: *Two Models, One Seated,* p 41. Weatherspoon Art Gallery, University of North Carolina at Greensboro: *Female Model in Red Robe on Wrought Iron Bench,* p 109. Whitney Museum of American Art: *Male and Female Models on Greek Revival Sofa,* p 131.

Unless otherwise noted, all photos by Adam Reich, and working sequences by Philip Pearlstein.

Alchemy Color Ltd.: p 16 Top R. Allan Frumkin Gallery: p 28 Bottom L (Courtesy Georgia Museum of Art); p 29 Bottom R (Courtesy Georgia Museum of Art); p 30 Top (Courtesy Georgia Museum of Art); p 34 Top and Bottom (Courtesy Georgia Museum of Art); p 150 Bottom; p 151 Bottom; p 164. Mark Archer: p 135 Top. Art Institute of Chicago: p 104. Geoffrey Clements: p 131 Top. Eeva-Inkeri: p 79; p 95; p 101 All; p 112; p 114; p 115; p 130; p 131; p 133 Top; p 134 All; p 135 Bottom, p 136; p 137; p 138; p 139; p 141; p 157 R; p 158 L; p 160 Bottom; p 161; p 163 Bottom. Landfall Press: p 152; p 154 All; p 155; p 156; p 158 R. Richard B. Meyer: p 100. Mignard: p 157 L; p 160 Top. David F. Penney: p 138. Eric Pollitzer: p 30 Bottom (Courtesy Georgia Museum of Art): p 99 Bottom (Courtesy Georgia Museum of Art); p 102; p 105; p 107; p 108; p 110; p 111; p 113; p 117; p 118; p 119; p 159. Quirinconi-Tropea, Chicago: p 106; p 140. Nathan Rabin: p 12 L; p 38 Bottom L (Courtesy Georgia Museum of Art); p 99 Top (Courtesy Georgia Museum of Art). George Roos: p 31 L. Michael Tropea: p 133 Bottom.

Text copyright © 1982 by Jerome Viola
Illustrations copyright © 1982 by Philip Pearlstein

First published 1982 in New York by Watson-Guptill Publications,
a division of Billboard Publications, Inc.,
1515 Broadway, New York, N.Y. 10036

Library of Congress Cataloging in Publication Data

Viola, Jerome.
 The painting and teaching of Philip Pearlstein.

 Bibliography: p.
 Includes index.
 1. Pearlstein, Philip, 1924– 2. Painting—
Technique. I. Pearlstein, Philip, 1924–
II. Title.
ND237.P33V5 1982 759.13 82-13401
ISBN 0-8230-3862-9

Manufactured in U.S.A.

1 2 3 4 5 6 7 8 9 10/86 85 83 82

To Mary Jo

Contents

ACKNOWLEDGMENTS

It is obvious that my greatest debt is to Philip Pearlstein, the subject of this book, who has shared his history and his work with me. Jamie Lustberg, his assistant at the time of the writing of the book, has been unfailingly helpful. Allan Frumkin, Pearlstein's dealer for many years, most kindly gave me access to his archives and, at the gallery, I also wish to thank George Adams. Many of my colleagues in the Art Department of Brooklyn College, City University of New York, were kind in various ways: Morris Dorsky, Chairman, in his inimitable style of support and, for useful information, Anne Arnold, Robert D'Allesandro, Allan D'Arcangelo, Lois Dodd, Paul Gianfagna, Joseph Groell, Jan Hildebrand, Annette Juliano, and Zalmar Perlin. Orlando Condeso of Condeso and Brokopp Studios was a sure guide through the labyrinth of etching techniques. And, at Watson-Guptill, I want to express my gratitude to Dorothy Spencer, David Lewis, Robin Goode, Susan Davis, and, especially, Betty Vera for her skillful and sympathetic editing.

My final debt is to my wife, Mary Jo, whose comforting presence and perceptive criticism were indispensable.

Preface

This book is about Philip Pearlstein and the way he works. Except in passing, or in discussing his prints, where considerable technical manipulation is involved, it is not especially concerned with such things as his palette or the kind of canvas he uses. Rather, the focus is on his ideas about his art and the ways those ideas find physical expression in his images. The development of those ideas is discussed in Part One. Part Two explains Pearlstein's approach to teaching; the extensive quotations in this part have been transcribed and assembled from tapes of his classroom lectures as well as talks before other groups. To illustrate Pearlstein's classroom assignments, I have followed his suggestion that the work of one student be shown to give the reader a sense of the diversity of the aesthetic solutions as seen from a single point of view.

Parts Three, Four, and Five are intended to show how Pearlstein works in oil, watercolor, and printmaking media, respectively. Each part begins with a general discussion of Pearlstein's working procedures in that medium, followed by at least one actual working sequence and a selection of finished work that demonstrates how Pearlstein exploits the aesthetic potential of his medium.

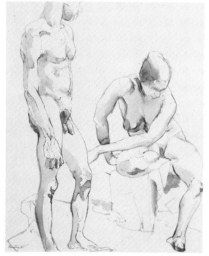

Male and Female Models in Studio, 1961, 17" × 14" (43 × 36 cm), sepia wash

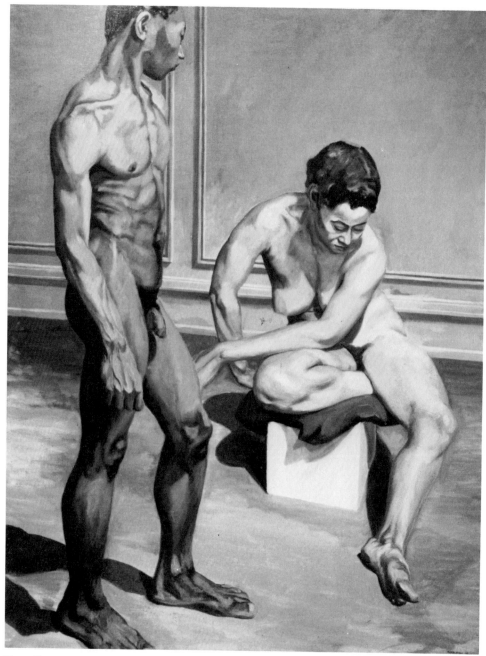

Two Figures, 1962, oil, 72" × 60" (183 × 152 cm)

The composition of Male and Female Models in Studio *became the basis of* Two Figures, *Philip Pearlstein's first large-scale painting from models, whose setting included inhabitable studio space and meticulously painted baseboard. In spite of the viewer's temptation to read emotional implications into the tired muscles of the posing models, Pearlstein's intention in this painting was compositional, especially the contrast between the vertical stance of the male and the circular, self-enclosing arms of the female, whose head is turned away.*

Part One
ARTISTIC DEVELOPMENT

MERRY-GO-ROUND, 1940, oil, 14″ × 18″ (36 × 46 cm)

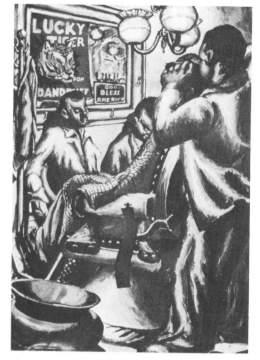

WYLIE AVENUE BARBER SHOP, 1940, tempera, dimensions unknown, lost

These paintings won Pearlstein first and third prizes in the 13th National High School Art Exhibition of Scholastic Magazine. Realistic in style and urban in theme, they are reminiscent of the work of Reginald Marsh, one of the judges of the contest.

P hilip Pearlstein's well-deserved and influential reputation as a realist painter has come from the tenacity with which, from 1962, he has clung to a single, self-chosen procedure. He paints only from direct observation, whether of landscapes or models and portrait sitters in his studio. That the people in his paintings, arranged in different ways, are most often nude belies the real point of view behind them. Pearlstein is not a traditional figure painter; he is a painter who uses the figure for the structure of his paintings. This distinction may seem minute, but it is important in understanding that Pearlstein's art, while never itself abstract, matured under the impact of Abstract Expressionism and that his paintings are conditioned by forms of composition derived from abstraction.

The choices, in his kind of realism, deliberately avoid the narrative, political, psychological, or other overtones historically associated with a realistic image. This is not to say that Pearlstein's art exists in an aesthetic and cultural vacuum. "Art comes out of art," Ad Reinhardt, Pearlstein's late colleague at Brooklyn College, used to say, and the public that sees only nude bodies in Pearlstein's work is missing an awareness of the cohesive structure of the art of a period. In its conscious and intellectual choice of something to be created in a specific mode, Pearlstein's work, although using traditional materials, is not that far removed from the options that Marcel Duchamp bequeathed to Conceptual Art and, in the primacy of what is immediately given, it is a cousin to Minimal Art. For all its close connections to contemporary forms of abstraction, Pearlstein's art has remained rooted in the realism with which he began.

Philip Pearlstein was born in Pittsburgh, Pennsylvania, on May 24, 1924. When he showed an interest in art as a child, his parents supported his talent as part of his general education. Later, however, the idea of his making a living from art during the Depression in an industrial city seemed totally out of the question. Pearlstein's secondary schooling, at Taylor|Allderdice High School, was strongly oriented toward the arts and provided his first success in his teens. In 1941 he won first and third prizes in the thirteenth National High School Art Exhibition of *Scholastic Magazine*. His first-prize painting, *Merry-Go-Round*, and third-prize painting, *Wylie Avenue Barbershop*, were reproduced in color in the June 16, 1941, issue of *Life* magazine. The captions from *Life* described *Merry-Go-Round* as having

been "painted with slapdash brush and bold colors well suited to this circusy subject. It is by Philip Pearlstein, 17, of Pittsburgh, who got his first training from the Saturday morning art classes at Carnegie Museum. Philip's family, like most modern parents, encourages his art career. Parents in the past were not always so intelligent." The caption to the scene of a barber shop in a black neighborhood pointed out the "smart exaggeration of perspective to emphasize the barber's feet and spittoon."

Upon graduation from high school in 1942, Pearlstein enrolled at the Carnegie Institute of Technology (now called the Carnegie-Mellon Institute) but a year later was drafted into the army. Ironically, it was the article from *Life*, which he carried with him, that conditioned his army experience and influenced the kind of training he received. After basic training, he was assigned to a silkscreen shop in Florida to make weapons charts and other visual aids. The men he worked with were commercial artists, and he learned a great deal from them about the techniques of graphic design. After a year he was shipped to Naples. While he was in Italy, Pearlstein made drawings in his spare time and mailed them to his parents. Just when he was due to be sent north to the front, he found himself transferred to the Headquarters Company to make training aids and signs. He later discovered that one of the officers who had been censoring the soldiers' mail liked the drawings Pearlstein had been sending home and diverted him from combat duty.

Besides providing invaluable training in graphic design, Pearlstein's army years were important in another respect; in Italy he had the opportunity to see great art of the past.

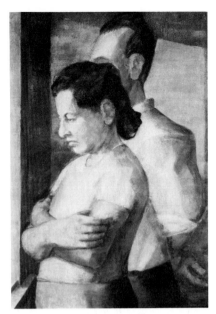

DOUBLE PORTRAIT OF THE ARTIST'S PARENTS, 1943, oil, 25″ × 18″ (64 × 46 cm)

The terrific thing about my Army experience had nothing to do with the war, but just with the opportunity of being able to see a lot of art. I spent time up near Florence after the war ended, and at least once a week I made the trip into Florence. There was a lot of stuff gathered at the Pitti Palace, which is not so far away from where the Masaccio frescoes are in the Church of the Carmine. That chapel was filled with scaffolds. . . . There was no one around. I would give a couple of cigarettes to the priest who was in charge there. He was the only occupant of the place who answered the doorbell. He would let me spend a couple of hours by myself up on the scaffold studying the frescoes at very close range. It was tremendous. I can't remember what it was that I was studying, but I recall this general impression of being there hour after hour, for hours memorizing every form.

Also, I got to Milan for some time. In Milan I mostly remember studying the Da Vinci "Last Supper", still standing. A little roof had been built over it, a little shed. And the wall was sandbagged so you were able to climb up the sandbags and be face to face with the painting. It was all out of doors and a very weird experience.

Earlier, the first couple of weekends when I got to Naples, I took tours around Pompeii and saw a number of the buildings with frescoes. In Rome fighting had ended. It was an open city and the British had put on a huge exhibition of all the works that had been put away in hiding. It was a terrific show, at the Palazzo Venezia, and the entire building was filled with these marvelous paintings which are now scattered all over Rome in various institutions. I was

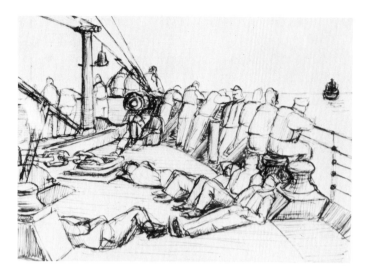

TROOP SHIP, 1944, pen, 4¾″ × 6½″ (12 × 17 cm)

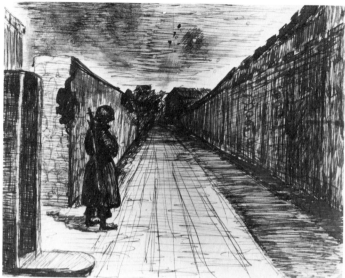

NIGHT WATCH NEAR ROME, 1944, pen, 4¾″ × 6″ (12 × 15 cm)

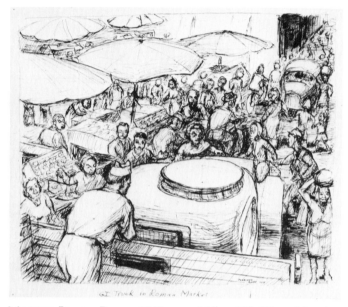

MARKET PLACE, ROME, 1945, pen, 10″ × 12″ (25 × 30 cm)

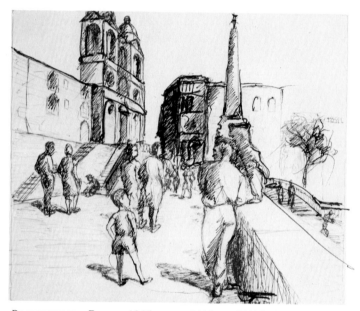

PROPOSITION, ROME, 1945, pen, 9¼″ × 10¾″ (24 × 27 cm)

Pearlstein's wartime drawings are similar to his realistic high school paintings but leap ahead in the skill with which he rendered perspective space and the physical details that tell the story: the monotony of the figures in Troop Ship; *the mirrored contrappostos of the soldier and the boy in* Proposition, Rome; *the loneliness of* Night Watch near Rome; *the crowded space of* Market Place, Rome.

able to see the Vatican Collections a lot because we took basic infantry training right outside of Rome and the weekends were our own. I would go into Rome every weekend, stay over night, visit the Vatican Museums, the big exhibition at the Palazzo Venezia, or this other show at the Borghese Gallery. I got to Venice for a two week stay shortly after the war ended too. The British Army had also organized a huge show in the Venice area at the Correr Museum, consisting of things that had been hidden away during the war. There were just hundreds of great things. I still have the catalogues. It was just a tremendous opportunity to get saturated in art.

So, that's how I spent the war. I was in Italy for almost a full year after the war ended. I had never been in combat so I didn't have what were called "points" that could get me home faster. So it was a time for me for real study

in art. I didn't know much about antiquity, so I was bored looking at Greek vases. I didn't pay any attention to that stuff. I just concentrated on the Renaissance.[1]

In the spring of 1946 Pearlstein was discharged from the army and resumed his education at Carnegie Tech. Three teachers there were important to his development. One was Balcomb Greene, whose painting was mostly abstract at the time; he provided an image of the possibility of being a painter who lived in the art world of New York City. Samuel Rosenberg, Pittsburgh's old master of social realism, embodied another possibility—being an artist and staying in Pittsburgh. The third teacher, and the one who was perhaps the most important to Pearlstein, was the Bauhaus-oriented designer Robert Lepper, the head of the design program at Carnegie Tech.

One of the assignments Lepper gave his advanced classes inspired a method Pearlstein adopted later in his own teaching: discussing broad ideas rather than specific techniques. Lepper gave his students the problem of analyzing Oakland, the community in which Carnegie Tech was located. The area included Pittsburgh's cultural center as well as some of its slums. Using all possible means, including charts, diagrams, illustrations, sketches, paintings and photographs, the students conveyed visually what they saw and what they thought about what they saw. They discussed everything in class meetings, with the aim of organizing their material for a formal visual presentation. Besides teaching at Carnegie Tech, Lepper also worked as a free-lance graphic designer for catalogs of building products. Because of the drafting and lettering skills Pearlstein had acquired in the army, Lepper hired him as one of his assistants in the summer of 1946. Graphic design work of this kind was to provide a source of income for Pearlstein for many years to come.

After his graduation from Carnegie Tech in 1949, Pearlstein moved to New York City, hoping to find a career in commercial art. During his first months there, while he was looking for work in illustration, he put together a portfolio that involved a graphic analysis of the electoral college, part of a projected work illustrating the United States Constitution. Although the art directors he saw rejected the portfolio, he eventually was hired by Ladislav Sutnar, a graphic designer who had been close to the original Bauhaus group. Pearlstein spent almost the next eight years working with Sutnar during the day, all the while painting at night. At the same time he became involved with the artists on Tenth Street—where many of the newer artists were exhibiting—and became a member of the Tanager Gallery, one of the first co-op galleries, in 1954.

The Constitution portfolio became the basis for the first paintings Pearlstein made in New York. Such paintings as *The American Eagle*, ca. 1949, *Dollar Sign*, 1950, and *Superman*, 1952, used images from popular American culture and were united by a common thread of emotionality, if not violence, in impasto or in subject and often in both. While these paintings anticipate the beginnings of Pop Art by several years, there is an important difference. Much of the later impact of Pop lay in the viewer's perception, correct or not, that the ubiquitous image of a flag, soup can, or whatever has been directly transferred to the canvas or other surface. In Pearlstein's paintings of the early 1950s, this perception is impossible, for the Abstract Expressionist paint handling is a constant reminder that an artistic personality is the intermediary between the banal image and its physical incarnation.

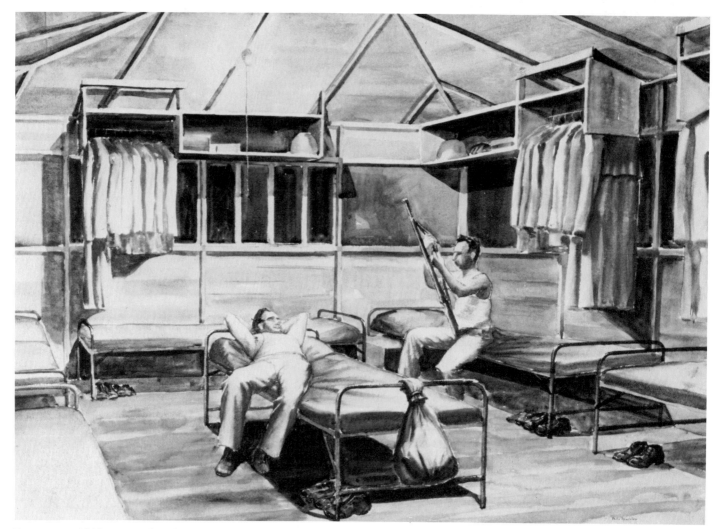

BARRACKS, 1944, watercolor, 21″ × 29″ (53 × 74 cm)

Pearlstein's earliest critical recognition came when Clement Greenberg selected him for an "Emerging Talent" exhibition at the Kootz Gallery in January 1954. Greenberg had seen one of Pearlstein's paintings in an invitational group show at the Tanager Gallery in December 1953. The Kootz show was intended to highlight Greenberg's newest discoveries, Morris Louis and Kenneth Noland, but also included Herman Cherry, Paul Feeley, Paul Georges, Cornelia Langer, Saul Leiter, Anthony Louvis, Sue Mitchell, and Theophil Repke (Groell). To make his selection from Pearlstein's paintings, Greenberg stood in the middle of Pearlstein's small studio, the paintings arranged around him; twice he spun around with his eyes closed and then pointed to the work that caught his attention after he stopped moving and opened his eyes.

Greenberg's random method of selection was particularly amusing to Pearlstein, who was working on a master's thesis on the Dada painter Francis Picabia. At the urging of Ladislav Sutnar, he had begun studying art history at the Institute of Fine Arts, New York University, where he earned an M.A. in 1955. For a dedicated painter, achieving a master's degree at the Institute was not easy:

Nobody wanted me to have it. I remember a conversation I had with [Karl] Lehmann. I think I was the only one who got an A in his survey of Egyptian art. So he called me in, and we had a little chat: Was I studying Greek, and would I go off with him to [Samothrace]? When I told him that I considered myself an artist, he said, "We have nothing more to say." And he never spoke

GERMAN PRISONERS OF WAR NEAR PISA, 1945, watercolor, 13½″ × 17½″ (34 × 44 cm)

to me again, not even to say hello. The same sort of thing with Walter [Friedlaender]. He liked the paper I wrote, and we had a talk, and he asked, "Why are you here? Don't you know that we are the enemy of the artist?" So I stuck with it, just because "Screw you. If you don't want me, I'll do it anyway." So then I went on and did the thesis on Francis Picabia.[2]

Friedlaender's remark notwithstanding, Pearlstein found his study of art history useful. Not only has he been able to use what he learned to teach his own classes; his historical studies also gave him the objectivity to look formally at his own paintings. His research on Picabia, especially, led him to rethink the history of twentieth-century assumptions about paintings and modern ideas concerning the roles of abstraction and subject matter. Aesthetic formulations, he concluded, are less important than the quality of a painting and what it looks like.

Until the early 1950s, Pearlstein's subjects had been entirely unplanned, growing out of his commercial work, remembered images, or ideas spun off from his portfolio of illustrations. Now, regarding his canvases with a critical eye, he saw that such paintings as *Emerging Figure* and *Burning Girl*, whatever he had thought when he painted them, were really landscapes. He decided to concentrate on painting landscapes. He was still earning a living doing drafting and page layouts for industrial catalogs, and he now had a family to support, having married Dorothy Cantor, a fellow student at Carnegie, in 1950. One summer they spent some time at Montauk Point, on the tip of Long Island:

I picked up a bunch of rocks on the beach, and that was what I painted from. As we moved from place to place, I carried a bushel basket of these rocks. They're still here, out in the back yard. They were my models. . . . I wasn't interested in describing the object as such. I was just looking for abstract compositions in nature. Also, everything about the abstract expressionist era had to do with nervousness, tenseness, frenetic. . . . One day I picked up a rock. It looked very splintered. It looked neurotic to me. So I combed the beach looking for neurotic rocks.[3]

Pearlstein painted the landscapes at night, after work, in his studio. At a time when modernist theory, involving the "essential" flatness of painting, and various kinds of expressionistic abstraction were both current modes of aesthetic discourse, it is surprising that these paintings—with their obvious landscape subjects and traditional, although restricted, space—were, on being exhibited, acceptable to the critics. Pearlstein had found a characteristically pragmatic solution: "In the Abstract Expressionist era I discovered that you could get away with the look of a landscape as long as you did not have too much sky in it. If the sky were up near the top it did not break the picture plane so violently."[4] Indeed, most of these paintings have very little sky, and what sky appears is almost as heavily worked as the rocks. When the rocks are seen so closely, bound by the confines of the canvas, their inherent size is less compelling than the intensity of their rendering. They could be mountains viewed from a distance or pebbles microscopically surveyed. Despite the synthetic composition of these rock paintings, they were—and remain—remarkably convincing and original in their evocation of violent landscape. The expressionist surface, so fashionable at the time, allowed Pearlstein to sneak in his basic, but as yet tentative, realism.

A major development occurred in 1956 when Dorothy and Philip spent the summer on Deer Isle, Maine, partly at the suggestion of the painter Mercedes Matter, whom he had met through Charles Cajori, a colleague at the Tanager Gallery. The scenery was exactly the kind that he had been reading into his hand-held rocks. He began doing detailed drawings with the intention of making paintings from them on his return to New York.

There were big boulders—neurotic rocks with fractures. When the tide went out it looked like all these monsters had been stuck in the mud since prehistoric times. A sense of violence was there—the beginning of the world, that sort of thing. There were uprooted trees all over Deer Isle. I spent that summer making very, very meticulous line drawings of the huge root systems of these trees and of the fractured rocks. Then I painted from the drawings. I was bringing in all my skill as a mechanical draftsman. . . . I had never worked that way before. I got caught up in making these drawings. That summer I made about three dozen, spending a full day, if necessary, on each one. They were as carefully done and as realistic, as true to the object as I could make them. By eliminating the sky, by looking down instead of taking in the whole scene, I got a composition that was essentially a two-dimensional arrangement, and, at the same time, it corresponded to nature. When I went home I made paintings.[5]

In 1957 Pearlstein, eager for more free time in which to paint, began working on layout for *Life* magazine. The job was no less demanding than graphic design, but it did increase his awareness of the expressive possibilities of composition.

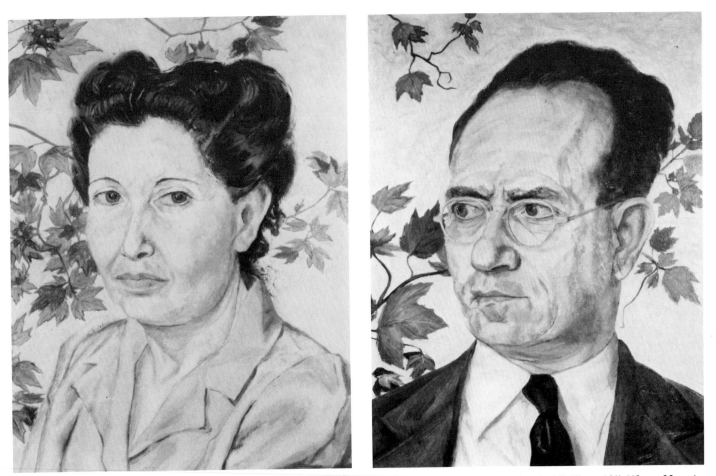

THE ARTIST'S MOTHER, 1946, oil, 16½" × 13" (42 × 33 cm) THE ARTIST'S FATHER, 1946, oil, 16½" × 13" (42 × 33 cm)

Life had a different scheme for each type of story. Subliminal psychological impact was implied by choice of typeface, how many columns, type size, margins, etc. Each type of story was handled differently—political, economic, entertainment stories, or an editorial. Each one had its own format, which you had to know. The training for that took me almost a year to master. . . . *Life* was a continuation of working on industrial catalogues that I'd done earlier. However, the photographs were the new element. Each time you got something on your desk the art director would have indicated how many different ways he wanted the same photograph cropped. You had to send the photograph down to the in-house stat place to blow it up or reduce it a certain percentage. Often you'd then get this gigantic blown-up photograph back so you could use just one small part of it. It was fascinating, seeing how scale changed. By scale I mean the size of the objects in the picture in relation to the outer edge.

I watched this happen with the same image over and over again. Some of these stories got worked on week after week after week. But I never thought that cropping had a particular meaning in my own work, and I was startled that cropping was seen to be a kind of trademark of mine. I saw it initially as a way of getting the scale of the forms bigger inside the canvas and controlling the space.

I know that in terms of the museum experience with fragments of antiquities, there is always an implied tragic element—something has been destroyed when you have an isolated fragment. I do like fragments—I collect them—Greek vase fragments and that sort of thing. But in my own work I don't mean it to have that kind of poetic overtone.[6]

After his discharge from the Army in 1946, Pearlstein returned to Carnegie Tech. The art classes he took were standard—painting, figure drawing, advertising, illustration—but, along with humanities courses, he was also exposed to the whole range of modern art, literature, and music. This exposure changed his approach to art. At the time, he considered these portraits of his parents his farewell to realism.

In the fall of 1958, Pearlstein achieved his aim of being a full-time painter when he was awarded a Fulbright grant to Rome. His work there, which consisted of many on-site drawings done during the day and a few paintings made from the drawings at night, was largely a continuation of his earlier landscapes. "I spent a year making drawings of the Roman Forum, Hadrian's Villa, and the Amalfi Drive. Those were all big nervous-looking rocks. But the idea, the symbolism, was still there in the back of my mind. These were all violent. Something violent had happened. The Roman ruins stand for something—a comment on civilization, if you will. But it was a kind of self-contained symbolism; it was there if you wanted it to be."[7]

Pearlstein exhibited the Roman drawings at the Tanager Gallery in the winter of 1959. In subject they related back to his earlier landscapes. Dore Ashton, in *The New York Times*, December 2, 1959, saw that the drawings represented ". . . a continuation of motifs that have long interested him: the morphology of mountains. In these large ink drawings, made in the mountains near Positano, Mr. Pearlstein maps the faces of stony wildernesses, carefully delineating essential rock forms. Large volumes, boldly simplified, are contrasted with shattering sequences of fissured rocks. Tiny veins and gullies are recorded with carefully thought-out graphic symbols. The sheer falling away of unimaginable heights is given in audacious sweeps of white emptiness. In short everything is observed, analyzed, and recorded with the economical reflection of the true craftsman."

As he had done with the Maine drawings, on his return to New York, Pearlstein continued to make paintings from the Roman drawings. The paintings were exhibited at the Allan Frumkin Gallery in April 1961, beginning an association with that gallery which still continues. The Roman paintings marked the end of the Abstract Expressionist phase of his career:

> The final Abstract Expressionist derived paintings I did were four big canvases; each was either eight feet high or long. . . . When I finished those four paintings I decided that was it. I had nothing more to say in terms of looking for things happening in rocks compositionally and tying it to the Abstract Expressionist painting technique, the drips and the splashes. They were the most complete statements I could make and finishing them left me free to start fooling around with the figure drawings, trying to develop them into paintings.[8]

Since the early 1950s, Pearlstein had been drawing from the model at weekly sessions organized by his friend Mercedes Matter, the painter who later founded the New York Studio School. On returning from his Fulbright year in Italy, he rejoined the group, which met at Matter's studio on MacDougal Alley, the former studio of Gertrude Vanderbilt Whitney, located behind what was then the site of the Whitney Museum of American Art. Over the years the group had shifting locations and membership. Among the participants, at various times, were Anne Arnold, Rudolph Burckhardt, Charles Cajori, Gretna Campbell, Lois Dodd, Louis Finkelstein, Joe Fiore, Mary Frank, Sideo Fromboluti, Paul Georges, Stephen Greene, Ted Groell (Repke), Philip Guston, Yvonne Jacquette, Alex Katz, Diana Kurz, Gabriel Laderman, George McNeil, Nora Speyer, Sidney Tillim, Jack Tworkov, and William White.

> A lot of the impulse and enthusiasm for the revival of figurative painting came from Mercedes. Mercedes was the force. Dorothy and I had moved uptown,

and I was so exhausted and felt so out of things, tired from jobs, that I was at first thinking of it as a way of keeping in touch with people, as a social thing. But there was dead silence and everyone was so intense. You got swept up in it, it was almost like going to church. Through that whole decade of the '60s I never missed a session. I really feel a tremendous debt to her. I never would have gotten involved with the figure if it hadn't been for Mercedes.[9]

In the early meetings of the drawing group, the models' poses were brief, usually about twenty minutes. Slowly, over the years, the sittings became longer, eventually becoming one pose for the entire session. Pearlstein was intrigued by the way Matter posed the figures. The models were art students, not professional models, so they did not strike traditional academic stances involving taut musculature. Nor were the poses chosen to suggest ideal physical beauty. Instead, Matter had the models sit, lie, or stand in relatively relaxed postures. There were almost always two of them together, their heads, trunks, and limbs dynamically interacting in space, and they were posed against Matter's collection of brightly colored Indian saris. This was very different from the art-school experience of a single model in a heroically strained position on the stand. There was an additional attraction for Pearlstein: the dispositions of the models' bodies and the structural accidents of their flesh seemed similar to the rock drawings he had done in Maine, and he was able to approach drawing them in exactly the same way. The figure drawings involved a shift in subject matter, not in technique.

Pearlstein showed the figure drawings at the Frumkin Gallery in the late spring of 1962. It was inevitable that the drawings would be seen in the light of the "New Images of Man" exhibition at the Museum of Modern Art in 1959, which postulated the expressionist, tormented figure as the symbol of mid-twentieth-century existence. For the public, and many artists, this exhibition legitimized a post-World War II image of the human form as an *angst*-ridden, flayed, and fragmented being. In this context the relative clarity of Pearlstein's figure drawings was startling to viewers who saw only the juxtaposition of two unclothed people and the consequent intimations of an erotic situation. What was surprising to Pearlstein was that so many emotional and sexual qualities could be read into drawings that were, essentially, blueprints of paid models, often faceless, just posing. Pearlstein worried about these implications, especially after he began painting from life in 1962, and it took a while for him to accept the fact that he was simply painting dynamic compositions that happened to involve nude people.

In 1962 Pearlstein made his first published statement about himself and his intentions. Part manifesto and part witty polemic, it was a brave act for someone who had just begun to paint from the model. Pearlstein described what he saw as the problems facing the contemporary figure painter and some of the options he could not accept:

Two tyrannies impose themselves on the artist. . . . One is the concept of the flat picture plane; the other may be termed the "roving point-of-view." Both have radically changed our way of seeing pictures and have conditioned those values that lead us to judge what a "convincing painting" is. We all bow low to them for it seems that we cannot overthrow them. But our battles with them sometimes produce paintings that are exciting in the resulting tensions. Unfortunately, too many easy compromises are being applauded in certain fashionable quarters.

A spread from the industrial catalog that gave Pearlstein his idea for Shower Attacking Woman. For several years Pearlstein worked on this and other catalogs as a layout artist and draftsman under the direction of typographic designer Ladislav Sutnar, and some of the imagery found its way into his paintings.

Pearlstein calls Bogey Man and Shower Attacking Woman his "symbolist" paintings. They grew out of his interest in the music of Mahler, the paintings of Redon and Klimt and the writings of Poe, Baudelaire and Rimbaud. The forms of the violent subjects were derived from his work on industrial catalogs. The figure of the monster in Bogey Man came from commercial illustrations of sections of extruded aluminum window frames. The aggressive shower, complete with spigot as menacing phallus, was based on a catalog page of bathroom fixtures.

Emerging Figure and Torso were chosen by Clement Greenberg for an "Emerging Talent" exhibition at the Kootz Gallery in January 1954. Emerging Figure, which had been titled before its selection, was based on a small fifth-century B.C. female sculpture that Pearlstein owned. Torso, with its thick, Hellenistic trunk, is one of Pearlstein's early landscape/figure paintings in which both images ceaselessly metamorphose into each other.

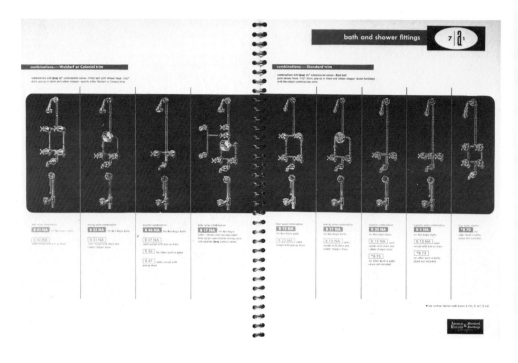

There are ways to make the figure "acceptable" to the taste-makers of today. All paintings have implied meanings, but some implications are more in line with current popular sympathies than others, and one path towards acceptability lies in the artist's choosing the proper kind of implication. Even the illusionists, those practitioners of perspective and chiaroscuro, find acceptance if they introduce lots of psychological overtones. The hallucinated verbal descriptions of Faulkner are given their visual counterpart in windswept Maine interiors. The gently decaying interiors and inhabitants of East Hampton and other Victorian places imply Chekovian degeneracy. Self-portraits loom behind their picture planes like the face of Dostoyevsky writing notes from the underground.

The monster image also affords many graceful solutions. The mythological half-beast-half-woman, ambiguous in meaning, is delightful. Scorched, charred, flattened out people have a ready market; this attractive Dubuffet formula does not disturb the picture plane while presenting an evocative image, primitivistic, apocalyptic, contemporary. Copied comic-strips and copied collages of commercial-art fragments are a bright new variant on the market. They have the built-in advantages of demonstrating our shallow America even to the blind, while remaining flat patterns. . . .[10]

Pearlstein was acutely aware that the aesthetic formulations of the early 1960s accepted the figure, as in De Kooning's Woman series, only if it seemed to be meshed with strong painterly emotions. What he proposed was different:

It seems madness on the part of any painter educated in the twentieth-century modes of picture-making to take as his subject the naked human figure, conceived as a self-contained entity possessed of its own dignity, existing in an inhabitable space, viewed from a single vantage point. For as artists we are too ambitious and conscious of too many levels of meaning. The description of the surface of things seems unworthy. Most of us would rather be Freudian, Jungian, Joycean and portray the human by implication rather than imitation.[11]

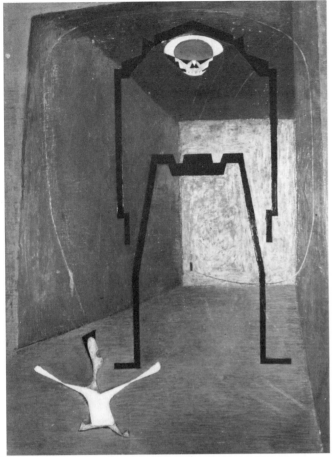

BOGEY MAN, 1949, casein tempera, 24½" × 18" (62 × 46 cm)

SHOWER ATTACKING WOMAN, 1949, casein tempera, 30" × 24" (76 × 61 cm)

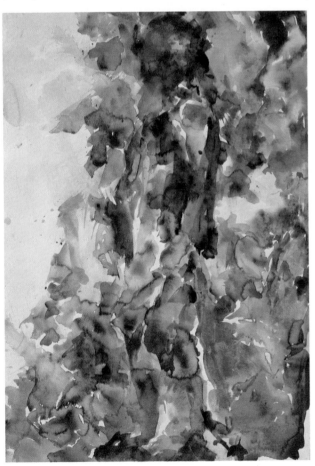

EMERGING FIGURE, 1952, watercolor, 22" × 15½" (56 × 39 cm)

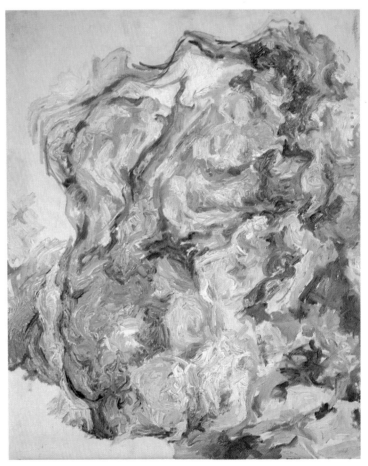

TORSO, 1954, oil, 36" × 30" (91 × 76 cm)

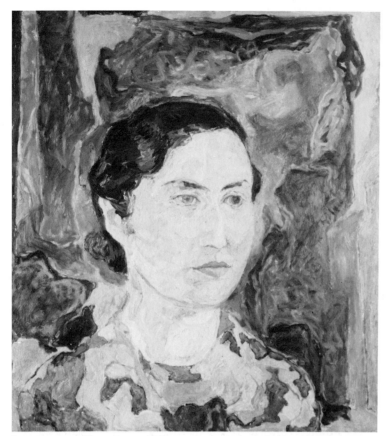

PORTRAIT OF DOROTHY, 1950, casein tempera, 26½″ × 24″ (67 × 61 cm)

DOLLAR SIGN, 1950, casein tempera, 40″ × 30″ (102 × 76 cm)

In Pearlstein's paintings of the early 1950s, his expressionist impasto tended to congeal the paint into small areas, creating an overall pattern that unified the surface.

The subject of Dollar Sign is more complicated, and brutal, than merely the symbol for American currency. It derived from a case study, "Medea in Modern Dress," described by psychiatrist Fredric Wertham in his book The Show of Violence, published in 1949. The case dealt with a widow who found herself increasingly unable to handle the difficulties of working and caring for her two children, a boy and a girl. She tried to murder them by hitting them with a hatchet and cutting their throats. Her daughter, whom she also set on fire with gasoline, died, but her son lived. Dollar Sign shows the children impaled on the lower prongs of the symbol of money. Burning Girl, a later painting, evolved out of the same story but, like Torso, is more closely related to the interest in landscape Pearlstein developed later.

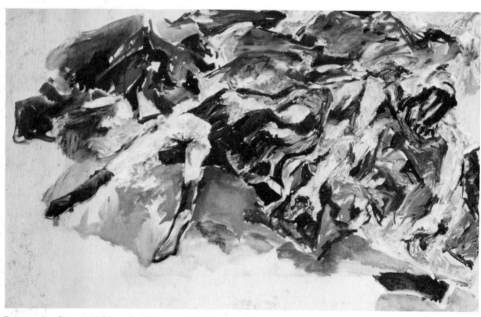

BURNING GIRL, 1952, oil, 30″ × 48″ (76 × 122 cm)

These paintings, and others of the early 1950s, show two themes, besides violence, which are sometimes combined: the city and flying figures. In The City, the vertical slabs of the buildings are set off by the horizontal elements below and the amorphous but threatening shape above. This shape becomes clearer and more malevolently effective in Angel of Death Over the City, inspired by Francesco Traini's fourteenth-century fresco The Triumph of Death in the Campo Santo, Pisa.

Like Dollar Sign, the imagery of The American Eagle derives from popular culture, but the impasto of the kaleidoscopically fragmented swirls of the flag set it off from the seeming

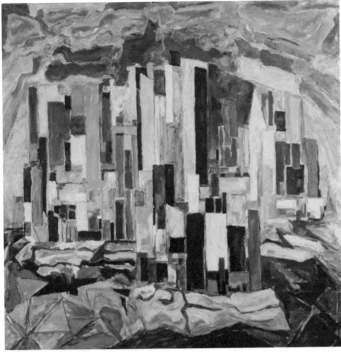

THE CITY, 1952, oil, 40″ × 40″ (102 × 102 cm)

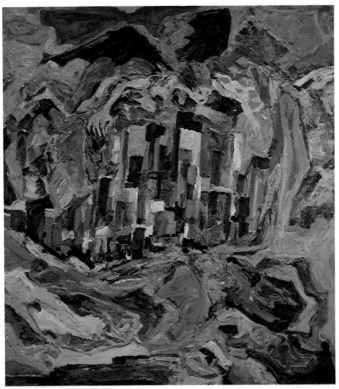

ANGEL OF DEATH OVER THE CITY, 1952, oil, 42″ × 36″ (107 × 91 cm)

THE AMERICAN EAGLE, ca. 1949, oil, 24″ × 20″ (61 × 51 cm)

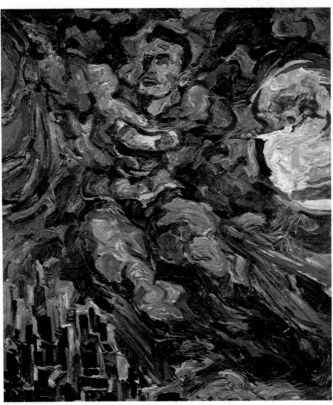

SUPERMAN, 1952, oil, 40″ × 36″ (102 × 91 cm)

objectivity of later Pop art. The form of the eagle was suggested to Pearlstein by the outline of a pork chop bone. The outstretched wings of the eagle are recalled in the arms of Superman, the only survivor of a handful of pre-Pop paintings of comic strip heroes that Pearlstein did in the early 1950s. The hero from Krypton—in the posture of Michelangelo's God, in the Sistine Ceiling, creating the sun and the moon—is preventing the collision of two missiles over a Metropolis apparently already in flames.

CREST OF THE MOUNTAIN, 1954, oil,
48″ × 36″ (122 × 91 cm)

MOONLIT LANDSCAPE, 1955, oil,
44″ × 48″ (112 × 122 cm)

BOULDER, 1958, wash, 18⅛″ ×
21¾ (46 × 55 cm)

WAVES, 1955, oil, 44″ × 48″ (112 × 122 cm)

BOULDER, 1958, oil, 50″ × 60″ (127 × 152 cm)

Pearlstein's early landscapes were based on interesting rocks he had collected on various trips. The rocks were held in his hand and their weathered, time-worn surfaces carefully examined. With imagined atmospheres around them, the rocks were extrapolated into canvases of cliffs and mountains violently writhing in concavities and convexities that resembled the compositions and facture of Abstract Expressionism. With this method, the imagined light could even be nocturnal, as in Moonlit Landscape, or the rocks transformed into water, as in Waves.

ROOTS, 1957, oil, 96″ × 44″ (244 × 132 cm)

TREE ROOTS, 1956, wash, 18″ × 21″ (46 × 53 cm)

POSITANO 7, 1959, wash, 20¾″ × 27⅜″ (53 × 70 cm)

POSITANO 2, 1960, oil, 67″ × 96″ (170 × 244 cm)

When Pearlstein began to make drawings of roots and trees with the intention of working them up into paintings, he was very careful in his rendering of the masses of component forms. In the drawing of Boulder, the ponderous rocks, with their dark washes of interior articulation, push forward belligerently, almost over-hanging the foreground, where the paper is relatively untouched. The sense of the physical presence of the rocks seen close up is augmented by the sparseness with which the trees and background are described. This has the effect of distancing the viewer from the scene. Much of the implied descriptiveness of the drawing comes from a characteristic inherent in the medium, the possibility of leaving areas of the paper blank to act as an imaginative foil for the forms emerging from the wash and to stabilize their movements. For all its expressionist activity, the drawing appears almost classically calm in comparison to the painting made from it in the same year. In the painting, areas left empty in the drawing are filled in, and the result is an overall animation of surface that fills the canvas and brings the forms closer to the picture plane and, thus, to the viewer.

The drawings Pearlstein made in Rome are different from his earlier work in their calmness and precision. Freed from the pressures of a job and with more time at his disposal, he was more thoughtful and contemplative about his drawing. The cliff of Positano 7 moves across the horizontal paper with the deliberate majesty of Sung mountains. Along with the familiar spatial elisions, there is a powerful sense of conscious objectivity in the contour that almost surrounds each movement of form and in the wide tonal range in the wash, which renders perceived values. After returning to New York in 1959, Pearlstein continued to make paintings from his Roman drawings. Using the drawing as a kind of blueprint, he carefully reconstructed each form in paint, but on a greatly enlarged scale. The process of translating the delicate wash notations into the less docile medium of oil paint was difficult. As in his earlier landscapes done from drawings, the result was a much more thickly painted, expressionist version of the subtleties of wash. At times, what seems like arbitrary expressionist color was actually an outgrowth of direct experience. The dazzling array of reds in Positano 2 was inspired by a section of the Baths of Caracalla as it was lit for the filming of the nightclub dancing scene in Fellini's La Dolce Vita. Despite the realism of the subject, the molecular build-up and diagonal orientation of the forms were very much within the Abstract Expressionist aesthetic.

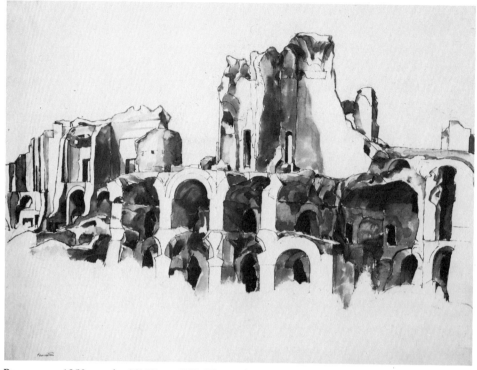

PALATINE, 1959, wash, 20½″ × 27″ (52 × 69 cm)

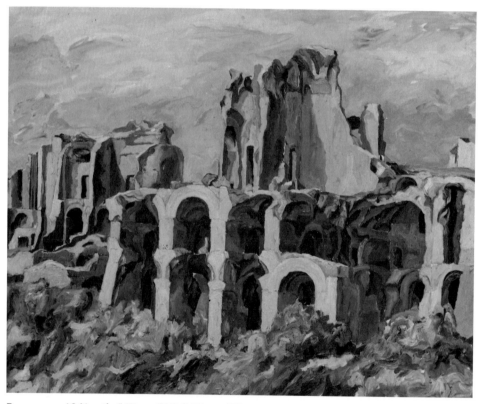

PALATINE, 1961, oil, 54″ × 70″ (137 × 178 cm)

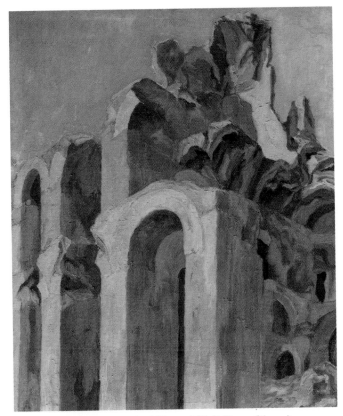

ROMAN RUIN, 1961, oil, 44″ × 36″ (112 × 91 cm)

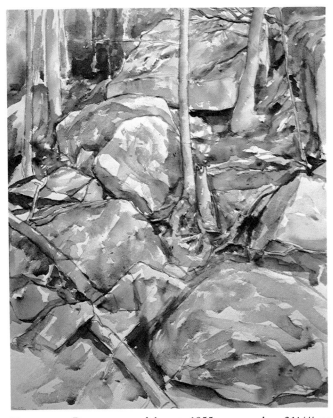

TREES AND BOULDERS IN MAINE, 1955, watercolor, 21½″ × 18″ (55 × 46 cm)

In his espousal of the figure as a fit subject for painting Pearlstein carefully avoided traditional humanistic rhetoric about the body. Instead, he phrased his argument in visually dynamic terms that even the most hard-boiled Abstract Expressionist could understand.

The naked human body is the most familiar of mental images, but we only think we know it. Our everyday factual view is of the clothed body, and on those occasions when our dirty mind will strip a person, it will see something idealized. Only the mature artist who works from a model is capable of seeing the body for itself, only he has the opportunity for prolonged viewing. If he brings along his remembered anatomy lessons, his vision will be confused. What he actually sees is a fascinating kaleidoscope of forms; these forms, arranged in a particular position in space, constantly assume other dimensions, other contours, and reveal other surfaces with the breathing, twitching, muscular tensing and relaxation of the model, and with the slightest change in viewing position of the observer's eyes. Each movement changes as well the way the form is revealed by light; the shadows, reflections and local colors are in constant flux. The relationship of the forms and colors of the figure to those of the background becomes mobile and tenuous. New sets of relationships continuously reveal themselves. . . .[12]

The position Pearlstein advocated stressed two points: the artist's own selection of the problems he or she wishes to face, and the attainment of sufficient craftsmanship to solve those problems.

The rules of the game are determined when the artist decides what kind of faithful record of which aspect of the experience shall be made. For, regrettably, the artist cannot transmit the total experience. The displayed forms themselves become only a point of departure. . . .

While Pearlstein's drawings of Roman ruins are often freer than his earlier landscapes in the application of the wash, the feeling of control is still there. In the drawing of Palatine, one aspect of this control is the exquisite tension between the three-dimensional massing of the ruins and the untouched paper within the arches which seems almost, but not exactly, parallel to the picture plane. The same tension appears in Roman Ruin, an oil done from an earlier drawing, in which the quietly brushed fronts of the arches stand, like memories of permanence, in front of the transiencies of nature.

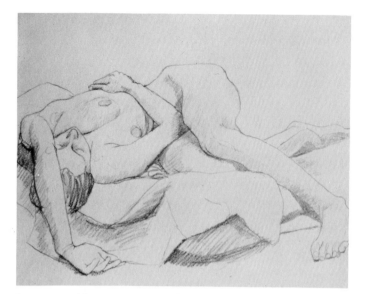

RECLINING NUDE, 1961, pencil, 10⅞″ × 14″ (28 × 36 cm),

RECLINING NUDE WITH LEG UP, 1962, pencil, 10⅞″ × 14″ (28 × 36 cm)

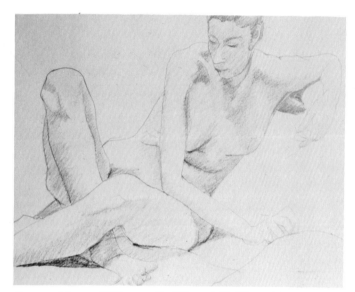

SEATED NUDE, 1962, pencil, 11″ × 14″ (28 × 36 cm)

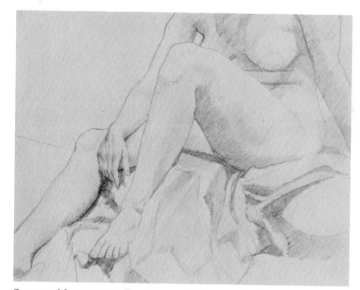

SEATED NUDE ON A BLANKET, 1962, pencil, 11″ × 14″ (28 × 36 cm)

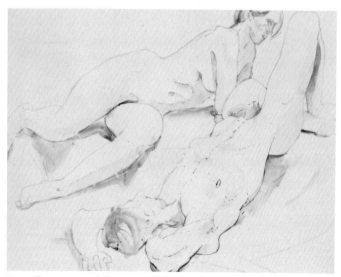

TWO RECLINING MODELS, 1962, wash, 18″ × 24″ (46 × 61 cm)

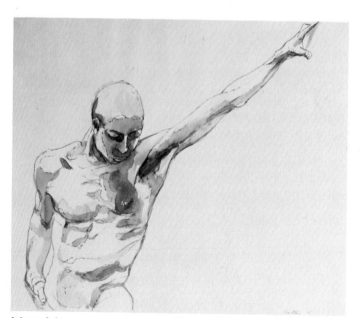

MALE MODEL WITH ARM ON WALL, 1962, wash, 14″ × 17″ (36 × 43 cm)

SEATED NUDE, 1962, pencil, 13¾" × 10¾" (35 × 27 cm)

The character of a work of art results from the technical devices used to form it, and the ultimate meaning and value of a work of art lie in the degree of technical accomplishment. The most fascinating subject matter becomes meaningless if the level of technical achievement is low, while a painting trite in subject becomes profound if a technical challenge has been met. As an artist I can accept no other basis for value judgments. . . .

In the battle of painting the figure, to pry open the flat picture plane and control the roving eye, the weapons must be chosen carefully and wielded skillfully. A human being, a profound entity, is to be represented.[13]

NUDE STANDING WITH ARMS CROSSED, 1964, pencil, 13¾" × 11" (35 × 28 cm)

Pearlstein's switch from painting from his drawings to painting from models coincided with a change in the manner of supporting his family. He had begun part-time teaching at Pratt Institute in 1959 and was appointed Assistant Professor in the Art Department of Brooklyn College in 1963. Teaching not only forced him to rethink his ideas about art and his approach to painting, it also enabled him to leave the field of graphic design. "The thing that happened after I left that kind of precisionist work and got into teaching for a living was that my work became more precise. Once I wasn't doing it for a living, the same impulse went into the painting. The paintings almost immediately got rid of the expressionism and began working toward greater and greater clarity and precision. At first I painted from my drawings. We were absolutely broke, had no money at all and three babies. Then I heard Cajori mention that he had hired a model privately. That sounded so astonishingly extravagant to me, but that's when I worked up the nerve to do it."[14]

The studio situation for painting from the model that Pearlstein began with was essentially the same as it is today, although a good deal more furniture has replaced the simple drape on the floor of 1962. From the start, he chose to limit the conditions of his paintings, almost as if they were scientific experiments. The first choice was an unvarying light source that would permit him to ignore any ephemeral effects and pay total attention to the forms of the model. Three "north-light," blue-tinged floodlights, canted slightly toward the wall, provided the only working illumination in a studio with covered windows and allowed painting at any time of day or night, regardless of the vagaries of the natural light outside.

Many of the drawings of the early 1960s show compositional themes that eventually came to be among Pearlstein's favorites and were repeated, with variations, in later drawings, watercolors, paintings, and prints: the raised arm; parallel extended bodies; and the single figure, seated or standing, usually with some compression of limbs. Increasingly, Pearlstein found the pencil too slow a medium for many of the brief poses. Returning to a technique from his commercial drafting experience, he began using wash applied with soft Japanese animal-hair brushes, which yielded both a fine point for contours and a broad surface for the tones in shaded areas. In the process, he also returned to a Cézanne-derived drawing device he had used earlier for rocks and Roman ruins. Broken lines became a personal notation of his perception of something structural happening in a particular area, an interior form or shadow, which he either did not have the time or the inclination to develop further at that particular moment. The dotted lines in Two Reclining Models become abbreviations for formal articulation which await development in another medium.

Pearlstein's early figure drawings were done at weekly meetings of the drawing group begun by Mercedes Matter. They neglect classical Renaissance triangular compositions in favor of dynamic trapezoidal configurations, either vertical or horizontal. They were done with thick pencil on coarse drawing paper with the idea that the combination would facilitate the rendering of continuous modeling, as in Seated Nude on a Blanket.

TWO SEATED MODELS, 1961, wash, 17″ × 14″ (43 × 36 cm)

The first paintings Pearlstein made from his figure drawings show the same heavily worked texture and patchy treatment as his landscapes. Despite his attempt to create a physical space for the figures, an ambience not found in the drawings, the viewer's eye moves restlessly over the expressionist activity of the surface, its attention divided between the figure and the surroundings. The sketchy indication of drapery to the left of the male model's head in Two Seated Models is transformed, in the painting, into an olive-green muddle of movement. At the same time, it is possible to see the rationale for Pearlstein's use of dotted lines in the drawings. These almost shorthand notations in the drawings enabled him to read back the effects of light on exterior anatomical forms in the paintings. This becomes clear if one compares the left arm, knee, and back of the male figure or the left arm and torso of the female model in both the drawing and the painting. Not just a personal mannerism, the dotted lines are more indicative of visual bodily events than they appear to be at first glance.

Another example of Pearlstein's way of combining dotted lines with different intensities of wash is Sitting Female and Standing Male, especially when it is compared with the painting that derived from it. The schematic construction of the bodies in the drawing has been re-created as fully developed masses in the painting. Every line and tone of the drawing—even the empty paper—has been decoded into a form of physical presence, including the floor and wall and the recession of space to the right. Two Figures, One Standing is exceptional among the paintings of 1962 for its radically cropped male figure. Most of the paintings of that year are distanced from the figures, more aloof, and show the models more or less intact.

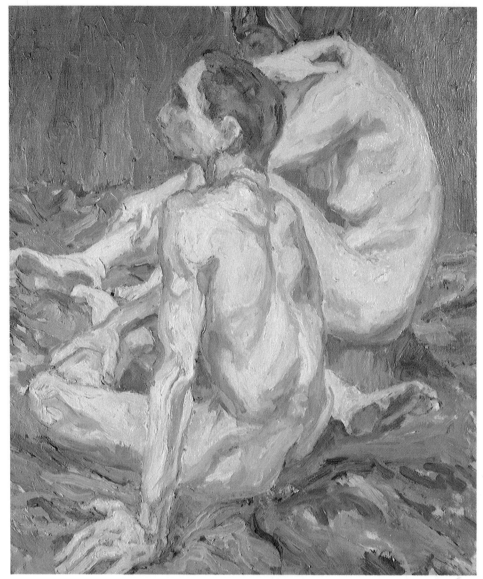

MODELS IN THE STUDIO, 1961, oil, 26″ × 22″ (66 × 56 cm)

SITTING FEMALE AND STANDING MALE, 1962, wash, 17″ × 14″ (43 × 36 cm)

TWO FIGURES, ONE STANDING, 1962, oil, 50″ × 44″ (127 × 112 cm)

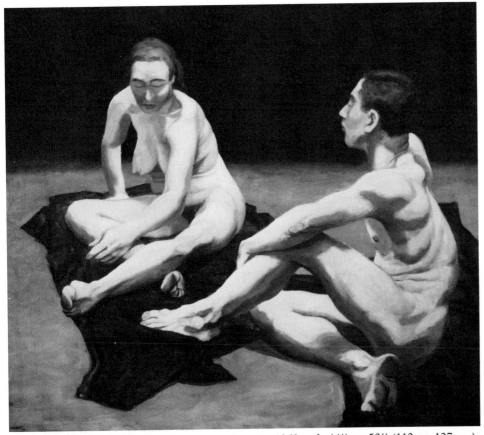

MALE AND FEMALE MODELS SITTING ON FLOOR, 1962, oil, 44″ × 50″ (112 × 127 cm)

MODELS IN THE STUDIO, 1962, wash, 14″ × 17″ (36 × 43 cm)

As early as 1962, when Pearlstein first began to paint from his drawings, bodily planes and contours became firmer and tighter. In his concentration on the models, he often left the figures intact, placing them in an ambiguous, but limited, setting. The Rothko-like proportions of the division of floor and background pushes the sculpturally modeled figures into a tangible space that makes it possible to ask questions about what they are doing.

The floodlights also provided a handy but manageable package of reflections and shadows that Pearlstein was to exploit in later paintings. Not since Proust's cork-lined room has a physical setting for aesthetic creation been so consciously and purposefully narrowed.

For a long time Pearlstein used his figure drawings as blueprints for potential paintings. He would select one with a composition he found particularly arresting and arrange the model or models, the same ones if possible, in the pose of the drawing. Working with more or less the same set of models for many years has given Pearlstein the opportunity to learn their bodily characteristics, the kinds of poses they can or cannot easily take. Often, especially recently, the models, who are sympathetic to Pearlstein and his painting, will suggest changes that he accepts. Often, too, the models, during breaks, will assume a distinctive personal posture that Pearlstein will fix in a quick sketch as a possible compositional idea. As a music lover and record collector, he uses an ideal method to time the models' poses: the length of time it takes to play one side of an LP recording. Aside from its use as a timing device, the music forestalls conversation, assists Pearlstein's concentration on the painting and diverts the models, when they don't fall asleep in their poses. Since his musical taste is wider than most, from the *Ring* cycle to Indian ragas, he concedes the models veto power over what music is to be played.

Pearlstein showed paintings both from drawings and from life at the Frumkin Gallery in March 1963. The exhibition resulted in the first important review of his work. Sidney Tillim, in *Arts* magazine, acknowledged that "Pearlstein, who for a number of years now has been showing landscapes redolent of Abstract Expressionism in technique, has achieved what has become difficult to say without wincing—a breakthrough. He has not only regained the figure for painting; he has put it *behind* the plane and in deep space without recourse to nostalgia (history) or fashion (new images of man)."[15] Tillim, however, sensing the ambiguities in Pearlstein's still developing attitude toward the figure, took the models' ennui as a philosophical proposal rather than for what it was—a description. Some of the infelicities that Tillim noted, such as the heavy modeling, were due to Pearlstein's speed of work at this time.

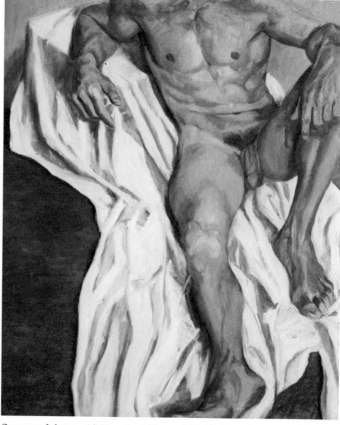

RECLINING MALE, 1962, oil, 17½″ × 14″ (44 × 36 cm) SEATED MALE, 1962, oil, 44″ × 36″ (112 × 91 cm)

Reclining Male *was Pearlstein's first work painted directly from the model. Consciously experimental, as evidenced by its small size, the composition is restricted to a simple diagonal accompanied by summarily rendered drapery. Pearlstein's next painting from life was the frontal* Seated Male, *a larger depiction of the same model. Both paintings display a specificity of shadows and light on flesh that came from direct observation of the figure under the new conditions of studio lighting. This specificity, in strong contrast to the generalized modeling of the figure paintings done from drawings, inescapably anchors the figures in these new paintings to the studio environment of their making. In so doing, Pearlstein deliberately sidestepped many of the conventions of the nude in art, both ancient and modern. With no personal attributes, these figures are neither gods nor personifications. The* Reclining Male *is obviously not a* Sleeping Hermaphrodite. *Nor, despite its genital display, is the* Seated Male *the* Barberini Faun *or Caravaggio's* Amor Victorious. *Nor are the models named in the titles.*

In the early '60s, when I started the big paintings, I was thinking of them as very large sketches. Because of the high cost of model fees, I gave myself a time limit. What I couldn't finish within four or five sessions was just too bad. The painting was completed at that time. In that period, when money was very tight, the money I was spending on the models was a real inhibiting factor. I couldn't work on the painting without the model being there. Allan Frumkin gave me a stipend each month, but I still felt very inhibited putting out all this money, so I went after the big scheme. It was the "concept" that was important: establishing the big divisions of the canvas first, and getting down as much of the surface characteristics as I could. But all those paintings of the first couple of years would now be my starting point.[16]

As Pearlstein gradually spent more time on each painting, the larger canvas held greater attraction. Because he was using the stiff bristle brushes with which he was familiar from his expressionist paintings, instead of the more amenable sable, he found the increased working area allowed for the development of his growing awareness of surface details and his desire that the ambience of the models be as fully worked out as their bodies. Besides the technical challenge of the larger scale, there was another reason for the big format. While he was moving away from an expressionist surface, Pearlstein wanted the dynamic elements of the composition to dominate and not the paint handling. Small canvases possessed neither the room for the strong bodily configurations he was after nor the physical assertiveness that, in the tradition of Abstract Expressionism, implied a confrontation with the viewer.

This confrontational aspect of Pearlstein's large paintings of the 1960s projected viewers into an area for which they were ill-prepared. Except for some work by such Regionalists as Thomas Hart Benton and John Steuart Curry, figural paintings of this size were uncommon in modern American art. Both they and

FIGURE, 1962, oil, 26″ × 30″ (66 × 76 cm)

TWO STANDING FIGURES, 1962, oil, 48″ × 40″ (122 × 102 cm)

such a possible European predecessor as Balthus were obviously more allegorical and allusive to narrative content than was Pearlstein. What added to the impact of Pearlstein's figures, life size or larger, was the close-up cropping of head and limbs which thrust the bodies toward the viewer and aimed attention on what was visible. Primarily, the cropping grew out of his method of composing, beginning with a formally complex center and working radially outward. "For me, what counts are the movements, the axial movement, the direction in which the forms move. So, if the torso is moving well, it doesn't need the head. If the head is moving in an altogether different way and I like it, I'll start with the head and let the feet go. It's how these things crisscross across the surface of the canvas that really matters."[17] The cropping, however, perhaps unconsciously, served another purpose. It often removed the model's face and, thus, the vehicle for the expression of personality and mood, leaving the viewer to grapple with the compositional complexities of a storyless image that, while cropped, seemed complete in itself.

Sharp-focus realism evolved as soon as I started painting directly from life. The difference between drawing and painting is that in drawing you deal with outline, which is relatively sharp. When you start dealing with surfaces in between the outlines, as in painting, then you have to start making choices. Nothing is sharp in between. How are you going to differentiate each area? That becomes an issue. That's where the focus began sharpening up. At first the backgrounds were quite ambiguous and didn't really deal with the space around the figure. When I started to deal with the background space as completely as I dealt with the figure, that made a big difference—this is what separated me from the other painters I then knew. It meant carrying the painting to a point of completion, which at that time was very unfashionable. It meant carrying the work out completely to the edges and defining what was happening all the way around the edge as well as the figure in the center.[18]

Not only was a completed painting unfashionable, realism itself was considered suspect because it had been superseded by the different styles of abstraction. Most objections to Pearlstein's figure paintings, expressed both privately and in print, hinged on comparisons with the academic tradition of painting the nude, then considered moribund. However, from his first figure paintings, Pearlstein carefully and consciously avoided the characteristics of the art school approach: using an attractive model and correcting any body flaws to conform to conventional ideals of beauty; eliminating cast shadows in the belief that they interfere with the sculptural forms created by continuous modeling; selecting a pose for the clarity of its anatomical display. A great deal of the impact of Pearlstein's paintings is the result of short-circuiting such academic expectations.

In the late 1960s, Pearlstein began to complicate his paintings by using textiles, rugs, and furniture along with the figures. The addition of furniture to the paintings began as a gesture toward the comfort of his models, but he soon realized that the furnishings, as another set of forms within the composition, greatly increased the potential for pictorial invention. It is important to Pearlstein that these objects are not studio props in any traditional sense—no spears, fans, or other objects that would imply a story—but things that he and his family sit and walk upon, the furniture they live with. He enjoys this introduction of his private life into his paintings; the fact that the furniture in his house, chosen for shape, texture, or pattern, has the possibility of eventual dynamic interaction with the bodies

As soon as he began painting from the model, Pearlstein was attracted to nontraditional poses that de-emphasized the integrity of the body and concentrated attention on the sweep of forms across the canvas. The gnarled pose of the model in Figure is so far removed from any usual notion of a beautiful body in a beautiful position that the average viewer will read it as the physical expression of a psychological condition before realizing the importance of the dynamics of the composition.

Two Standing Figures is close to certain Picasso paintings of 1903 but, with some distance between them, the figures in the Pearlstein are much less emotional. As in Two Figures (page 12), he is still keeping his distance from the models, painting them as more or less complete entities.

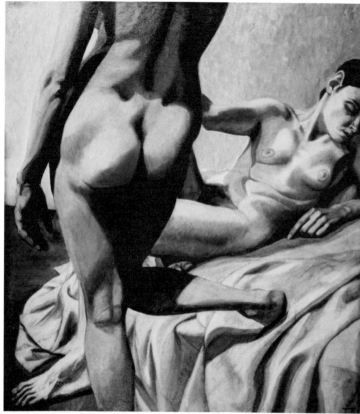

TWO FEMALE NUDES, 1964, oil, 50" × 45" (127 × 114 cm)

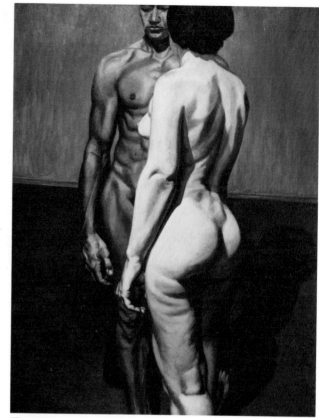

TWO STANDING MODELS, 1964, oil, 72" × 54" (183 × 137 cm)

BACK—FEMALE NUDE, 1963, oil, 30" × 26" (76 × 66 cm)

While Pearlstein is no stranger to large paintings, many of his early figures were relatively modest in size. The modeling of the smaller figures was generally summary, the arrangement of the studio lights either bleaching out flat planes, as in Reclining Model, or creating the sharp tonal divisions of Two Female Nudes on Floor. In effect, these were trial pieces in which he experimented with radical cropping (Back—Female Nude) or unorthodox points of view (Reclining Model). He soon began to enlarge the scale of his figure paintings, interspersing large paintings with small ones, sometimes with repetitions. For example, the volumetric contrapposto of the small Back—Female Nude was so appealing, especially with the sinuous contour of the right side of the model's body, that he used this figure again in the larger Two Female Nudes in which it overlaps the thighs of another, contrasting diagonal figure.

Up to the middle 1960s, Pearlstein had usually posed his models on simple drapery, placing them on ordinary furniture, on the floor or, occasionally, standing, as in Two Standing Models. As he began to concentrate on firmer modeling, the space around the figures became as important as their bodies. His desire to situate the figures clearly in space led to the more careful re-creation of the drapery, as in Nude on Green Cushion, or the studio space, as in Female Nude on Yellow Drape, or both, as in Two Nudes and Couch.

of his models. If the sofa or chair is light enough to be moved easily, Pearlstein has it carried upstairs to the studio, leaving a void in the living room for as long as he takes to complete the painting. If the object is too heavy to move, lights are set up downstairs and the painting is done there.

In 1965 Pearlstein renewed his interest in portraits. At first the subjects were his children and his friends, often fellow artists for whose work he traded the portraits. Rapidly the circle of sitters widened to include poets, writers, collectors, art critics, and historians, and quite soon he received official commissions. It was the portraits, more than the figure paintings, that brought him to the attention of the general public.[19]

One of the more important aspects of Pearlstein's recent work has been his renewed interest in landscape, as seen in oils, watercolors, and related aquatint etchings. The landscapes have strong connections to the art of both the past and the present. In depicting historic ruins of different civilizations, rather than contemporary bucolic plains, they are reminiscent of the art of many nineteenth-

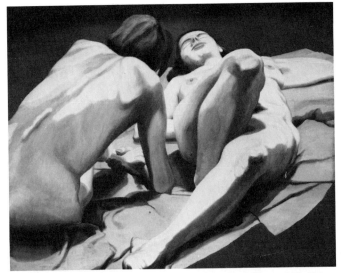

TWO FEMALE NUDES ON FLOOR, 1963, oil, 36″ × 44″ (91 × 112 cm)

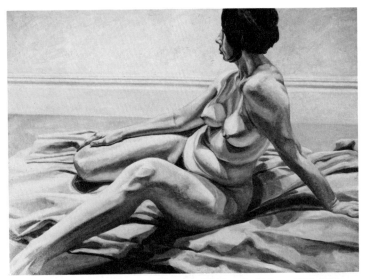

FEMALE NUDE ON YELLOW DRAPE, 1965, oil, 54″ × 72″ (137 × 183 cm)

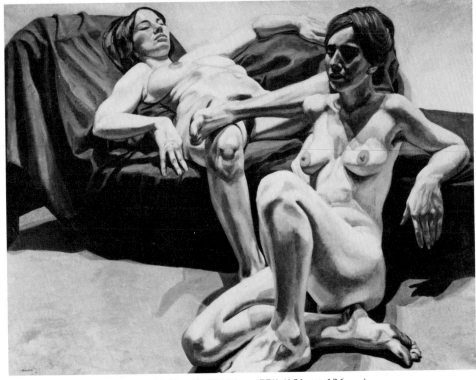

TWO NUDES AND COUCH, 1965, oil, 59½″ × 77″ (151 × 196 cm)

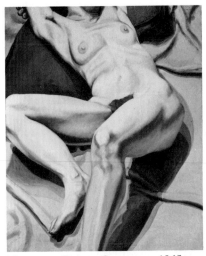

NUDE ON GREEN CUSHION, 1965, oil, 44″ × 36″ (112 × 91 cm)

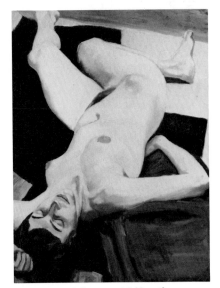

RECLINING MODEL, 1963, oil, 40½″ × 30″ (103 × 76 cm)

century American and English Romantic landscape painters on a Grand Tour of cultural remains; he collects old photographs of great scenery, Egypt, and the American Southwest. Pearlstein uses movies and slides to document his trips and the evolution of a watercolor on the spot. This photographic record, seemingly so close to tourist photography, is related to the ideas behind Earthworks, those remote constructional situations whose visual existence is heavily dependent on the medium of the camera. In the documentation, Pearlstein's portable drawing table is a constant, peripatetic presence announcing that, instead of making an archaeological object, he is painting one that already exists.

Pearlstein's growth as a realist painter over the last twenty years has been exemplary. Like a geometrician joyfully intent on enlarging the development of axioms, in his art he has consistently grown from within. The point has not been lost on a generation of younger artists. As Pearlstein puts it, "I tried to make the world a little safer for realists."

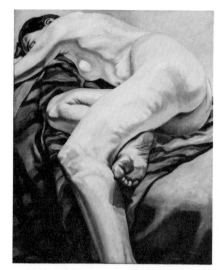

RECLINING MODEL ON STRIPED CLOTH, 1966, oil, 44″ × 36″ (112 × 91 cm)

Male and Female Models *is one kind of composition Pearlstein enjoys: centralized, dense, and spatially intricate. While the models are of opposite genders, their intertwined pose defies a narrational reading. What fascinated Pearlstein as he worked on the painting were the intervals between the forms: the woman's left hand which, in relationship to the male model's head, marks the advance of her right knee to the plane of his left leg; her shadowed left breast filling the concavity between her left arm and his head; her left leg, with foot reaching toward the picture plane, enclosing the figural triangle on the right. The seemingly gargantuan proportions of the female model's left leg is a function of Pearlstein's way of painting one section at a time and focusing his eyes on individual areas consecutively, rendering closer forms as larger and bypassing the mind's tendency to give important parts, such as heads and faces, greater physical presence.*

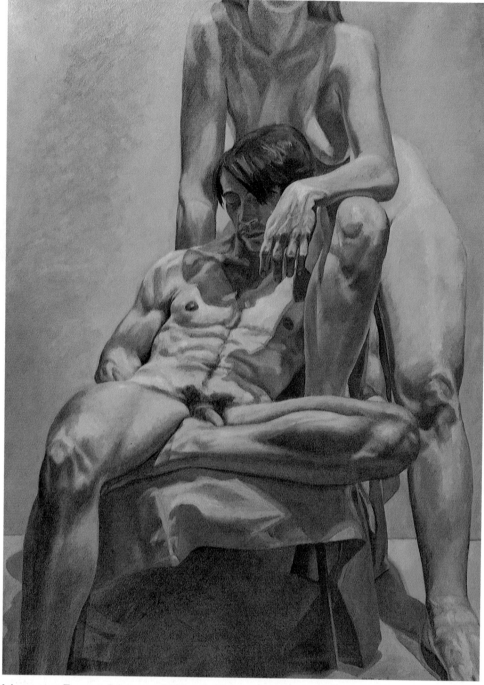

MALE AND FEMALE MODELS, 1965, oil, 72″ × 53″ (83 × 135 cm)

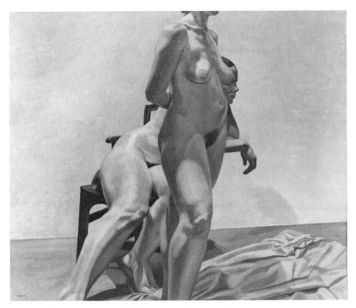

TWO MODELS, ONE SEATED, 1966, oil, 60″ × 72″ (152 × 183 cm)

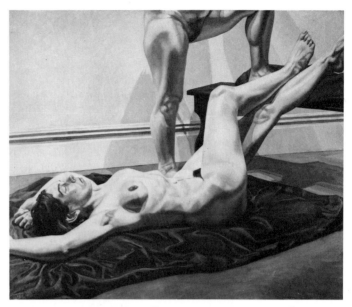

TWO MODELS WITH BLUE DRAPE, 1967, oil, 60″ × 72″ (152 × 183 cm)

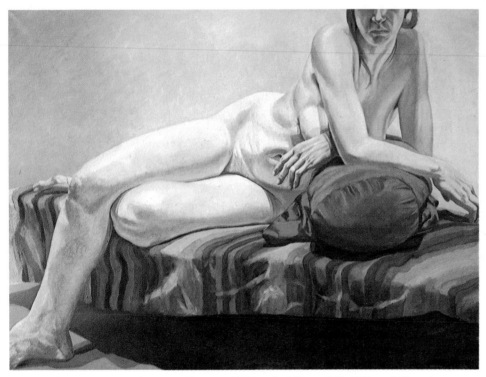

FEMALE RECLINING ON STRIPED CLOTH, 1966, oil, 54″ × 71″ (137 × 180 cm)

In his work of the late 1960s, Pearlstein's style matured in paintings that were uncompromising in their fidelity to the visual facts of a carefully controlled studio situation. At the same time, he began the process of complicating that situation—a process that still continues. The first complication he introduced was brightly colored fabrics, which replaced the monochromatic drapes. Besides their providing other areas of chromatic interest in his paintings, he found that the new cloths posed an additional problem: reflected light, as in the buttocks and breast in Reclining Model on Striped Cloth *and in the torso and legs in* Female Reclining on Striped Cloth. *Compositions, too, became more complex. In* Two Models, One Seated, *with its overtones of Caravaggio and the almost Surreal substitution of nipple for eye, he used audacious, Manneristic overlapping, and in* Two Models with Blue Drape, *he used equally daring cropping. Along with the novelty of Pearlstein's compositions, the massive accumulation of details of his clearly depicted figures in clear spaces creates a shocking monumentality that adds to the impact of the paintings' size.*

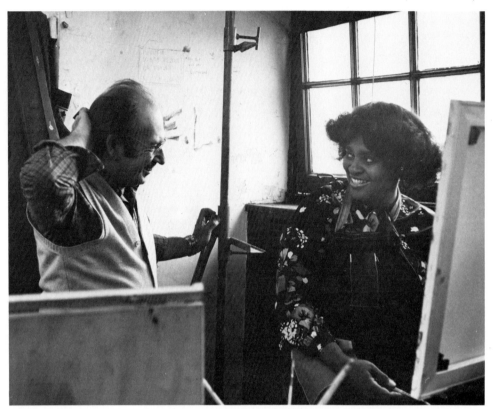

Philip Pearlstein and student in his undergraduate painting class, Brooklyn College

Part Two
TEACHING

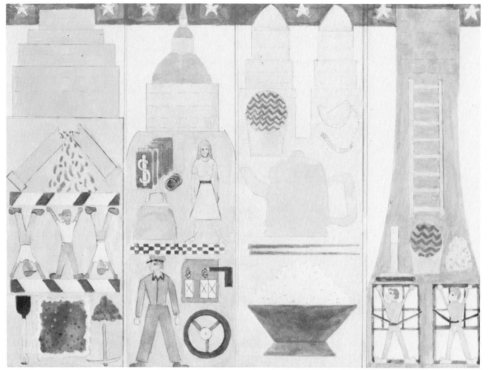

All the work shown on pages 44–51 is by Dennis Joyce, a student in Philip Pearlstein's graduate History of Art Workshop at Brooklyn College in the spring of 1980. Joyce took a photograph of a Manhattan street scene as the basis for his semester's work. While not exactly an image from The Wasteland, *the photograph is of a modern, urban subject—and it is particularly rich in a variety of forms, shapes, and spatial relationships.*

For one of the first exercises in flat modes of realism, Joyce extracted the figures of the two workmen from his photograph and depicted them in the manner of Greek red-figure vase painting, in which the negative space of the black paint outlines the bodies, which retain the red coloration of the clay. The mode in Joyce's second painting is Egyptian: flat forms are arranged in registers which are meant to be read as successively receding planes of space. In his third piece, Joyce followed the twentieth-century example of Paul Klee, whose use of privately invented symbols is also Egyptianlike; here Joyce used the shapes as serially repetitive pictographs in an arrangement that has a sense of fantasy.

When Philip Pearlstein began teaching in the late 1950s, the change in his means of earning a living resulted in his painting taking a new direction, for he found himself painting with a preciseness that had previously been confined to his work as a graphic designer. His teaching, in turn, has been greatly influenced by the development of his own art, his background in commercial design, and most important of all, his studies in art history.

In the late 1950s practicing artists with graduate art history degrees were relatively rare, and it was Pearlstein's academic background that secured his first teaching job at Pratt Institute in September 1959. Although he was hired primarily to teach a history of art workshop, over the next four years he also taught foundation courses in drawing, two-dimensional design, and advanced painting. It was during this time that he began to concentrate on drawing and painting the figure from life, and he had his first exhibition of figure drawings while associated with Pratt. Subsequent to his show he was invited to be Visiting Critic in Art at the Yale University School of Art and Architecture, where he taught drawing for the 1962–63 academic year.

Pearlstein's experience in graphic design and his connections with the Bauhaus-influenced designer Ladislav Sutnar were positive elements in his being hired in September 1963 as Assistant Professor in the Art Department of Brooklyn College, where he is now Distinguished Professor. At the time of his appointment, the Brooklyn College Art Department was heavily committed to the Bauhaus approach to the teaching of art which stressed abstract elements. At first Pearlstein taught basic courses in design and color, descriptive drawing, advertising, and interior design. Gradually, as the department's membership and, therefore, attitudes changed, courses in figure drawing and painting were added to the curriculum and found their way into his schedule.

In his graduate workshop Pearlstein continues his theme of two dimensional design with a discussion of the work of Seurat and Mondrian, two modern exponents of flat, strongly structured painting. He asks the students to analyze Seurat's A Sunday Afternoon on the Island of La Grande Jatte *in terms of Mondrian's Neo-Plasticism. Joyce first reconstructed the composition in large planes; his next study defined it further; and in the third one he added color.*

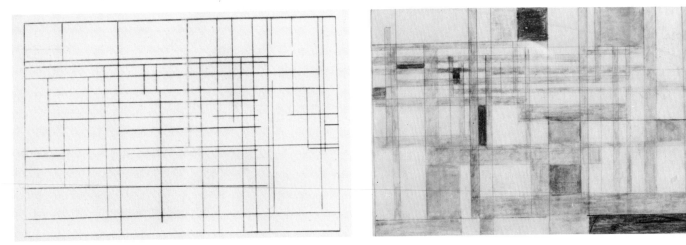

Pearlstein's approach to teaching studio classes is oriented more toward increasing his students' knowledge of past art than to improving their technical facility. He aims to make his students aware that, in the twentieth century, there is no longer a single correct way to paint, and that the history of art offers them a wide variety of options and stylistic precedents for their own work. Like Robert Lepper, with whom he studied, Pearlstein discusses painting in terms of broad concepts rather than specific techniques. He devotes a portion of each class to a slide-illustrated discussion of one of the various historical methods of making a realistic painting and some of the cultural assumptions behind that method. In using examples from both Eastern and Western art, Pearlstein enjoys "playing a big game with art history," but the process provides the students with a large visual vocabulary of pre-existing types of representational painting.

An important part of using this vocabulary is understanding the different artistic attitudes toward the picture plane, or the surface of the painting. He reminds the students that most of the world's painting is flat. The two main exceptions to this two-dimensionality are Renaissance and post-Renaissance illusionism, in which the picture plane is a window through which objects in space are seen three-dimensionally, and the amorphous, nontactile space of Chinese Buddhist painting. Although Pearlstein matured artistically in the ambience of Abstract Expressionism, in which the idea of a painting's flatness was articulated most vocally by the painter Hans Hofmann and the critic Clement Greenberg, his awareness of the importance of the picture surface came late. "I was never a student of Hans Hofmann, so I never gave too much thought to the picture plane. But when I tried to break the plane in some of my paintings, my friends who had studied with Hofmann criticized me and raised my picture plane consciousness."

In undergraduate figure drawing and painting classes, Pearlstein's historical presentations set the tone for assignments that run for the working part of one or two meetings and might require outside work as well. The model's pose is dependent on the nature of the project at hand. For example, when the assignment

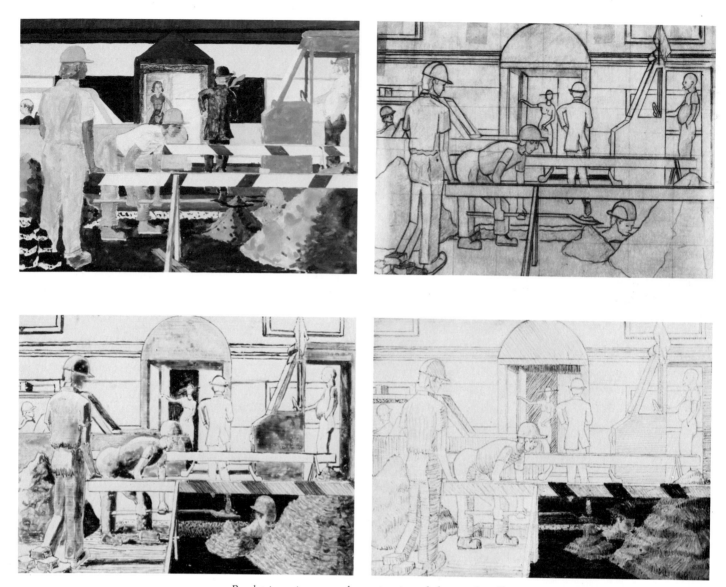

Pearlstein assigns several exercises intended to explore Renaissance methods and painting techniques. First the students are asked to make a drawing of their photograph subject which emphasizes the deep space of one-point perspective. Dennis Joyce, however, also painted a watercolor version over his perspective drawing (top, left) and chose to use instead a limited planar recession in which orthodox perspective concerns are reflected only in the diminution in scale of the figures and such details as the canopy and the windshield of the truck.

In the next exercise the watercolor was scaled down to a smaller drawing (top, right) the size of a Masonite panel which had been prepared with a gesso ground of four layers of rabbit-skin glue and powdered white pigment. Each layer had been sanded smooth before applying the next one. On the panel Joyce made a green underdrawing (bottom, left) using terra verde, an earth pigment composed mostly of iron silicate, which was widely used in the Renaissance for underpainting, especially of flesh tones. Joyce painted the lower right section with the traditional medium of egg tempera, in which the pigments are mixed with egg yolk, and built up the surface with small strokes. In the last of these exercises Joyce made a painting (bottom, right) using a technique common in fifteenth-century Flemish painting and the works of Jan van Eyck; in the area at lower right, he floated powdered pigment ground in an oil-varnish medium over an egg tempera base.

calls for painting the figure in shallow space, the model sits or stands, thus emphasizing the contours. On the other hand, if perspective is involved, the model reclines, and the students are forced to deal with the problem of foreshortening from any angle of vision.

Usually the first project is painting the model flatly, that is, with little or no recession. The students are asked to respect the picture plane, not break it, as in ancient Egyptian painting or Greek vases. In those styles, Pearlstein points out, forms placed parallel to the surface of the painting divide it geometrically, emphasizing outlines; overlapping shapes interrupt the flatness only occasionally, and minimally. He discusses these qualities in relation to other styles in which closed, tightly contoured forms are found, such as Byzantine and Persian paintings, Jap-

anese wood-block prints, Synthetic Cubism, certain works of Matisse, and the rectangular permutations of Mondrian.

The second project concerns European illusionistic painting and the techniques of creating a sense of spatial recession on a flat surface. He asks the students to draw or paint as if the picture plane were a transparent window through which the viewer could look at the model beyond it. The most important tool for this kind of painting is the device known as one-point perspective, traditionally thought to have first been formulated by the Florentine architect Brunelleschi in the early 1400s and probably first seen in Masaccio's fresco of *The Holy Trinity* of 1425 in Santa Maria Novella, Florence. In one-point perspective, all the lines in the painted space that are seemingly at right angles to the picture plane, although like railroad tracks theoretically parallel, are painted to meet at one point, the vanishing point. The illusion of the third dimension depends on the complete internal consistency of these lines. In the Masaccio fresco, this illusion is most evident in the lines of the coffering in the barrel vault above the figures.

To Pearlstein, one-point perspective, while historically crucial in European painting, is an intellectual construct that is not true to empirical vision and, in addition, is bound to the Renaissance philosophical assumption of fixed relations between all things. "They developed one-point perspective so that they could make paintings that would give the illusion of reality, to put across their materialistic attitude about the world. All this popped into my head as I was trying to teach perspective for the first time, without doing enough homework. I got up in front of the class and found myself all tied up in knots. But the one thing I got out of that was that it is impossible to make a correct perspective of something or a scene while you're looking at it. Once you've set up the scheme, the vanishing points on the eye level, the horizon line, you have to forget what you're seeing and just take information from what's in front of you [to fit] the diagram."

The students' next task is to resolve the first two projects into a modern synthesis in Pearlstein's terms, "the projection of Renaissance perspective onto the flat forms of Greek vase painting." He asks them to think of the model almost architecturally, in terms of facade, elevation, and ground plan, to dispose the forms in recessional space so that the component shapes, as well as the intervals between them, are of equal compositional interest. Since post-Renaissance painting often involves differentiating objects within three-dimensional space through the effects of light on their surfaces, sometimes Pearlstein has the class draw with a kneaded eraser on charcoal-blackened paper, making the forms emerge from darkness as in a Caravaggio or Rembrandt painting.

Pearlstein feels that Renaissance perspective has such a hold on the mind that it has literally altered the way we see, or the way we think we see. "To represent the line where a wall meets the ceiling directly in front of you, you would draw a straight line across the page. If you look up into the right-hand corner of the room, you would make that same line a diagonal that slants down from the uper right corner of the paper. If you look up into the left-hand corner of the room,

For two projects in Baroque multiple-point perspective drawing and painting techniques, Joyce selected aspects of his original photograph and depicted them from odd points of view. In the painting on the left the viewpoint is high, concentrating on the single street worker and the diagonal perspective of the barricades. To make it, Joyce stretched a small linen canvas on wood bars, sized it with rabbit-skin glue, and painted a ground on it with a thin flake white oil paint. After the canvas had dried for a week Joyce transferred the drawing to it and covered the surface with a dark brown scumble of oil paint. He built up the forms with white tempera made of powdered pigment in an emulsion of egg, oil, and water. Finally he washed thin glazes of oil color over the dried white tempera. In his drawing, center, Joyce changed the windows in his photograph into high arches that dwarf the low-placed viewer in the manner of Piranesi's architectural fantasies.

The painting on the right is Joyce's version of Chinese Buddhist painting. He scattered the marks of his washes sporadically over the blank paper, which symbolizes the void of universal space. The washes are intended more to indicate the location of something within that space than to define its form.

you would represent that same line with a diagonal that slants down from the upper left corner of the paper. The line of the floor seems to be at a different level when it passes behind something to the artist's left than when it emerges at his right, because he has turned his head or his eyes to see it. Every time the artist looks up, his eyes are in a different position. If he draws what he really sees, he produces something seemingly filled with visual errors."

This intermittency of vision is the point of another project, which Pearlstein characterizes as "existential." In this assignment the students are to view the picture plane as the symbol of space in the Buddhist sense of the oneness of the universe—a great void pregnant with all possibilities—rather than as a physical entity. The surface is like the screen of the mind on which images hover only tentatively because they defy precise location; the edges of the picture merely stand for the limits of the visual field. Pearlstein asks the students to draw in such a way that each mark is placed deliberately and articulates the space in a loose manner by describing the placement of forms and junctures of forms within it. Here the forms are open; there are no continuous outlines or completed contours, only fragments.

Pearlstein's interpretation of Cézanne is the crucial modern example of this kind of painting: "Cézanne's drawing has nothing to do with perspective," he told the students at one of his lectures. "I think the way he drew was, he looked up and saw something in front of him that was either sharply focused or dark or light or bright, and he put a mark down on the paper that more or less approximated where that mark was in the space in front of him. He looks down, looks up, looks down, looks up, and each time the mark represents where his eyes fell first. And there's no attempt to link it all up. . . . That is the way we *do* see. We see in fragments and we make notes, mental notes, in fragments. Cézanne gave us the system of how to record them.

"I think, in a Cézanne landscape drawing, that system is a pattern of eye movements through space and he's using the picture plane in a Buddhist way, in a Zenlike way, where the picture plane equals vast, eternal space. The piece of silk that a Chinese Southern Sung landscape painting is done on is a machine, a mechanism. You are to project yourself into it, into this representation-model of eternal space and you get to the center of the universe, become one with the great nothingness or whatever it's called.

"I think Cézanne used that approach to the picture plane—the picture plane doesn't exist and every mark you put down is somewhere *in* that space and it's a drawing of *where* things are rather than *what* things are."

Pearlstein expands on the existential approach by using the example of Mondrian. "He took Cézanne's system a step further, especially in the *Plus and Minus* drawings, which start as drawings of a pier going out to the water toward the horizon line. But he's obviously not looking at anything. What is important here

is the mark. He's not concerned with what it is or where it is, but if where it is is right, as a mark, in relation to the canvas. Now, he did something strange. Apparently, he would sit and stare at his work for hours and hours, just lose himself in it—that's the description of him at work. He'd make little marks, little adjustments and then stare. I think that what he was doing was projecting himself into the undifferentiated space of the paper or canvas and moving the marks around, depending on the kind of after-image that happens when you stare at something a long time—things float off, they move around, usually at a diagonal. I think he would erase his marks and move them off along that diagonal pattern until they stayed where they stood in relation to one another.

"Well, this is an existential process, what I think of as existentialism, which has to do with the fact that you don't know if you're being right and the eraser is used as much as the pencil. In Mondrian and Giacometti drawings, there is a great deal of erasure, almost all of their drawings that exist are erased, over and over and over again—more erasures than final marks. The erasing becomes part of the question. This comes down to the Abstract Expressionist attitude where nobody could think of finishing a painting. It's always in the process. It could always be different."

The aesthetic and existential consequences of fragmented or discontinuous vision entail a corollary assignment dealing with multiple views or points of view. Drawing objects from more than one point of view can lead to a greater understanding of the importance of rendering the points where objects coincide in space. "When I was first teaching at Pratt I had students make Cézannesque open-form drawings of things on tracing paper, from several points of view. When you pile them one on top of another and then make final tracing, picking and choosing the main lines, you get something that looks very much like an Analytical Cubist

To illustrate Cézanne's method Pearlstein has his students make three separate still life drawings on tracing paper, using interrupted contours and broken modeling. Each drawing is done from a different point of view. To demonstrate the connection between Cézanne and Analytical Cubism, Pearlstein has the students superimpose the three drawings and make a fourth drawing from them on a sheet of tracing paper by arbitrarily selecting the edges and shapes from the combination. The appearance of Joyce's fourth drawing is very close to that of Analytical Cubism.

Joyce made a drawing after his photograph that emphasizes Futurist ideas concerning the activity of forces on a city street. In the two subsequent drawings he removed more representational details to reveal the Futurist concept of urban vitality depicted by means of the abstract linear energies of the interacting forms.

drawing or painting. If my students could do it, I'm sure the Cubists were able to do that sort of thing much more imaginatively. It may not have been what they did, but they did something like it."

Pearlstein is sure that he has found a neglected source for multiple points of view in the Cézanne-Cubism connection in the motion photographs of Eadweard Muybridge, which he interprets from his graphic design background: "I first saw Muybridge photographs when I was doing the work on my Picabia thesis, those great big volumes that Muybridge did in the 1870s and 1880s at the University of Pennsylvania. I think they are fundamental to the whole development of twentieth-century art and he hasn't been given credit for a great deal that he deserves credit for. Not that he did it consciously; he did it accidentally. For one thing, Muybridge's pages are marvelous typographic designs, and if you really look at them, it's William Morris design along with James Whistler design. In the flat picture plane of the page, it's like Morris's book and wallpaper designs. And it's like Whistler as a designer. He was the first to hang pictures in rows, on white and pastel walls. They predict Neo-Plastic design in the way typographic design went all during the 1920s and 1930s. If you remove the image, they even begin to look like Mondrian. Somebody had to sit down and draft that grid that surrounds all of his images.

"The other thing that is peculiar about Muybridge, that I think is very important today, is the use of the grid behind figures. There's a big graph so that you could measure the movement of the figure as it moves through space against this graph. He used two kinds of graphs, black lines on white background and white lines on black background. But they have a faded look to them, a wan faded look, which somehow always takes on a symbolist look. Any precise drawing—even while I was working on those industrial catalogs, I noticed this—always takes on a metaphysical look when you forget what they're about. Floor plans of houses become fascinating when looked at as abstractions. Industrial plans are fantastic works of art in that sense. They're accidental works of art. But grids—the whole idea of the grid, of course, has become a dominant theme in American art today. I think that, to a great extent, it entered the mainstream of culture through Muybridge, through these plates. . . . As you can see, the movement of the figure is horizontal across the surface and then, vertically, you have the simultaneous views—side view, front view, and back view—moving against the grid. . . . A lot of people subscribed to these plates that were being put out by the University of Pennsylvania and the list of these subscribers exists. These plates were lying around in the studios of every prominent artist from about 1980 on. You find figures for Rodin's works in them. Rodin's *St. John the Baptist* starts as one of these Muybridge photographs. Degas was always referring to them, too, especially the series of horses. Degas hired another photographer in Paris to make ballet dance photographs. Down into our own time, you find Francis Bacon using Muybridge's imagery.

"There [have] been several influences, I think, out of Muybridge. One has to do with flat pattern, as in rectilinear Art Nouveau and the Bauhaus. I even think there's a Muybridge influence on collage, in the sense of disparate images assembled into one picture frame or visual experience. Then there's what we think of now as Cézanne and existentialism. A philosopher, I think Bergson, wrote that you can't know what anything looks like without knowing it from several points of view. He virtually describes a Muybridge plate in those terms. And that was the idea that Picasso, Braque, and others picked up and did. That's what Analytical Cubism is based on. And to accomplish this, they used Cézanne's drawing techniques."

In his undergraduate studio classes, Pearlstein aims to enrich his students' work from the model by enlarging their awareness of the many historical modes of representation that are open to them. Pearlstein's intentions are similar in his graduate Workshop in the History of Art, but he approaches his material somewhat differently. As the course title implies, Pearlstein takes a "workshop" approach

In his final collage for the workshop Joyce used portions of his drawings, Xeroxes of some of the other projects, cotton, paper, and acrylic paint.

that enables his graduate students, most of whom are working artists, to experience history in a direct, personal way.

Pearlstein's slide-illustrated presentations for the graduate course are similar to those of his undergraduate classes but are broadened to include examples of works in media such as literature and music as well as painting. In addition, a common theme runs throughout the semester's work: at the first class session, the students listen to a recording of T. S. Eliot reading his poem *The Wasteland* and are then asked to take or select a photograph of people in architectural space, indoors or out, that corresponds to an urban image in the poem. In successive weeks, the students are given studio assignments in which they must transmute the elements of the photograph into examples of the various historical picture structures: the closed forms and pictographic space of Egyptian and Byzantine art; the open forms of Southern Sung, Cézanne, Analytical Cubism, Mondrian, and Giacometti; the illusion of three-dimensional space constructed by using Roman multiple-point perspective; the Renaissance contribution of a single vanishing point on the horizon line, and so on. Two stops along the way expand on the possible versions of perspective: the dual vanishing points of Piero's *Flagellation of Christ*—Pearlstein sometimes has the class draw a side view of it—and Seurat's *Grande Jatte*, an example of the post-Impressionist combination of multiple-perspective views and flat space.

The final project in the graduate art history workshop is an extended exercise in the modern idea of the collage. The project is, in effect, a summing up that allows the students to synthesize, in their own individual styles, the visual information they have acquired during the semester. Pearlstein enlarges on the concept of the collage by discussing examples from different art forms: in painting, the disassembled objects of Synthetic Cubism; in literature, T. S. Eliot's *The Wasteland* and James Joyce's *Ulysses*; in music, the songs of the Beatles as well as works by Gustav Mahler and Charles Ives, two composers who juxtaposed quoted fragments of popular music with original themes. The students are asked to cut apart their earlier images and combine them to form a new version of the original photograph. They establish consistency of mood by the painterly use of color in the transitional areas and the addition of extraneous materials, making this last project more of an assemblage than *papièrs collés*. When Pearlstein first used this procedure in his class, all the student works looked like Robert Rauschenberg's *Inferno* prints, then being exhibited for the first time. The students were amazed. So was Pearlstein.

Pearlstein's teaching has not been confined to his classes at Brooklyn College. Since 1963 he has visited colleges, museums, and art groups throughout the country to lecture, present his own work, critique student work, and make demonstration prints. Paradoxically, these teaching visits seem to have given him greater recognition in other parts of the United States than in the more faction-ridden art world of New York City.

Pearlstein's visit to the University of Nebraska at Omaha in 1981 included his typical teaching activities, although the fullness of his schedule resulted in a somewhat more hectic pace. He was invited by Professor Thomas H. Majeski specifically to do a demonstration lithograph before the art students and faculty, who viewed segments of the procedure in small groups. It took Pearlstein three days of extralong hours to complete the drawings on each of the four stones for the color lithograph. The university had reserved classroom space and hired two models, and Pearlstein had brought along a couple of his favorite kimonos as props. The drawings were done directly from the models for each stone—not just the key stone—before a steady stream of interested observers. When the drawings were done the printmaking students pulled proofs, while Pearlstein gave a public lecture on his work before a university audience followed by an open critique for the students majoring in painting. The last three or so days of his week-long stay were devoted to the actual printing of the edition. This process, which Pearlstein photographed, is shown in the working sequence that follows.

TWO MODELS IN OMAHA

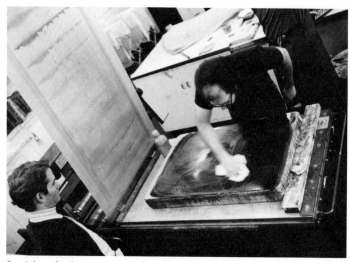

2. After the key stone was lightly etched with acid to fix the image, master printer David Keister washed off the grease with a turpentine solution.

1. After the drawing was completed, the heavy lithographic stone was moved on a fork-lift dolly to the printmaking room. This stone, on which the image had been drawn with a Korn's no. 4 black grease crayon, would be used to print the black color of the final lithograph; it would also serve as the key stone to which stones for three other colors—blue, yellow, and brown—would be registered.

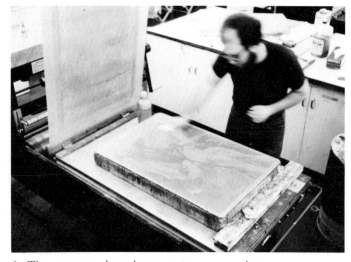

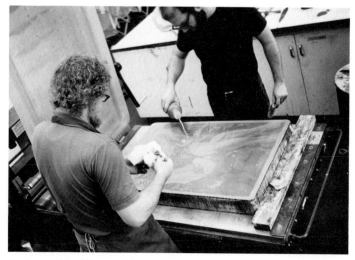

3. The stone was cleaned once again to ensure that no excess grease from the crayon remained on the surface.

4. Assisted by Thomas H. Majeski, Professor of Printmaking at the university, Mr. Keister swabbed gum arabic on the stone with a wad of cheesecloth to enhance water retention in the porous, unmarked areas of the stone.

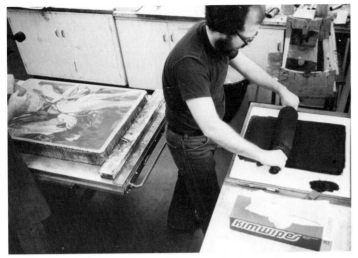

5. Next, even layers of black ink were applied to a roller.

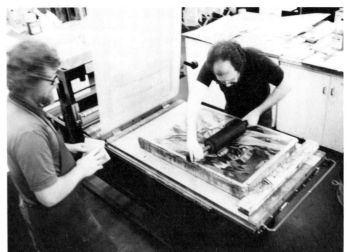

6. Mr. Keister passed the roller over the stone several times, both vertically and horizontally, to make sure the surface was evenly inked.

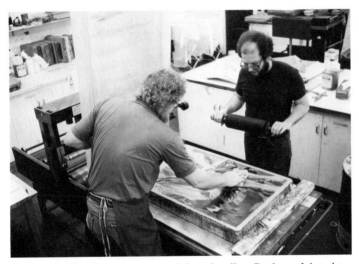

7. Periodically, between passes of the ink roller, Professor Majeski wiped the stone with water; this kept the blank areas of the surface damp so that they would repel the ink.

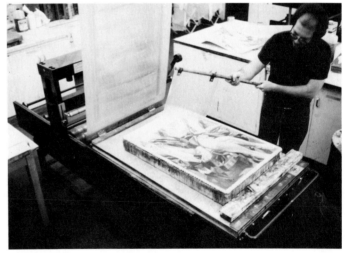

8. After inking, Mr. Keister fanned the stone to remove most of the water remaining on the surface.

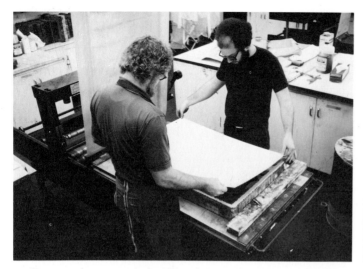

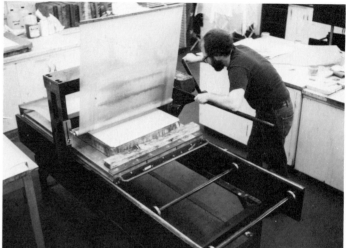

9. Dampened paper was placed on the stone for printing. Great care was taken to align the registration marks on the paper with those on the stone.

10. The stone and paper were put through the press to transfer the image.

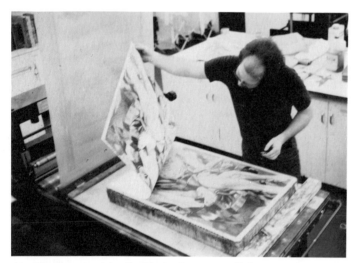

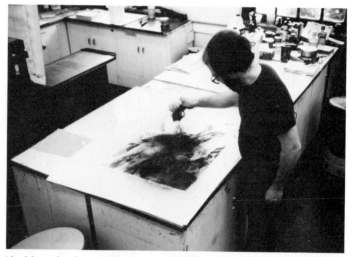

11. The first proof for the black plate was pulled.

12. Next the drawing had to be transferred to the other stones so that the other colors would register properly when printed. To do this, Mr. Keister scattered particles of iron oxide evenly over the freshly pulled black proof.

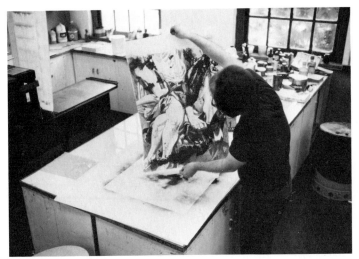

13. When the excess particles were shaken from the proof, the rust adhered only to the wet ink.

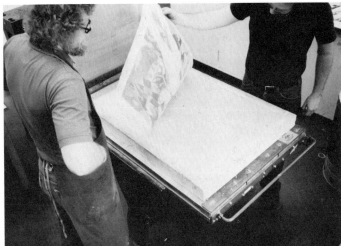

14. When the proof was pressed onto a clean stone, a faint iron-oxide image remained on the surface.

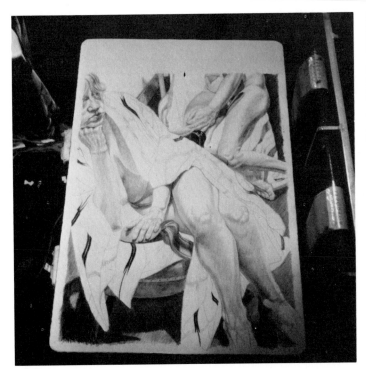

15. Using the rust image as a guide, Pearlstein made his drawing for the brown color next (the completed stone is shown here on the fork lift), and the printmakers pulled proofs from it as they had done for the black. These procedures were repeated for each of the stones that would print the blue and the yellow, keying them to tracings from the black stone. (Regardless of the colors with which these plates would be inked, all were drawn with black grease crayon.)

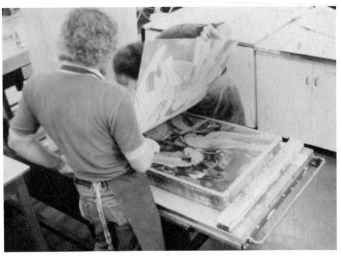

16. Professor Majeski and Mr. Keister are shown here aligning a sheet of paper—on which the brown, blue, and yellow have already been printed—with the registration marks on the black stone. Usually the lighter colors are printed first as printing the darkest, most opaque color last tends to mask slight errors in registration. In this case, the printing order was blue, yellow, brown, and black.

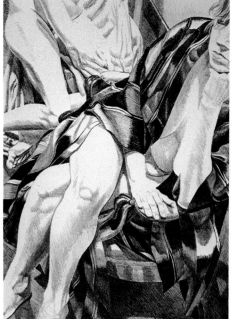

The black key drawing

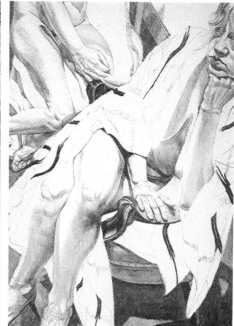

Proof pulled from the brown stone

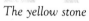

The yellow stone

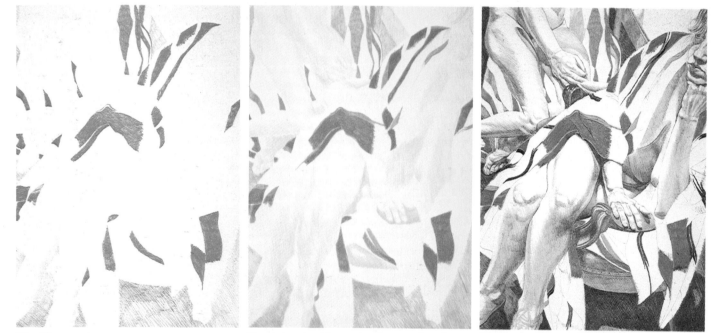

The blue stone

Proof showing blue and yellow combined

Blue and yellow with the brown added

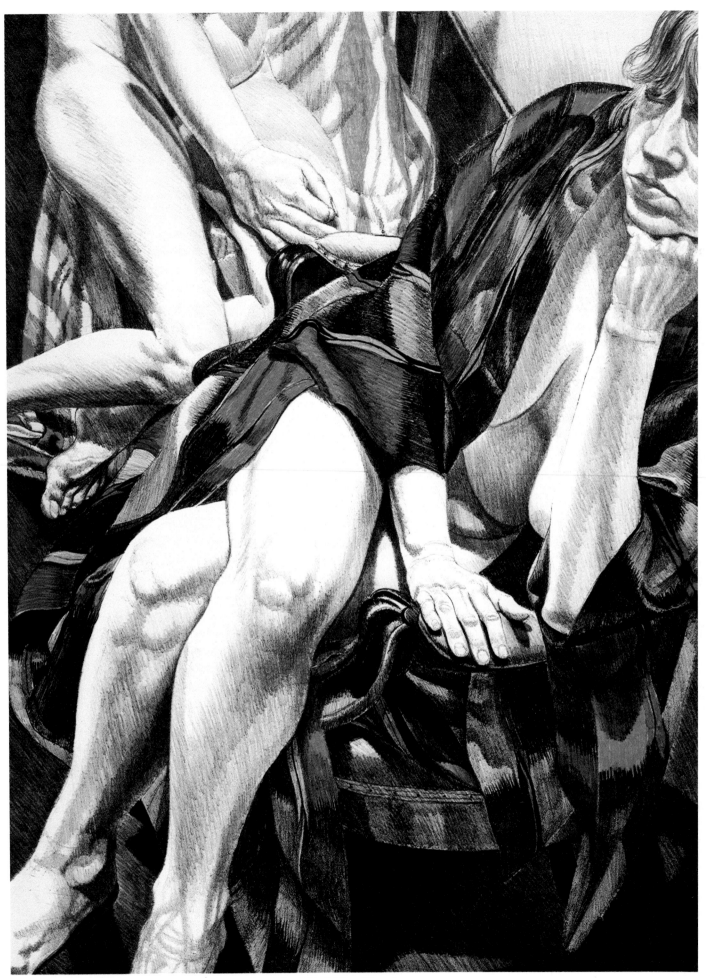

Two Models in Omaha, 1981, color lithograph, 30″ x 22½″ (76 x 57 cm)

The final impression, with black added to the first three colors

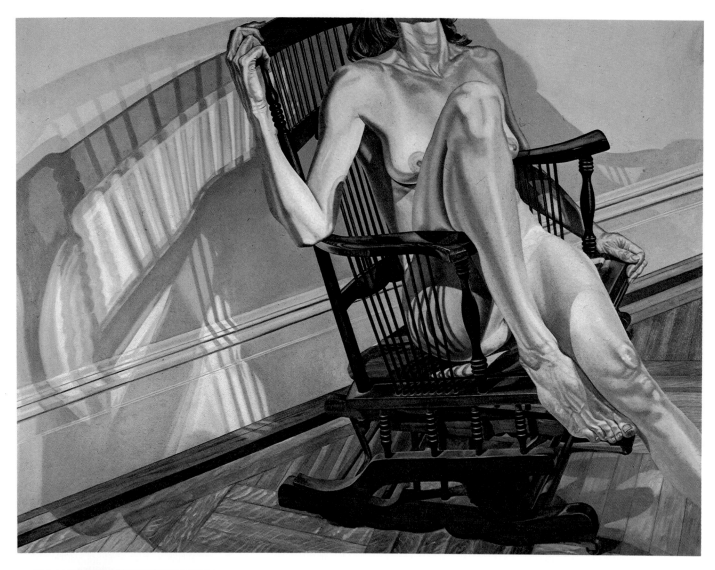

FEMALE MODEL ON PLATFORM ROCKER, 1978, oil, 72″ × 96″ (183 × 244 cm)

The oil painting of Female Model on Platform Rocker was done on a much larger scale than the earlier two versions of this theme, and in it the complexities of the chair, the floor, and the almost Futurist movement of the shadows become the real subject of the painting.

FEMALE MODEL ON PLATFORM ROCKER, 1977, watercolor, 29½″ × 41″ (75 × 104 cm)

NUDE WITH ROCKER, 1977, color lithograph, 3¼″ × 33¾″ (59 × 86 cm)

Part Three
OIL PAINTING WORKSHOP

Pearlstein takes a disciplined methodical approach to his art, working with his models every day for at least one four-hour session that is interrupted at regular intervals by rest breaks. During the week each session is devoted to a different project—oil, watercolor, or print. In this way, he can approach each session as a fresh experience and avoid prolonged and exhausting concentration on one work or one medium. The variety keeps his interest high and lessens muscle strain in the models.

Because Pearlstein's models contribute a great deal to his work, he chooses them for promptness and reliability. When he must cancel a session, they are paid anyway. In turn, they oblige him by not changing their hairstyles in the middle of a painting and by giving him ample notice when they will not be available.

When he starts a new painting, Pearlstein may use the better part of the first session to establish the composition, the models' poses, and his own vantage point. Usually he selects a chair, hammock, or other prop and allows the models to find their poses. He moves around the setup, looking for a point of view that offers a particularly interesting arrangement of shapes and spatial relationships. He sets up his stool and easel usually about five feet or less away from the models and marks his own position on the floor with a cross of tape directly under his nose. This ensures that his head will be in the same position each time he returns to work on the painting. In addition to marking the models' poses and his own position, Pearlstein sometimes takes Polaroid pictures of the composition for reference, especially for re-posing the models and their drapery. He does not, however, work from these photographs, nor does he use flash. The flash would eliminate the cast shadows, which are an important part of his composition. Since the three overhead lights in the boarded-window studio never change position, these cast shadows become key reference points. Sometimes, for possible future use, he will photograph a pose that he sees in passing, a model resting or moving about the studio.

Although, on occasion, a figure drawing or a watercolor will become the impetus for developing the same pose in oil, Pearlstein starts each new painting afresh, re-posing the models, the same ones if possible, and working directly from them. This allows him to make alterations in the pose or to find a compositionally more interesting point of view. He does not make preliminary drawings or sketches. Instead, he begins the drawing immediately, sometimes using charcoal but most often using a thin wash of raw sienna that will eventually disappear and become part of the painting. He starts the drawing at some focus of interest, usually near the center of the canvas, and works outward from there. The first form he draws establishes the scale for the rest of the painting, which is visually measured against it. He draws what he sees without dealing with conventions of anatomy or perspective. His process involves imagining a grid, with vertical and horizontal axes, superimposed on his canvas and judging the vertical and horizontal measurements of forms and distances by using the tip of his brush. Any changes, such as the

models adjusting the pose for comfort or Pearlstein altering his own vantage point for greater visual interest, take place at this drawing stage. When the entire composition has been drawn on the canvas, he is ready to start filling in the color.

Since Pearlstein's paintings are large, they are placed on adjustable easels mounted on wheels so that he can move the canvas, not himself, to facilitate work on a specific area. He prefers to paint larger than life-size figures because he wants to be able to develop carefully even the smallest forms of hands and feet, such as knuckles and nails, the parts he feels have been ignored or glossed over in painting since the mid-nineteenth century.

Pearlstein develops the first layer of paint, that is, the underpainting, with its approximation of the final color and modeling, over the entire canvas. Then, systematically, he works on the final surface of each area, glazing in a thin layer of the colors of the middle tones. He blends the tones together with a rapid brushing gesture, adding the darker values and then the highlights into the still wet paint and using the initial underpainting as the basis for the more smoothly blended modeling of the second layer. Finally, he tightens all the edges of forms and firms up the sense of volume in the modeling and the differentiation of the tactile qualities of the various surface textures.

Pearlstein's choice of colors has been quite personal. His discussions with other artists, over the years, made him strongly aware of some of the prevalent assumptions about color inherited from the Impressionists. His unromanticized depictions of models posing under unflattering studio lights represent a conscious decision to reject those assumptions and assert his own belief that "human flesh looks more like a baked potato than a peach."

When Pearlstein began painting from the model, he kept the same earth colors he had been using in his landscapes. He especially liked the Mars colors—red, violet, and black—as well as cobalt violet, ultramarine violet, and green earth. Eventually, he began eliminating some of the Mars colors, retaining Mars yellow and black, and began adding more of the cadmiums. The colors he now uses are arranged on disposable paper palettes, beginning with titanium zinc white on the lower left and continuing clockwise, with Naples yellow, Mars yellow, raw sienna, raw umber, cadmium orange, cadmium red light, and cadmium red deep. Viridian green, ultramarine blue, Mars black, and other colors are used when necessary for fabrics and other props.

During the course of a painting, the models are always present and posing, even if Pearlstein is just painting the floor or the walls. He needs the entire ensemble to interact in his field of vision. It is not always possible to be so demanding of his sitters when he is painting a portrait or when his subject is a landscape and changing light and weather interfere, and so he changes his procedure to fit the circumstances. The working sequences that follow illustrate how he paints the figure and a portrait in his studio and a landscape painting on location.

TWO FEMALE MODELS ON A PERUVIAN DRAPE

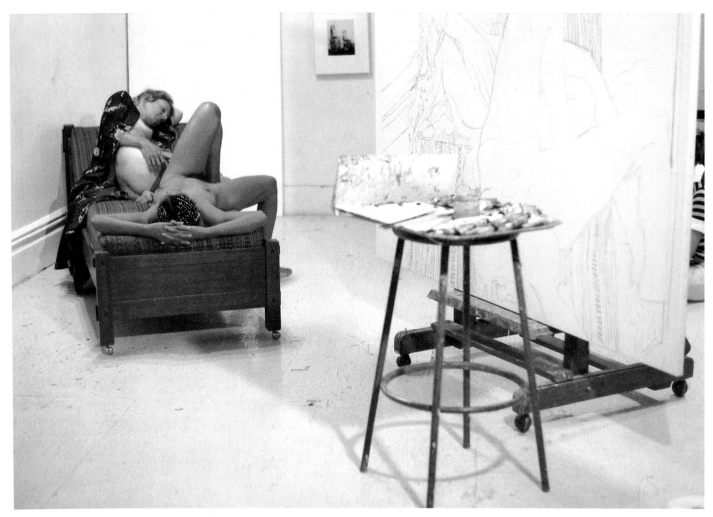

1. The studio setup shows the models, easel, and palette in position. The left edge of the canvas is approximately three feet from the elbow of the foreground model. When painting, Pearlstein tries to keep his head and feet in the same position, moving both the canvas and the easel from side to side and up and down to accommodate work on the specific area.

The composition was first done as a watercolor. Pearlstein, considering the image complex enough to be viable on a larger scale, had canvas stretchers built as close to the proportions of the watercolor paper as possible.

For flesh colors, Pearlstein's palette consisted of titanium-zinc white, Naples yellow, raw sienna, raw umber, Mars yellow, cadmium orange, cadmium red light, and cadmium red deep. The canvas was Belgian portrait linen, chosen for its fine weave, double primed with lead white. He preferred the tactile resistance of flat, hogs' hair filbert brushes to the slickness produced by sable brushes. In order to keep the paint surface thin, he used a medium of ¼ Damar varnish, ¼ boiled linseed oil, and ½ rectified turpentine, which he added to the pigment on the brush.

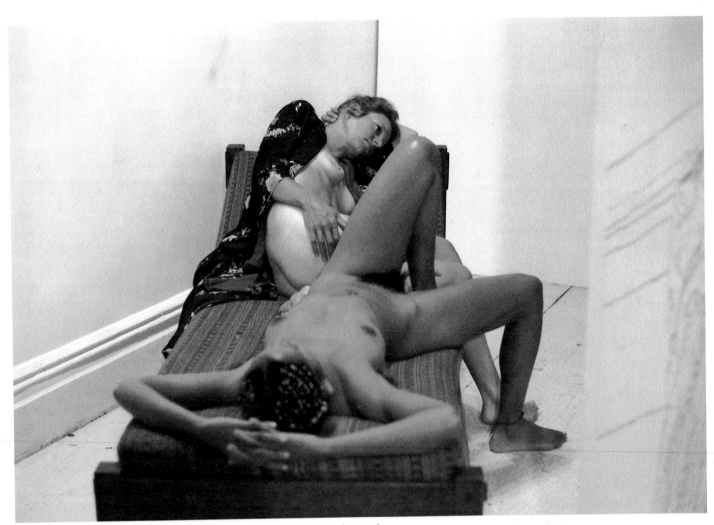

2. *The models are shown here from Pearlstein's point of view at the easel.*

3. Pearlstein began the charcoal drawing somewhere around the middle of the canvas, at a particularly interesting nexus of forms, drawing the contours of the flat shapes as he came to them. Then be began painting in the first layer of color. Since Pearlstein feels that the color of oil paint changes drastically as it dries, he works in at least two, but often more, layers. Although the first layer, pictured here, is brushed in as quickly as possible, the entire procedure takes fifteen to twenty working sessions of four hours each.

4. *Detail of the first underpainting on the foreground figure.*

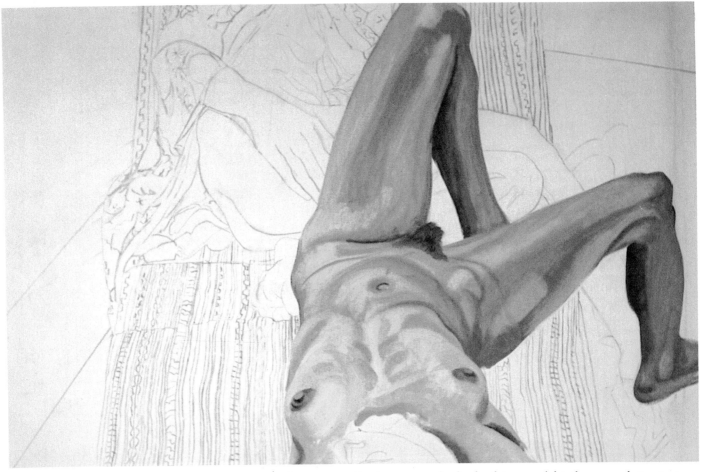

5. *While the first paint application was rough, the development of details was made precise in subsequent layers by careful work on just one section at a time. He began with the nearest figure because the rest of the painting would be visually measured against her.*

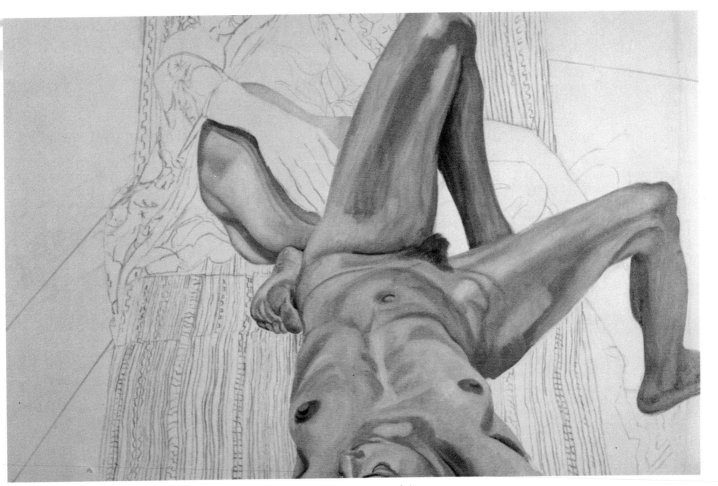

6. Next he developed the tonal areas of the foot and buttocks of the background figure.

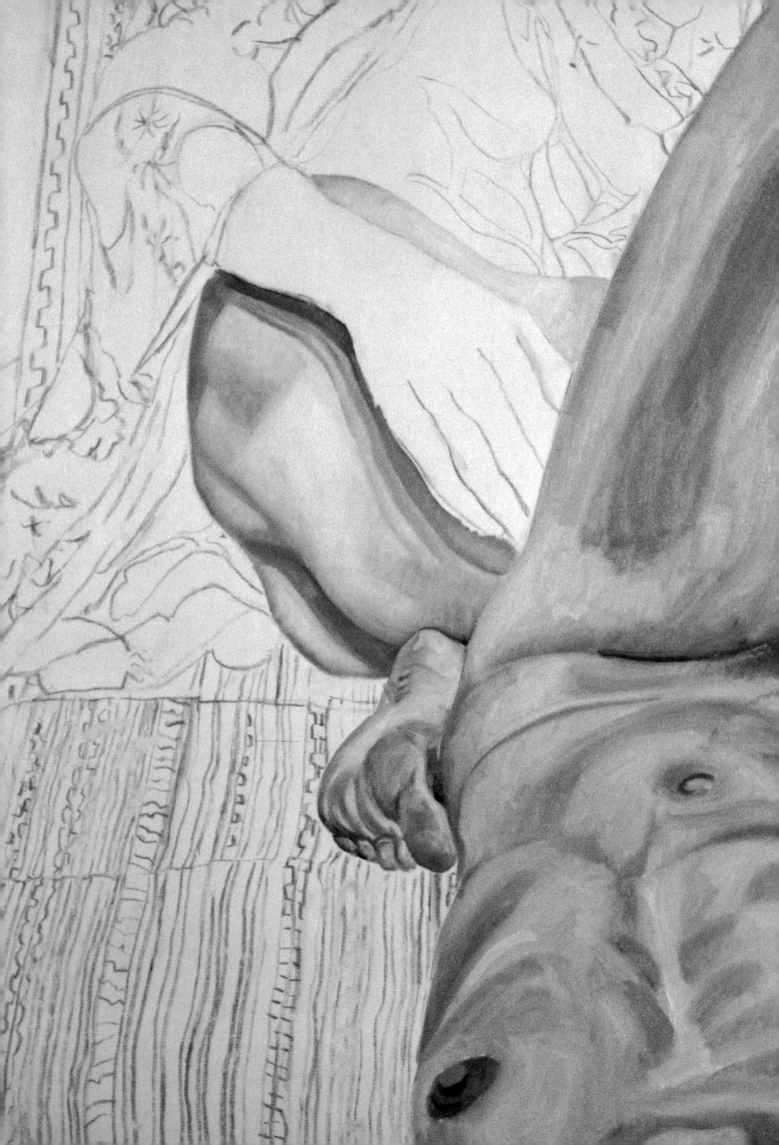

7. *Detail showing developing juxtaposition of complex forms where the foot and hand of the background model meet the hip and thigh of the foreground figure.*

8. *Pearlstein began the underpainting of the striped fabric.*

9. *(overleaf) He continued underpainting the figures, the green floor on the left, the shadows on the floor at the right, and the stripes on the textile.*

10. *Detail of textile adjacent to the foreground figure.*

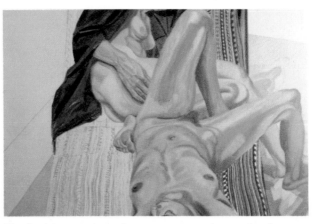

11. *At this stage the underpainting is nearly completed.*

12. *Having finished the underpainting, Pearlstein firmly established the folds of the blue kimono in one session. The red folds remained tentative at this stage.*

13. *A week later, after the cloth has been placed in the same position, the flowers are painted over the dried blue. Since it is almost impossible to get all the folds the same way at every sitting, the red folds were established at a later session.*

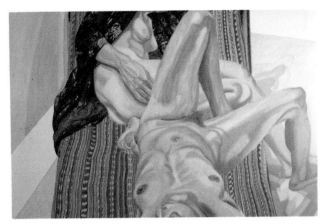

14. *The floor, shadows, and the background model's legs have been repainted. Pearlstein has begun work on the right leg of the foreground model, and he has begun developing the hand and the torso of the background model. For a detailed sequence of the development of the hand, see pages 88–91.*

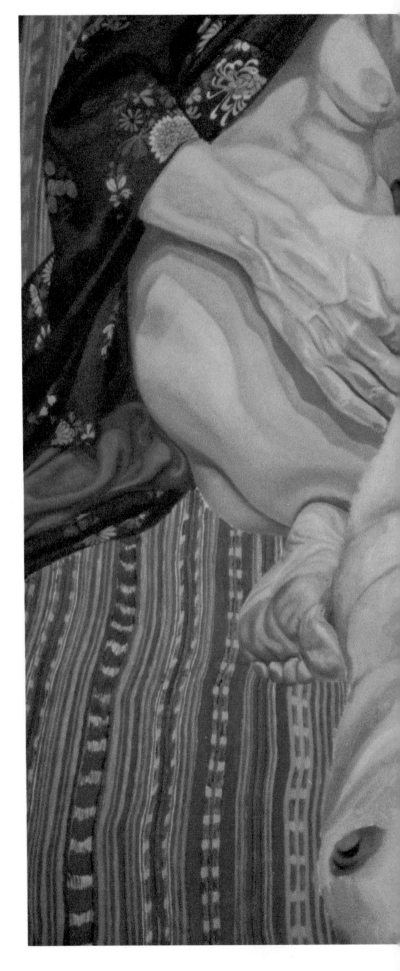

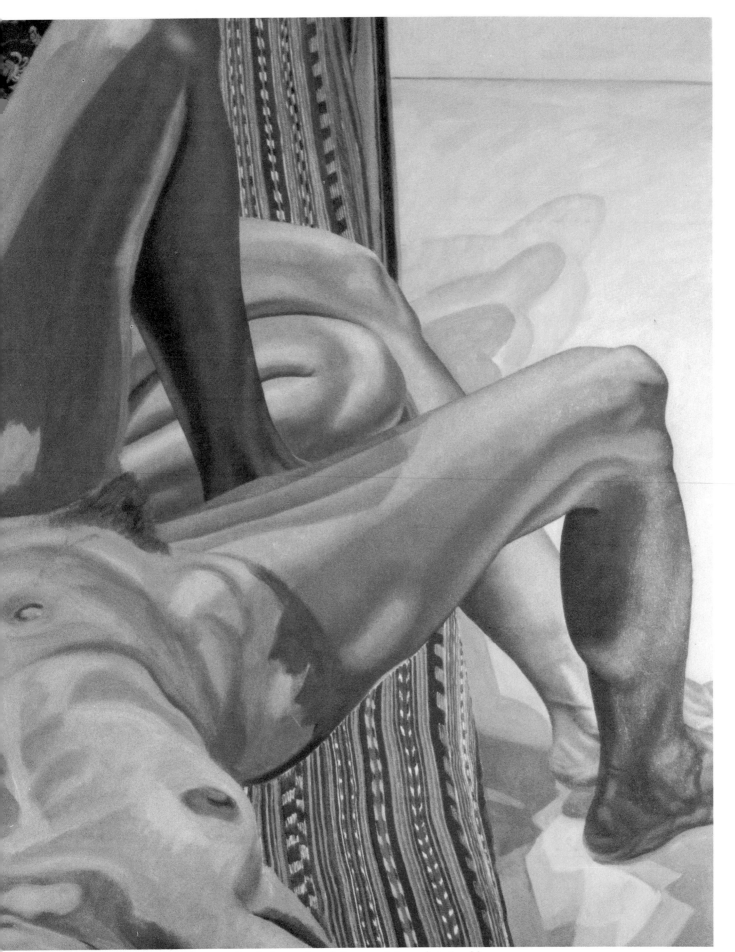

15. An approximate middle dark tone was brushed over the whole area of the underpainted leg. He blended color into the wet, creamy surface, adding highlights and emphasizing the deeper values in the shadow areas.

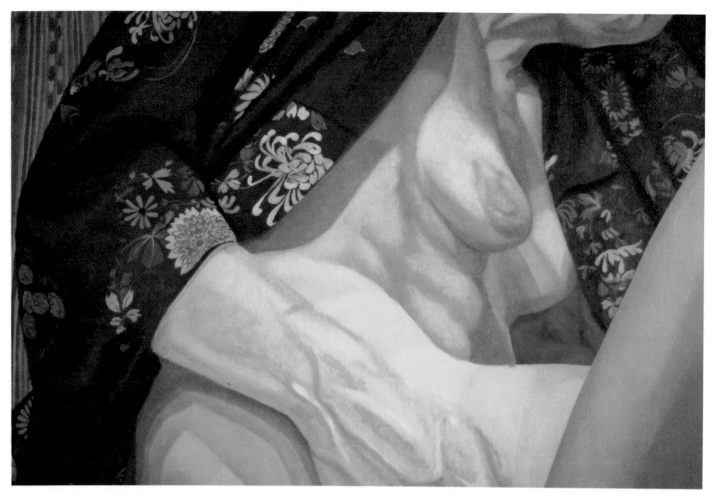

16. *Now Pearlstein concentrated on finishing the torso of the background model. As he had done with other areas of the painting, he worked his highlights and darks into a fresh layer of color.*

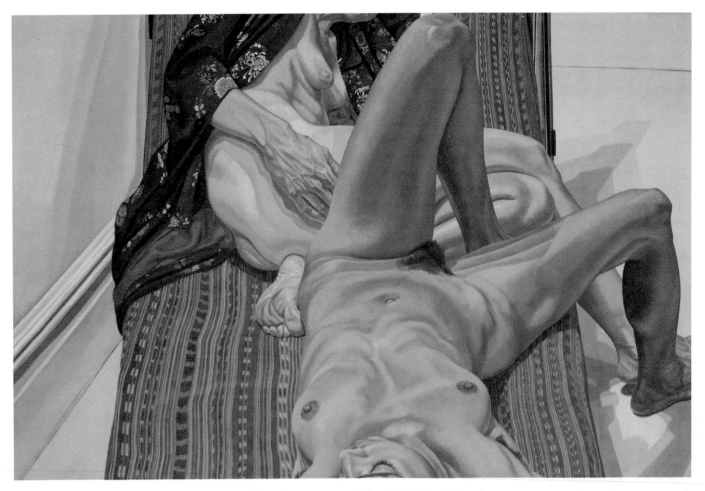

TWO FEMALE MODELS ON A PERUVIAN DRAPE, 1980, oil on canvas, 72″ x 48″ (183 x 122 cm)

17. The painting is now completed. The edges of all areas have been more sharply defined and the highlights reworked so that they will maintain their intensity after the paint has dried.

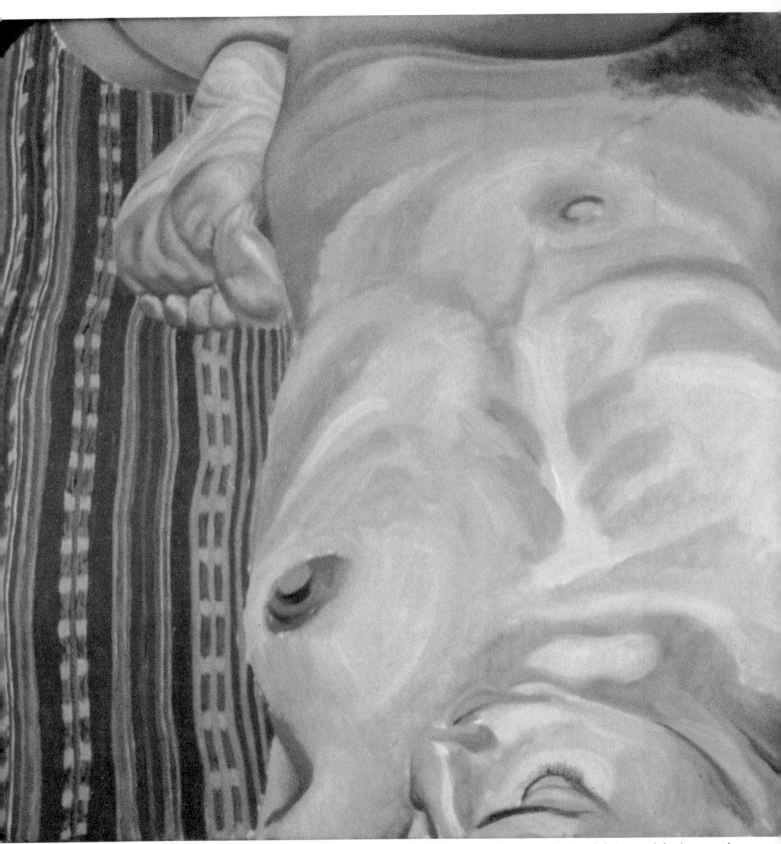

18. This sequence (pages 80–87) shows how Pearlstein developed the torso of the foreground figure. The detail here shows the underpainting and preliminary modeling of the torso.

19. Here Pearlstein has glazed the entire torso with a middle value.

20. (overleaf) Next he painted more emphatic highlights and darks into the wet color. Working into the creamy paint facilitates smoother blending of tones.

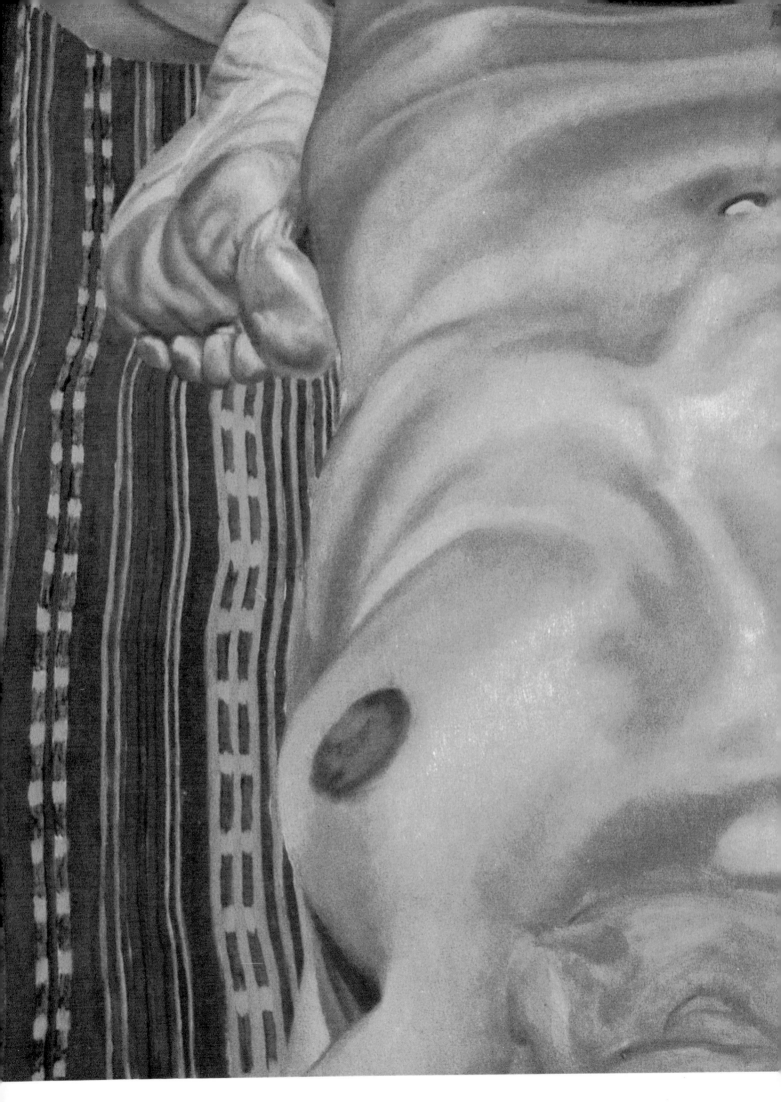

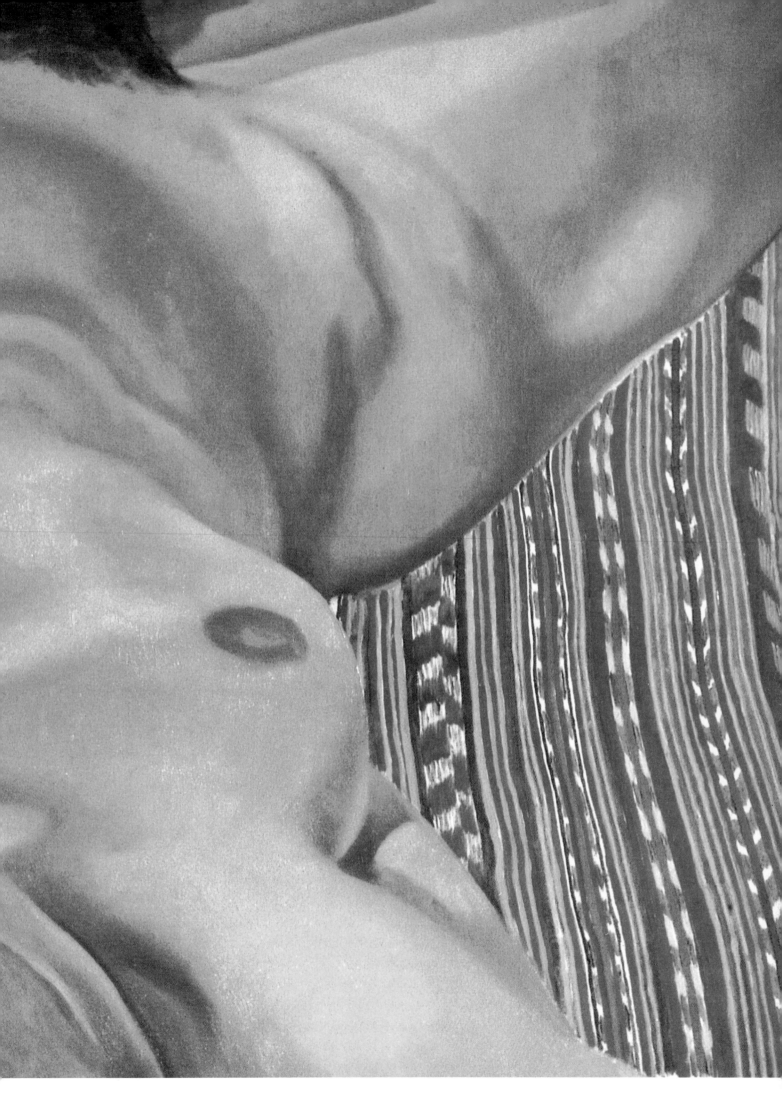

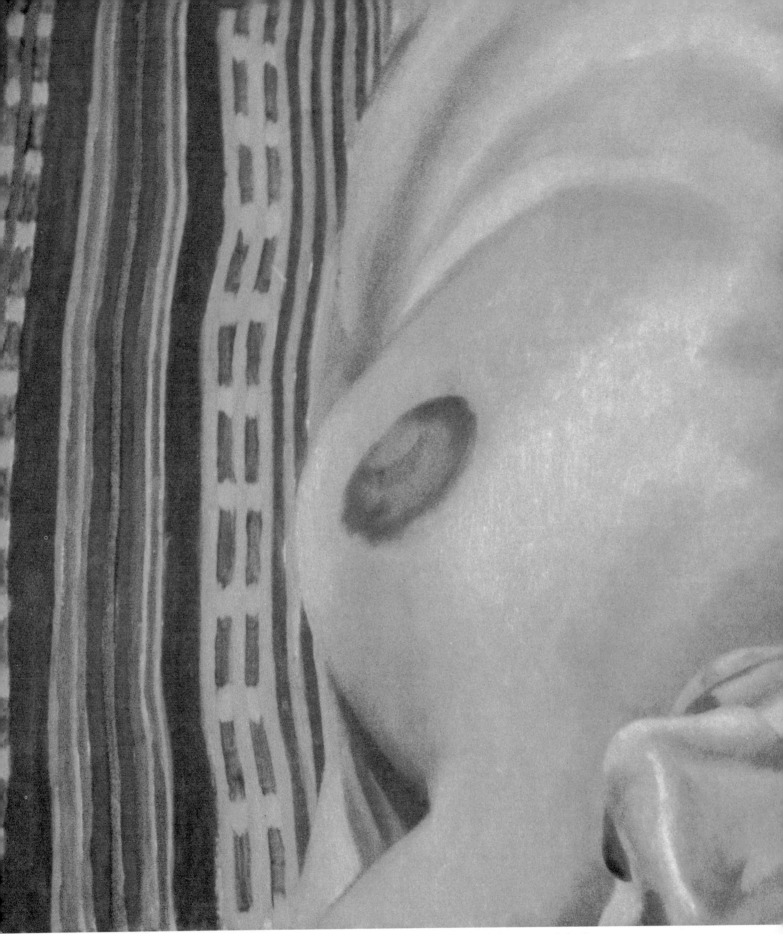

21. He continued to refine the modeling of the torso and the face.

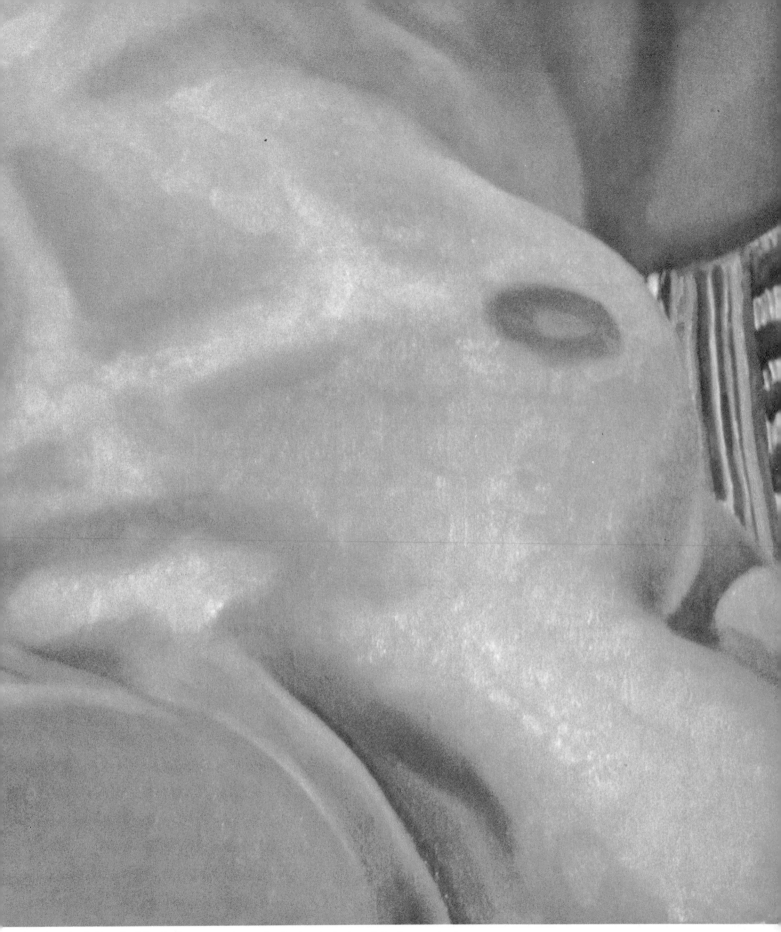

22. (overleaf) Detail of finished painting shows the final articulation of the breast, the features, and the striped fabric.

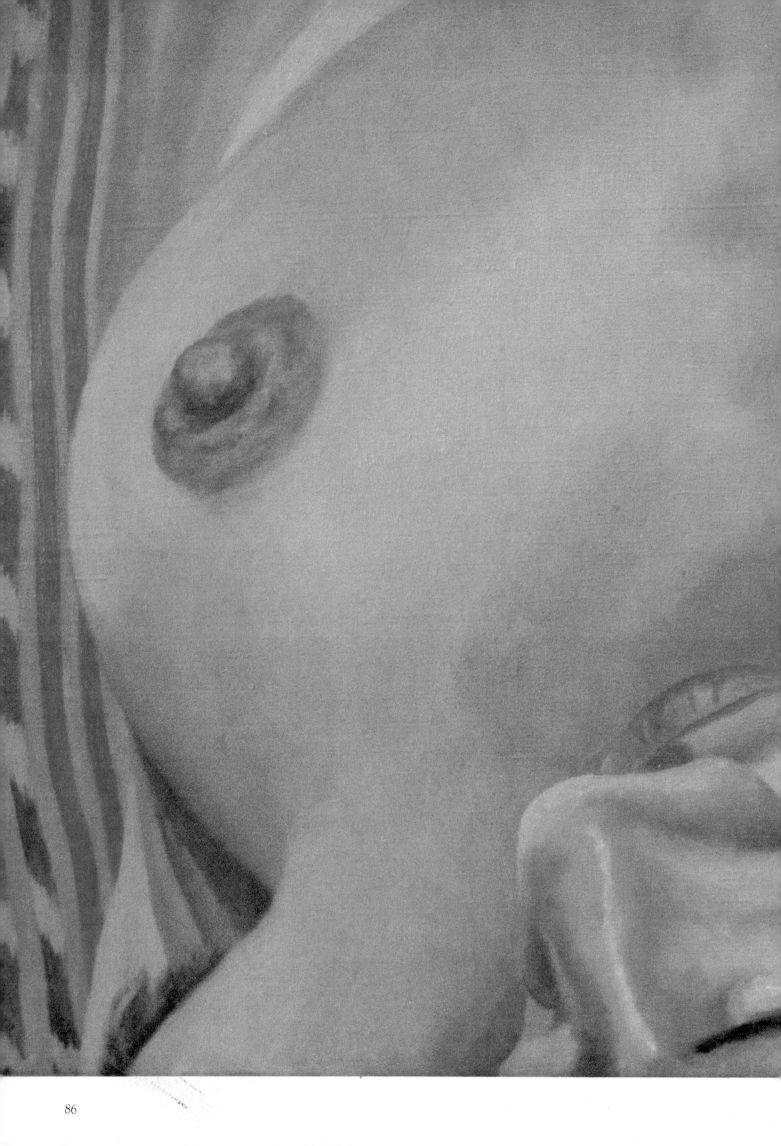

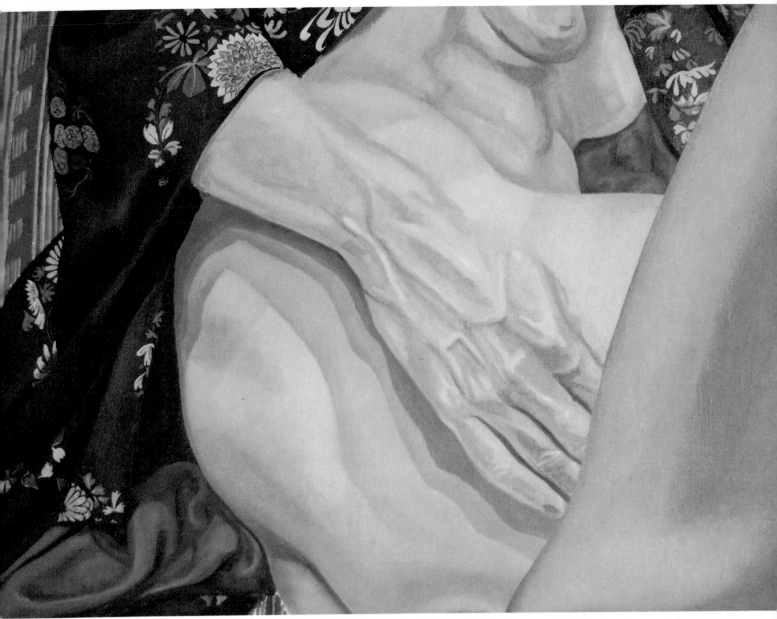

23. This sequence (pages 88–91) shows the development of the hand and torso of the background model. At this stage the flowered kimono has been completed, and Pearlstein began to model the veins and fingers of the hand.

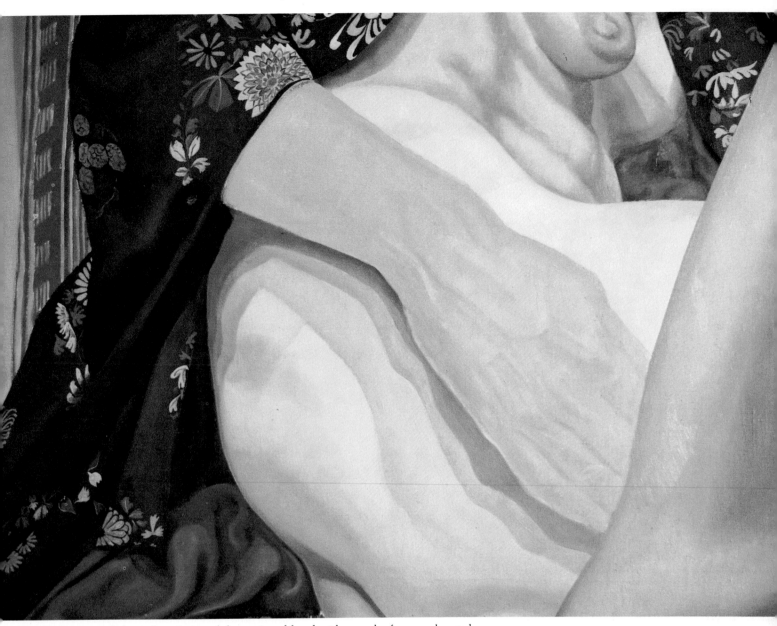

24. *He has covered the underpainting of the torso and hand with a wash of raw umber and Mars yellow mixed with white. This wash served as the basic middle value of that area and covered any bare canvas showing through the first coat. It was brushed on thinly so the earlier modeling would still be visible. The dark shadows on the torso were painted in with cadmium red light added to warm the tonal values.*

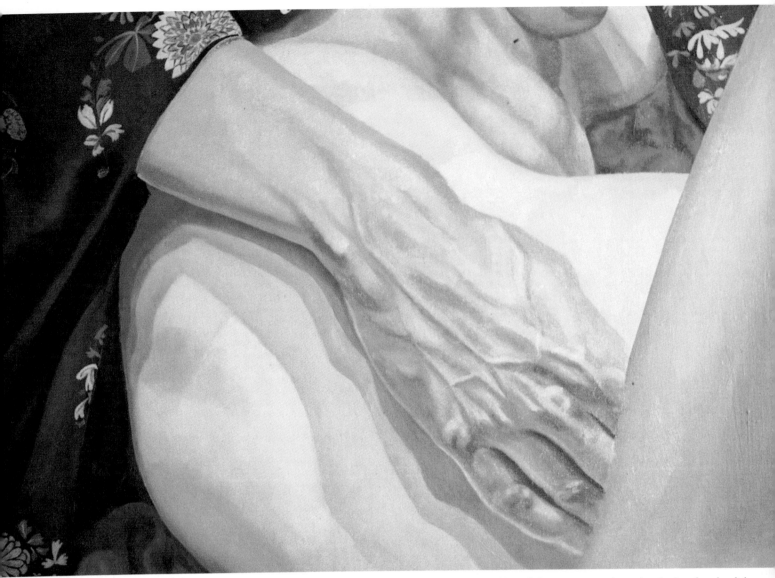

25. *Working into the basic wash, Pearlstein followed the same procedures for the hand as he did for the torso.*

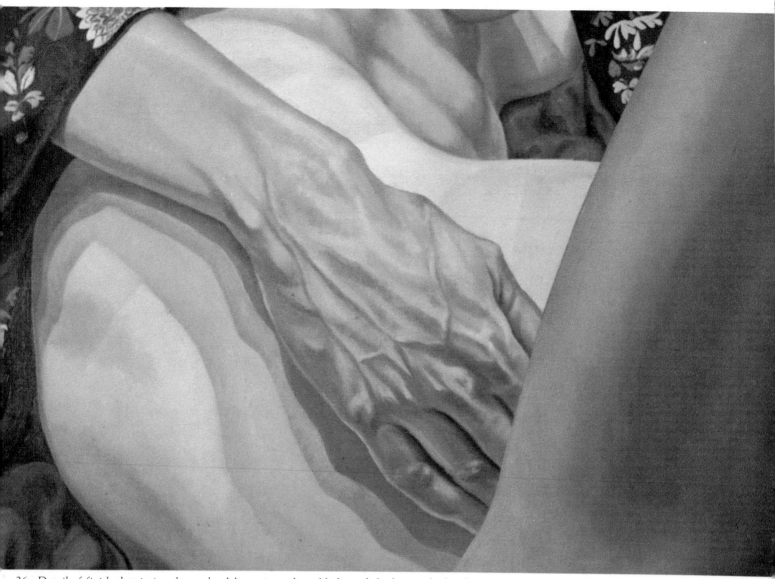

26. *Detail of finished painting shows the delicate interplay of light and shadow in the hand.*
The hip and torso show the shadows cast by the three studio lights.

PORTRAIT OF SYDNEY AND FRANCES LEWIS

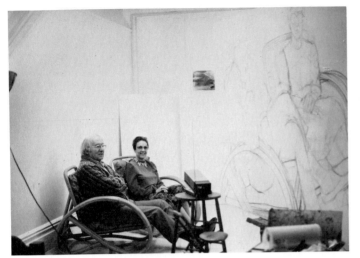

1. The couple posed, while watching a small color television set, during the preliminary charcoal drawing, visible on the easel.

2. The preliminary charcoal drawing was completed.

3. On the second sitting, Pearlstein began to rough in the underpainting. At this point, he saw that the figure of Mrs. Lewis would be too small in relation to the total canvas. He later washed out the whole canvas, changed his position, and moved closer.

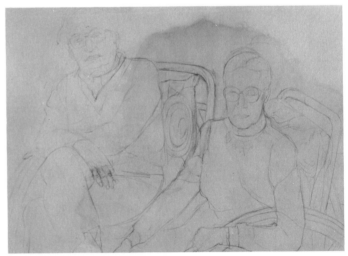

4. The new drawing was almost the same pose but from a different angle.

In this portrait, Pearlstein was very much aware of contrasting patterns: Mr. Lewis's sweater, Mrs. Lewis's skirt, and the stylized forms of feathers in her necklace that relate to the perspective views of Navajo baskets covering the cushions of the bamboo chairs purchased in a neighborhood junk shop.

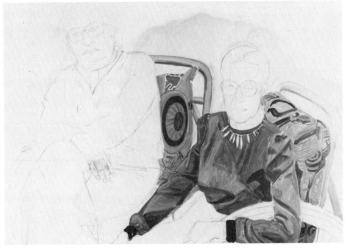

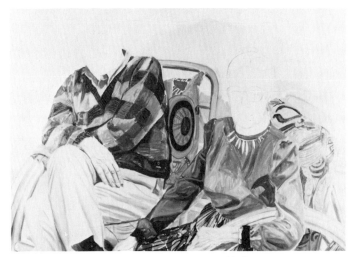

5. The color was brushed in on Mrs. Lewis's blouse and the cushions behind the Lewises.

6. Mr. Lewis's sweater and trousers were added.

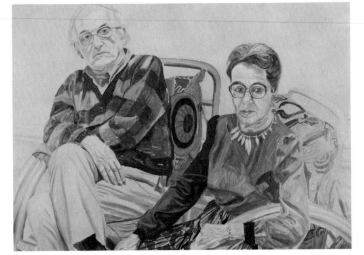

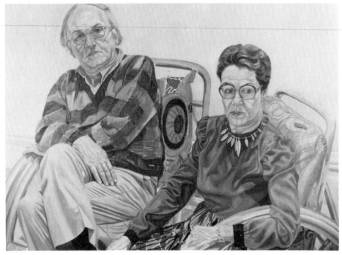

7. Next came the underpainting of the hands and faces.

8. With the refinement of the faces and clothing, the underpainting was completed.

9. In this detail of Mr. Lewis's head, his brow has been completed. The final painting of the lower part of his face has been begun by brushing in a middle value to produce a new wet surface into which to work subsequent details.

10. With the exception of the eyes and glasses, the head and neck were finalized.

11. Mr. Lewis's right eye was finished.

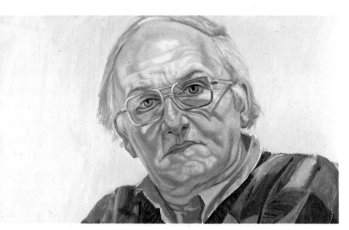

12. His left eye and the reflections in the glasses were added.

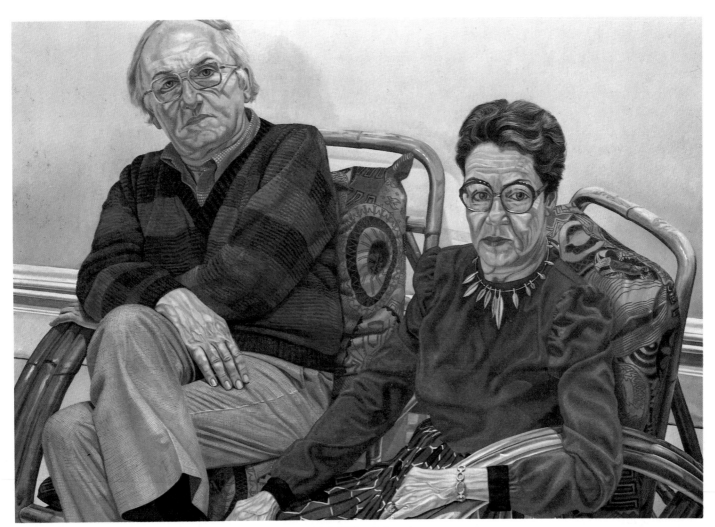

PORTRAIT OF SYDNEY AND FRANCES LEWIS, 1981, oil, 60″ x 72″ (152 x 183 cm)

VIEW TOWARD POSITANO

1. A photograph of the scene, showing the Siren Islands at the right.

2. The first day's work was a raw umber drawing of the landscape and a blue wash for the sky.

3. On the second day, the water was added with the deeper color and reflections in the cove.

4. At the beginning of the underpainting of the cliffs, the cliffs in the far background were not visible through the fog. With the addition of the distant cliffs and the foreground, the underpainting was completed. Detail is added on the left foreground cliff and in the water of the cove.

In 1973, Pearlstein went to Italy, having received an award from the American Academy and Institute of Arts and Letters. His aim was to apply his method of working only from direct observation to painting the landscape. The canvas he chose was the largest that could be easily portable, given the content of the painting. For fourteen of the fifteen days he was working on the painting, Pearlstein drove to a little restaurant, a half-hour walk from the site, where he stored the painting in progress. During his stay, the weather was misty, although only one day of strong rain prohibited work on the landscape.

5. A photograph of the scene on a day of brilliant sunlight, which, Pearlstein was told, forecast a coming storm. The water changed and became rippled. Pearlstein used the opportunity to work on the farther cliff and to pick up the strongest shadows on the land and the water.

6. After the stormy day, the rain subsided into a drizzle in which he could work. Despite the drizzle, the water was relatively calm, allowing Pearlstein to begin to stabilize the water's surface.

7. The surface of the water was intensified, and the middle zone of the cliff darkened, with details added later, working wet into wet.

8. The completed painting.

View Toward Positano, 1973, oil on canvas, 48″ x 48″ (122 x 122 cm)

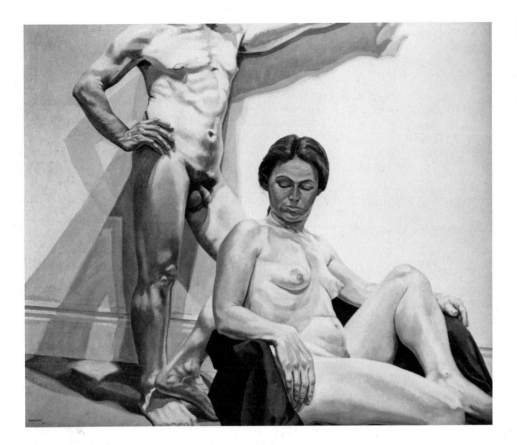

MALE AND FEMALE MODELS IN THE STUDIO, 1967, oil, 60" × 72" (152 × 183 cm)

This is one of Pearlstein's more open compositions, a right triangle inside a square, broken by bent elbow and knee. It was one of the first paintings in which he purposely contrasted dynamic shadows on a wall against passive figures.

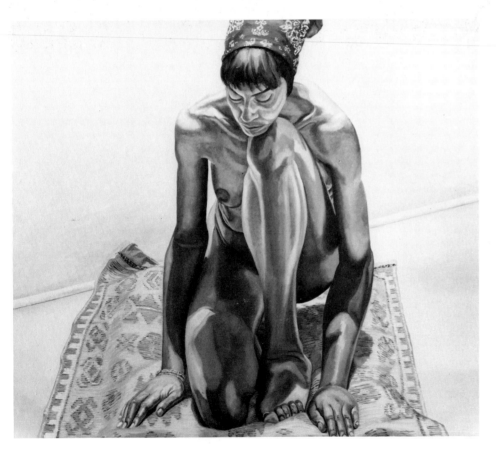

CROUCHING NUDE WITH BANDANA, 1969, oil, 64" × 72" (163 × 183cm)

One day the model arrived for a painting session wearing a blue bandana. Pearlstein liked the accidental combination of colors: blue, flesh, orange drape, and green floor. One of the condensed single-figure compositions in which the cropping is minimal, Crouching Nude with Bandana foreshadows his later use of partly clothed models wearing robes and kimonos.

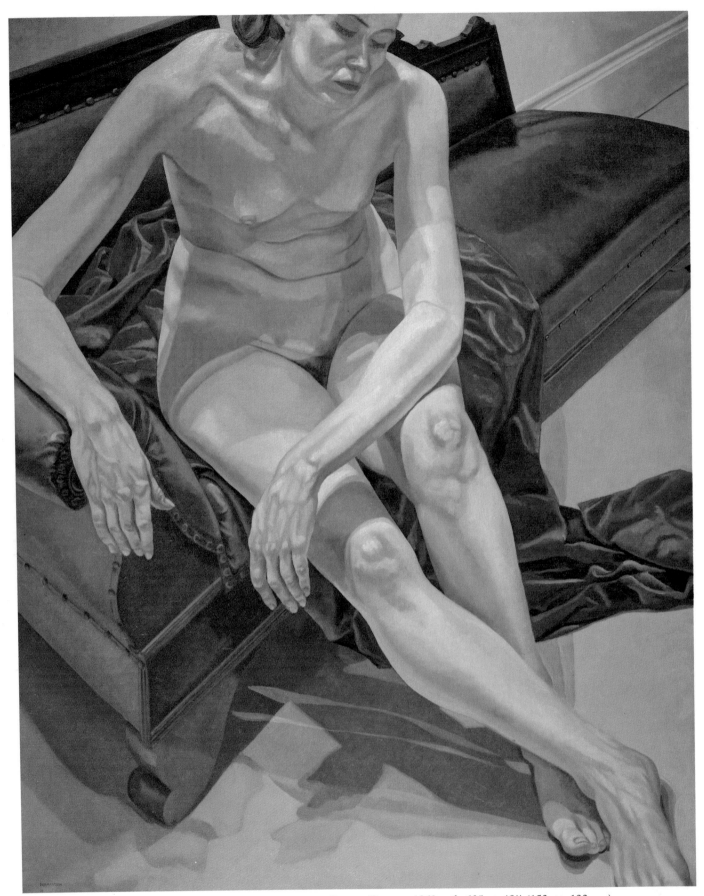

SEATED NUDE ON GREEN DRAPE, 1969, oil, 60″ × 48″ (152 × 122 cm)

Even after he began adding furniture and accessories to the compositions, Pearlstein's interest in the intricacies of cast shadows continued. At first the furniture was used simply, usually as a diagonal to offset the pose of the model and highlight the vertical, horizontal, and oblique accents of the figure. The shadows fortify the space containing both models and furniture. In Female Lying on Green Rug with Foot on Stool and Seated Nude on Green Drape, the shadowed areas are as present as the upward-thrusting figures.

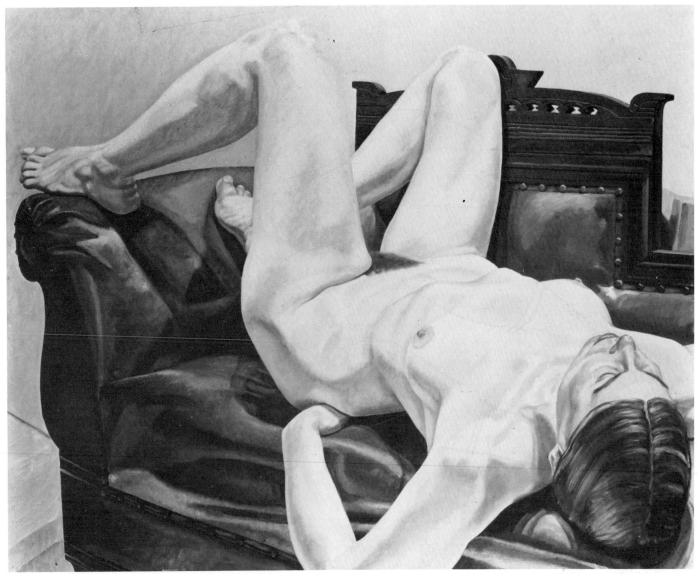

FEMALE NUDE LYING ON COUCH, 1969, oil, 48″ × 60″ (122 × 152 cm)

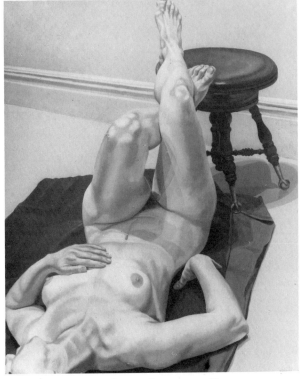

FEMALE LYING ON GREEN RUG WITH FOOT ON
STOOL, 1968, oil, 44″ × 36″ (112 × 91 cm)

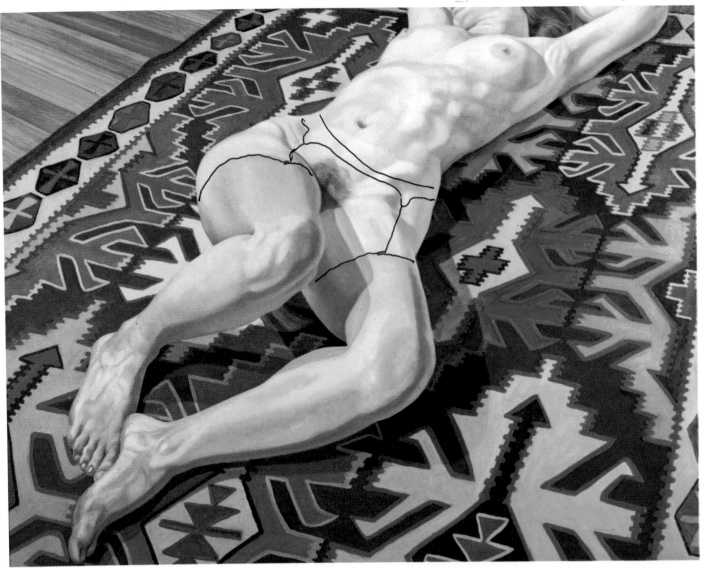

NUDE ON KILIM RUG, 1969, oil, 60″ × 72″ (152 × 183 cm)

Visually this is the most stunning example of Pearlstein's early use of rugs. By almost filling the canvas with the parallel model and rug, he made the angle of the parquet floor at the upper left whipsaw against their contrasting directions. The rich play of shadows on the body stands· out in sharp relief against the design of a rug so intense that it competes with the model for the viewer's attention.

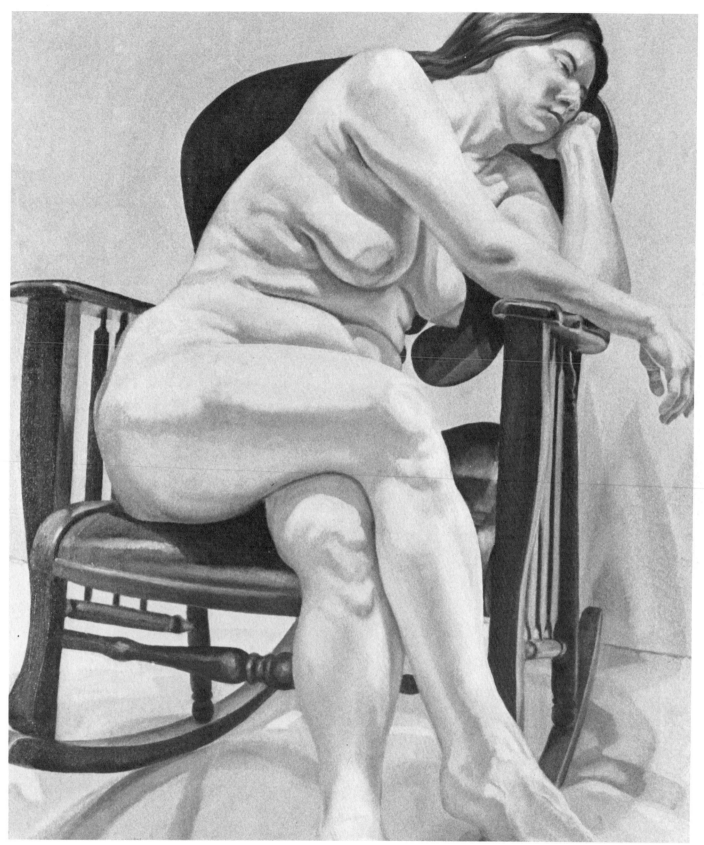

GIRL ON ROCKING CHAIR, 1970, oil, 28″ × 24″ (71 × 61 cm)

Pearlstein uses furniture in different ways. Sometimes, as in Girl on Rocking Chair, *it acts as a rigid container, a foil for the soft forms seated within it.*

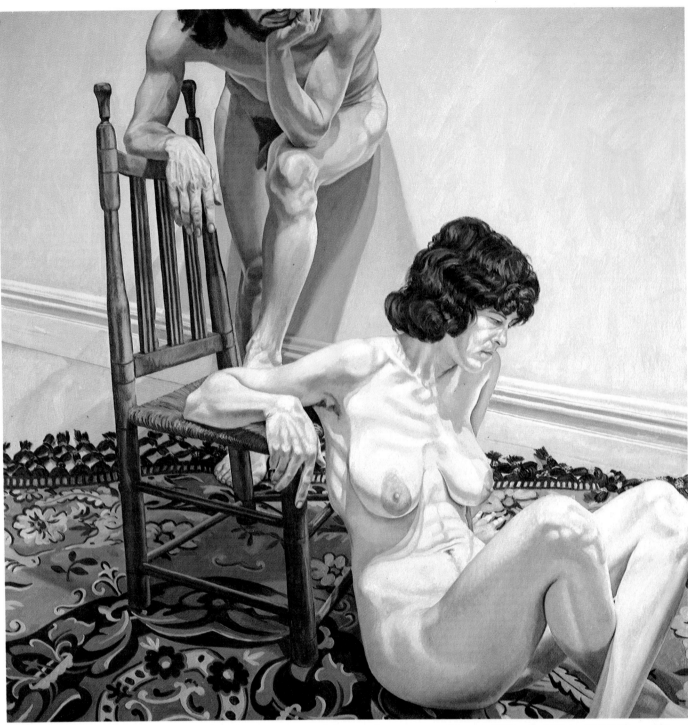

MALE AND FEMALE MODELS LEANING ON CHAIR, 1970, oil, 72″ × 72″ (183 × 183 cm)

At times a piece of furniture, such as the chair in Male and Female Models Leaning on Chair, *echoes the angles of limbs and torsos. A similar parallelism in composition can be seen in* Two Female Models with Iron Bench. *The iron bench in this painting and two others he owns became favorites in the early 1970s because of the complexities of their construction and the shadows they cast.*

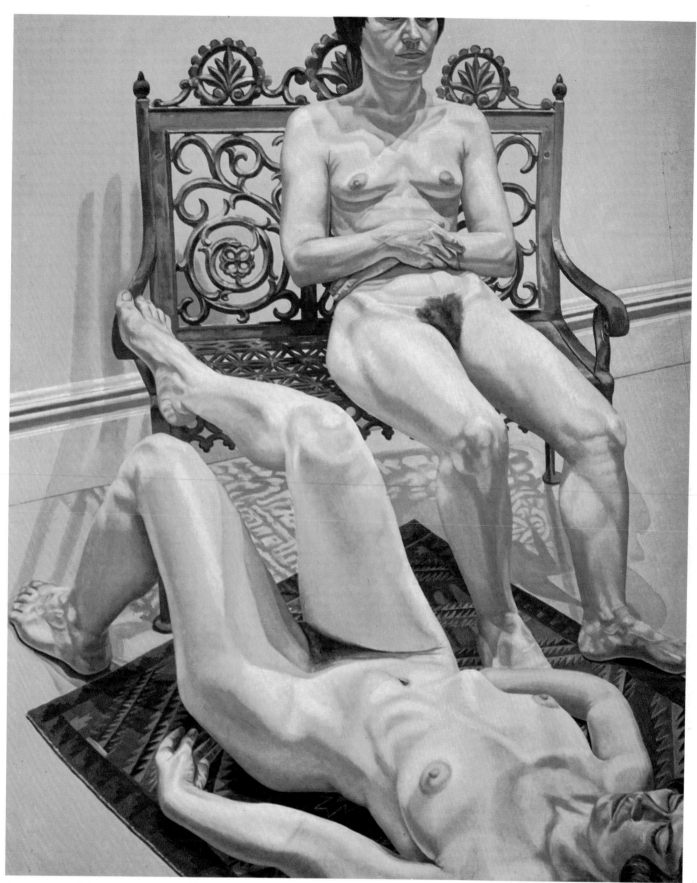

Two Female Models with Iron Bench, 1971, oil, 72″ × 60″ (183 × 152 cm)

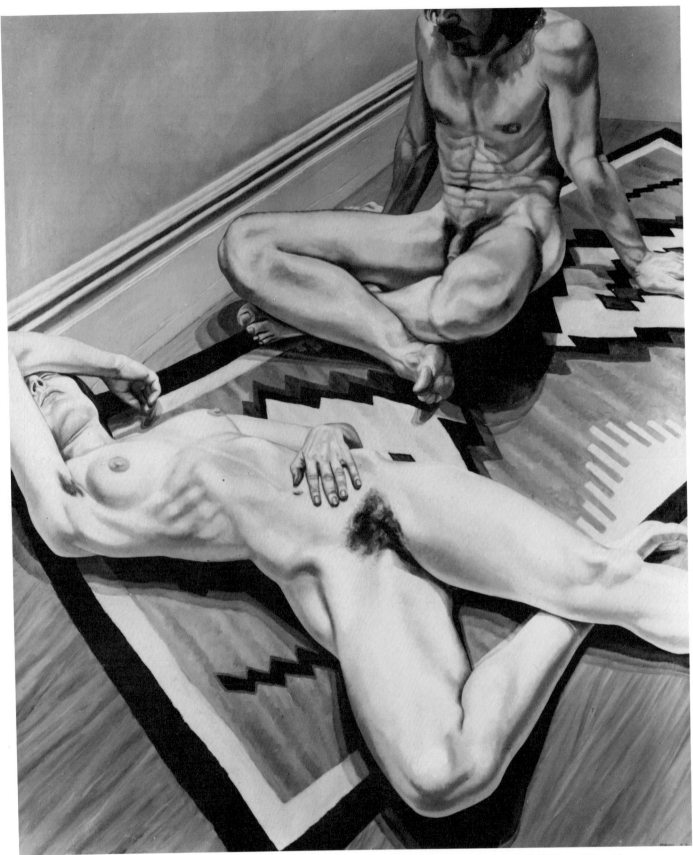

COUPLE ON OLD INDIAN BLANKET, 1971, oil, 72″ × 60″ (183 × 152 cm)

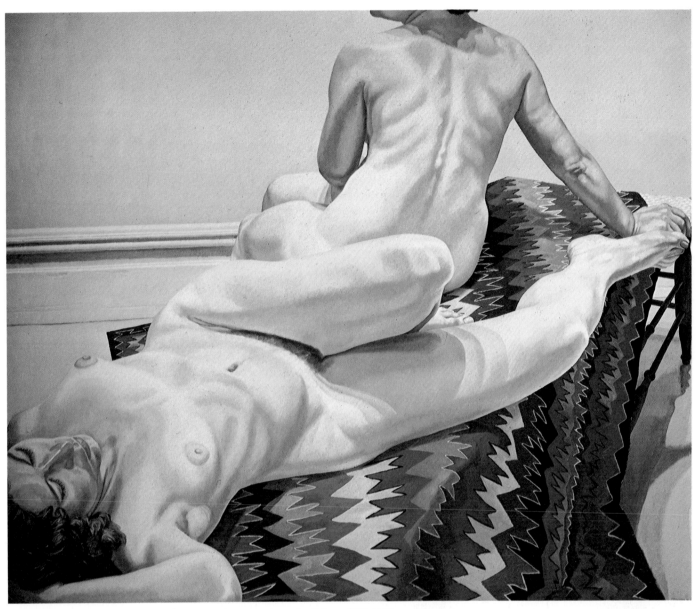

TWO FEMALE MODELS ON [NAVAHO] RUG, 1971, oil, 60″ × 72″ (152 × 183 cm)

Especially with the use of rugs, Pearlstein began more frequently to adopt a high point of view, making the dense designs of the rugs fill large areas of a painting's surface. The high point of view flattened the space of the painting, tending to negate the right-angle distinction between floor and wall. This made it easier to reconcile receding space with the two-dimensional thrusts of the forms.

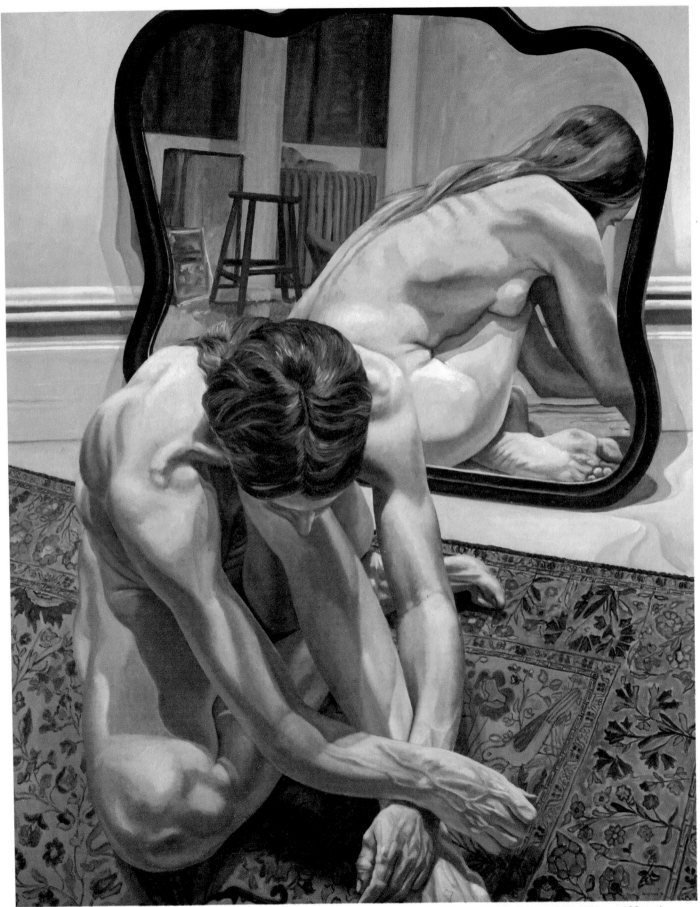

CROUCHING FEMALE NUDE WITH MIRROR, 1971, oil, 60″ × 48″ (152 × 122 cm)

As in Ingres' portraits, the addition of a mirror both opens and complicates the space
of the painting, giving an alternate view of the condensed pose of the model while, at the same
time, providing a glimpse of the studio seemingly behind the viewer.

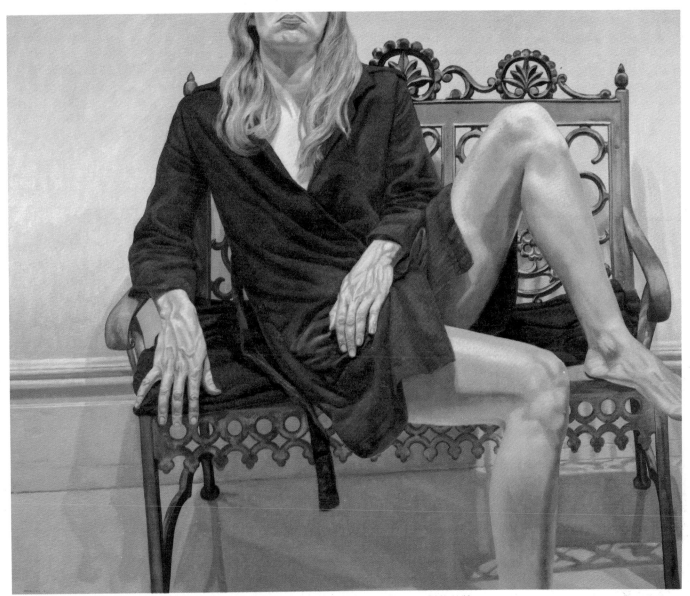

FEMALE MODEL IN RED ROBE ON WROUGHT IRON BENCH, 1972, oil, 60″ × 72″ (152 × 183 cm)

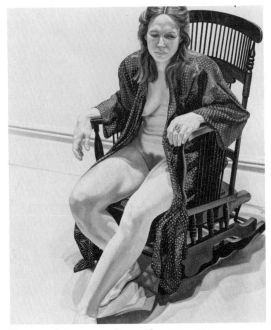

FEMALE MODEL IN ROBE SEATED ON PLATFORM ROCKER, 1973, oil, 72″ × 60″ (183 × 152 cm)

Along with the furniture and consequent shadows, Pearlstein began using robed models in the early 1970s. This arose from the observation of his models relaxing between posing sessions, and the first robe paintings show the models in relatively easeful positions. Besides providing another contrast in color and texture, the robe, depending on its use, could both exaggerate and de-emphasize a figure's nudity.

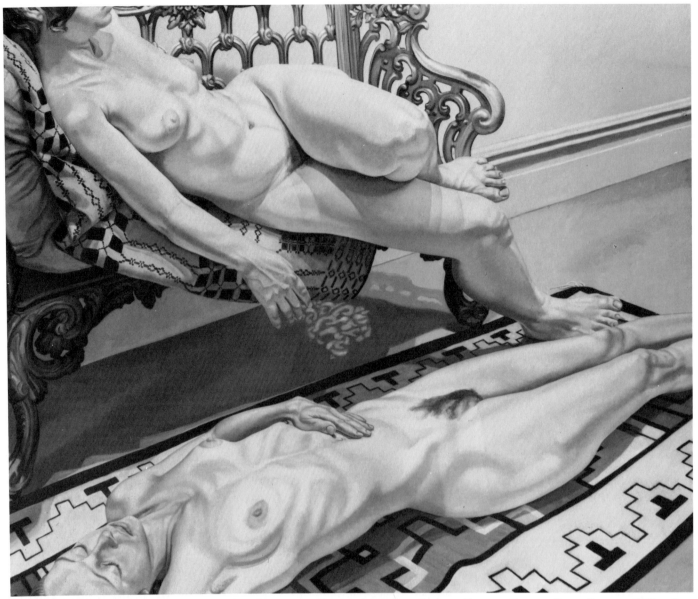

TWO RECLINING FEMALE MODELS, ONE ON FLOOR, ONE ON IRON BENCH, 1973, oil, 60″ × 72″ (152 × 183 cm)

Pearlstein grew fond of the iron benches and used them in several paintings and prints. Besides the shadows cast by the open iron patterns, he liked the contrast of the metal against the softness of the models. In Two Reclining Female Models, One on Floor, One on Iron Bench, *the bench adds another parallel, diagonal element to the extended figures, the rug, and the baseboard.*

FEMALE MODEL ON IRON BENCH, 1973, oil, 48″ × 40″ (122 × 102 cm)

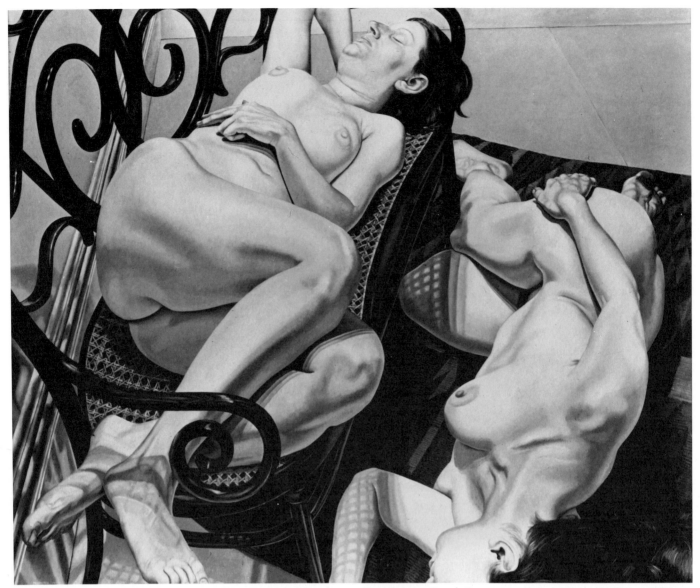

Two Female Models on Bentwood Love Seat and Rug, 1974, oil, 60″ × 72″
(152 × 183 cm)

*The furnishings became a hallmark of Pearlstein's compositions in the 1970s. Some items of
furniture were especially appealing as foils to the posed models. The love seat was borrowed for
this reason. Its open, organic curves set off and complement the similar shapes of the human
body. With the addition of drapery, in Female Nude Reclining on Bentwood Love Seat, or
another figure and a rug, in* Two Female Models on Bentwood Love Seat and Rug, *the
combinations create a complex progression of forms across the surface, both confirming and
denying the receding space in the paintings. The caning of the chair's seat also offered
Pearlstein a new set of shadows to explore.*

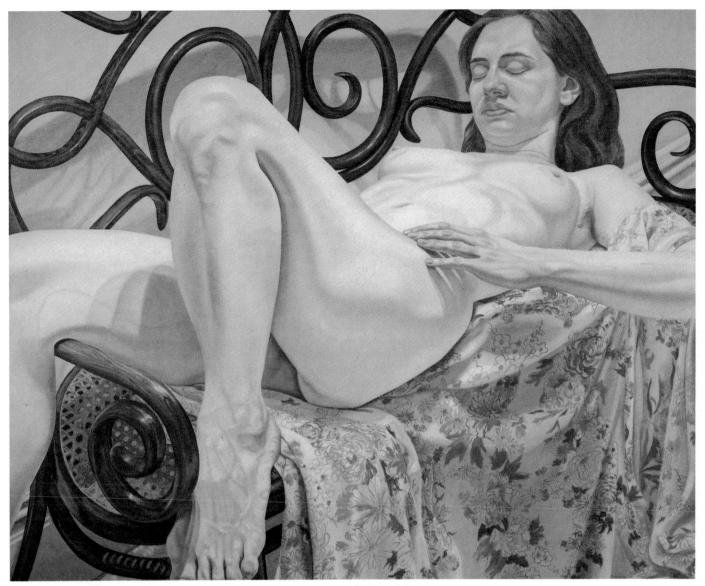

Female Nude Reclining on Bentwood Love Seat, 1974, oil, 48″ × 60″
(122 × 152 cm)

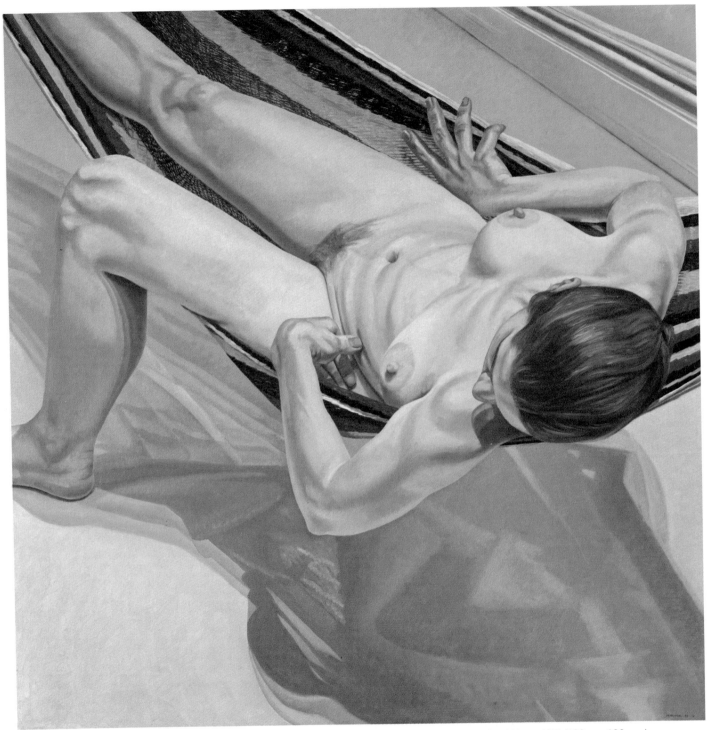

FEMALE NUDE LYING ON A HAMMOCK, 1974, oil, 48″ × 48″ (122 × 122 cm)

The hammock, set up in the studio, became another favorite prop, appearing in paintings, watercolors, and an aquatint etching still in progress. It acted as another kind of foil for the models, a weighty, oblique force of direction that cast complex shadows and further extended the diagonal in their postures.

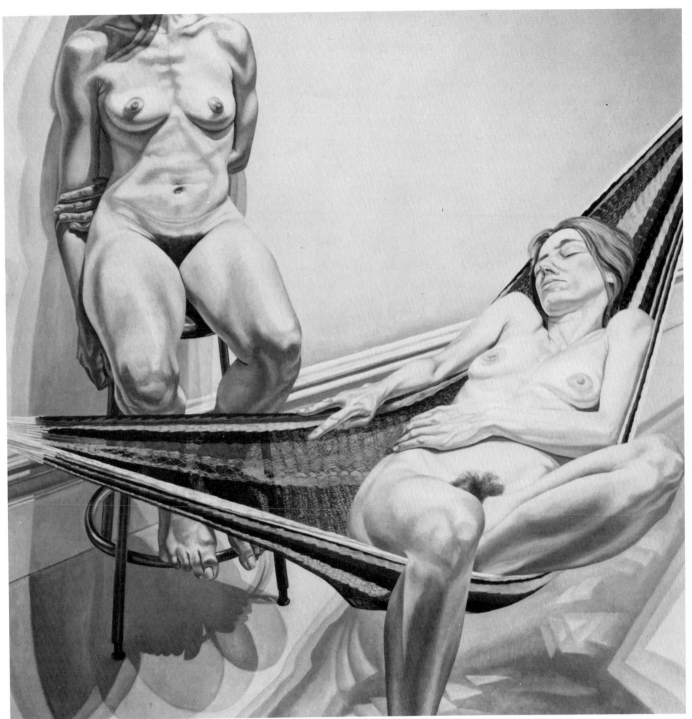

TWO FEMALE NUDES ON HAMMOCK AND STOOL, 1974, oil, 72″ × 72″ (183 × 183 cm)

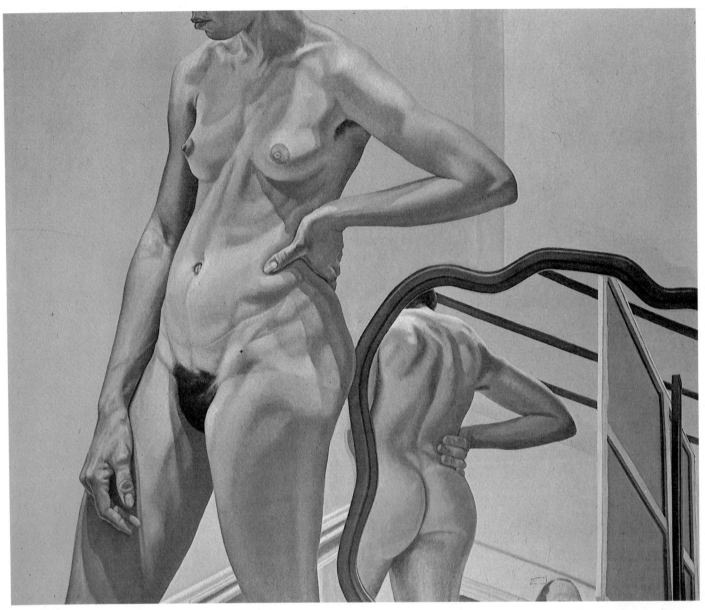

STANDING FEMALE NUDE WITH MIRROR, 1973, oil, 60″ × 72″ (152 × 183 cm)

Spatially, this is one of Pearlstein's most complicated compositions. The wood-framed mirror, placed just behind the model and echoing the curves of her body, cuts off the baseboard receding to the corner of the room and flattens the space of the foreground. The mirror reflection of the canvas on the easel, apparently jutting out to mark the space behind the figure, introduces studio furniture to the accessories of Pearlstein's paintings. The partial self-portrait in the mirror, his head cropped at the eyes, was a witty addition.

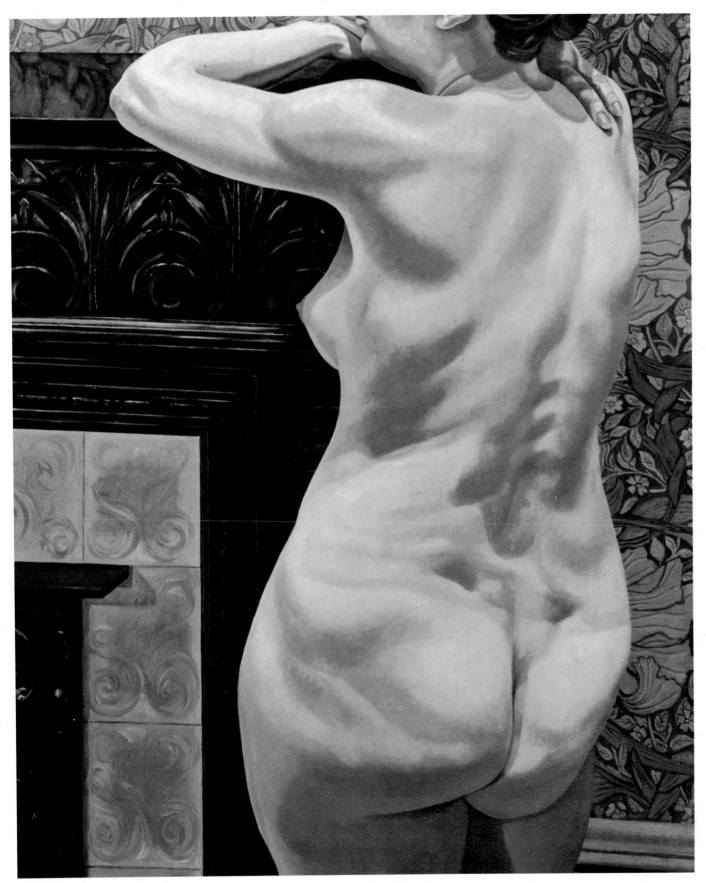

FEMALE MODEL LEANING ON MANTEL, 1974, oil, 44″ × 36″ (112 × 91 cm)

This painting is unusual in showing an actual room of the Pearlstein house, the living room, with its fireplace and William Morris wallpaper.

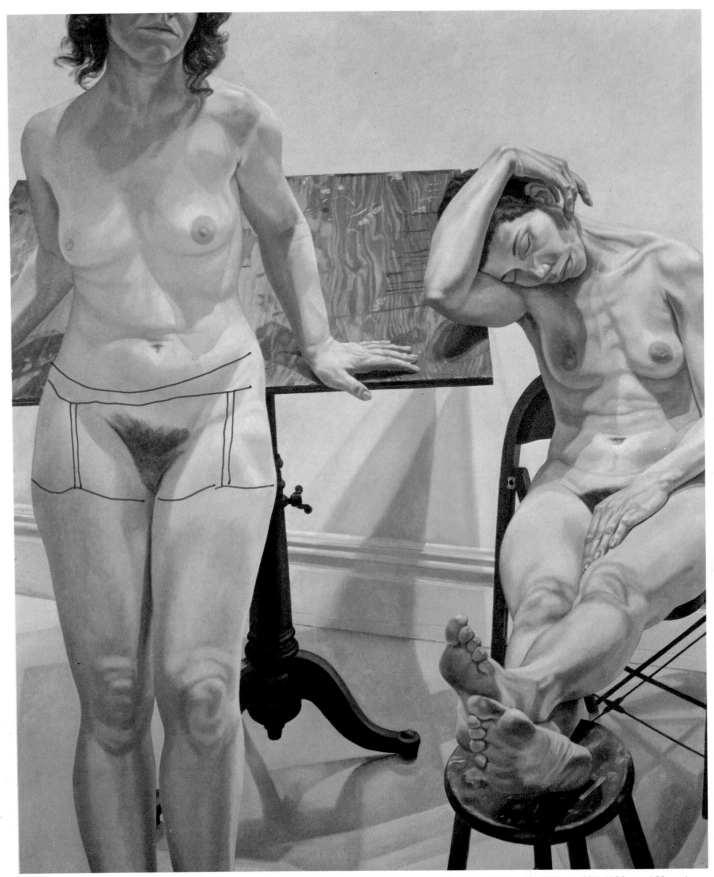

Two Female Models with Drawing Table, 1973, oil, 72″ × 60″ (183 × 152 cm)

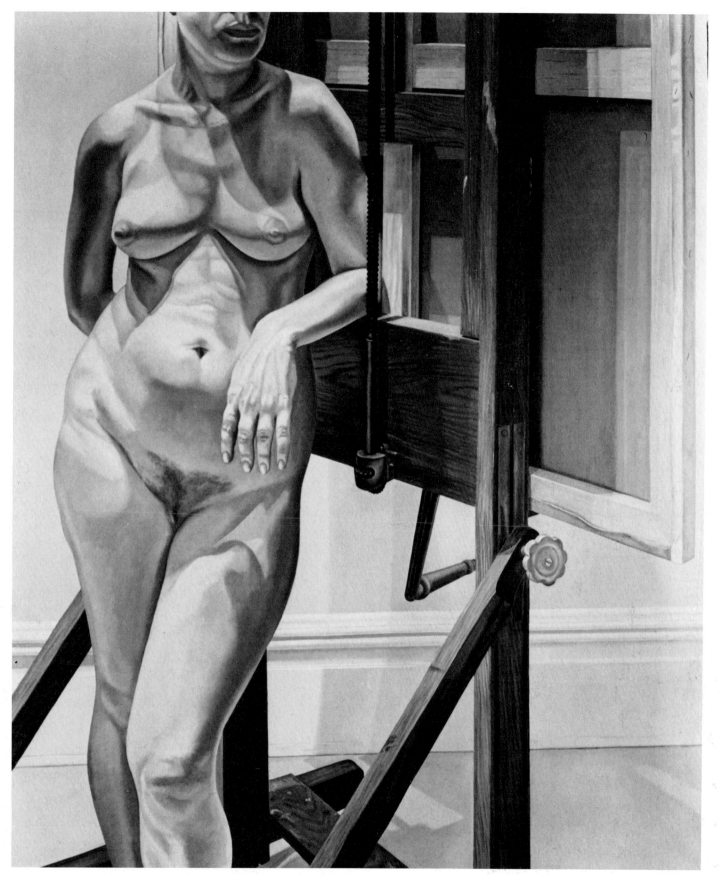

FEMALE MODEL STANDING BY EASEL, 1974, oil, 72″ × 60″ (183 × 152 cm)

The easel and the drawing board made several appearances in Pearlstein's paintings, watercolors, and prints. Like the other furniture, they were used compositionally and as supports for the models' bodies. In Female Model Standing by Easel, he also liked the contrast of the contours of the body against the straight lines of the easel and the diagonal parallels of her left arm and thigh and the base of the easel.

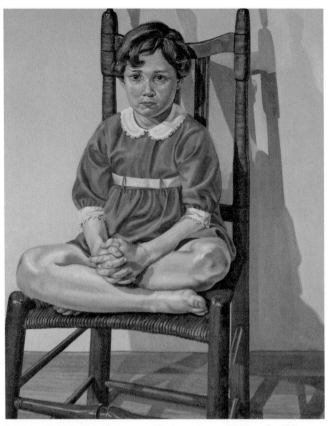

PORTRAIT OF THE ARTIST'S DAUGHTER, 1969, oil, 60″ × 48″ (152 × 122 cm)

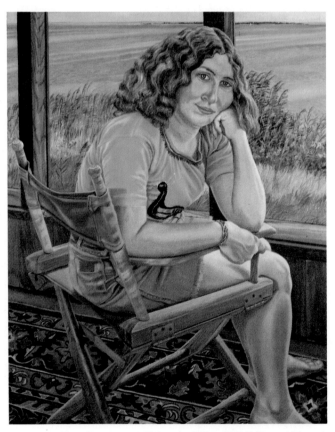

JULIA ON FIRE ISLAND, 1974, oil, 60″ × 48″ (152 × 122 cm)

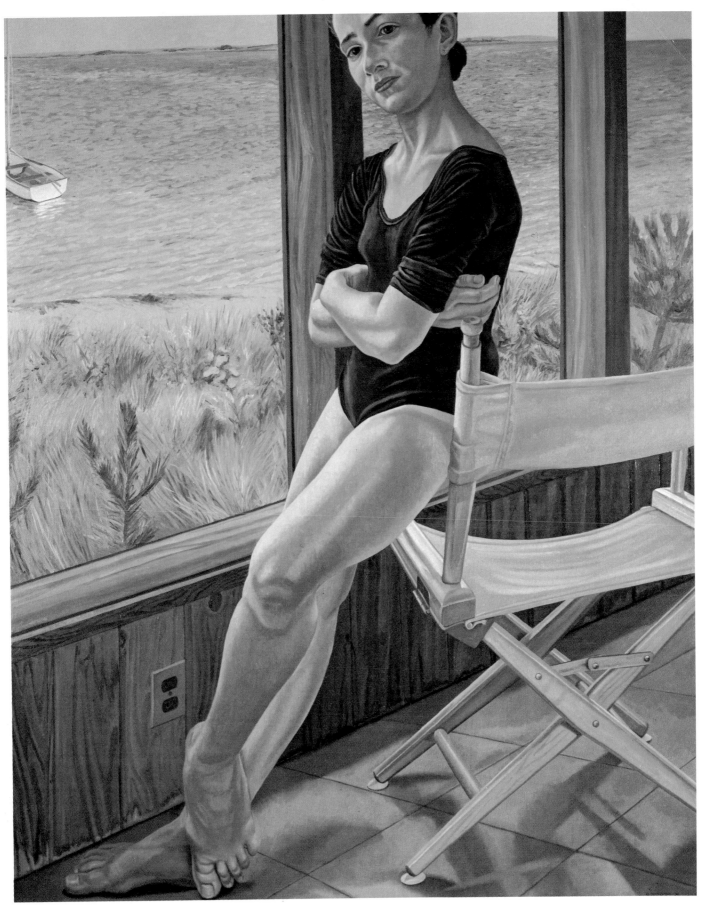

ELLEN ON FIRE ISLAND, 1974, oil, 60″ × 48″ (152 × 122 cm)

About 1969, Pearlstein began to use frontal poses in his portraits. The condensed triangular pose in Portrait of the Artist's Daughter *is countered by the strongly depicted shadows of the chair. Two later portraits of his daughters,* Ellen on Fire Island *and* Julia on Fire Island, *are unique in combining figures indoors with the natural light of a beach scene outside the windows.*

121

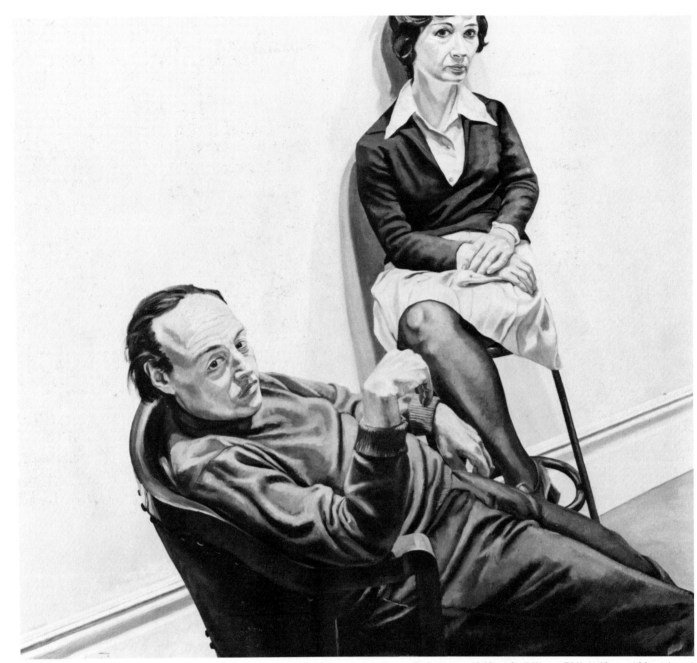

PORTRAIT OF AL HELD AND SYLVIA STONE, 1968, oil, 66″ × 72″ (168 × 183 cm)

When Pearlstein applied frontality to his portraits of couples, the result was a facial expression more personal than a somnolent stare, as in the engaging directness of Martin and Nancy Meltzer. *Many of Pearlstein's portraits of couples have diagonal compositions, allowing for a choreography of forms moving both across the surface and into three-dimensional space. When the canvas was large enough, as in* Portrait of Al Held and Sylvia Stone, *he used the contrast, also found in his figure paintings, of an extended pose against a more compact one. On occasion, chance inserted an extra element into the portraits. In* Jerome and Ponnie Weiner, *the face of Mrs. Weiner, seated behind her husband, is seen refracted in the left lens of his glasses.*

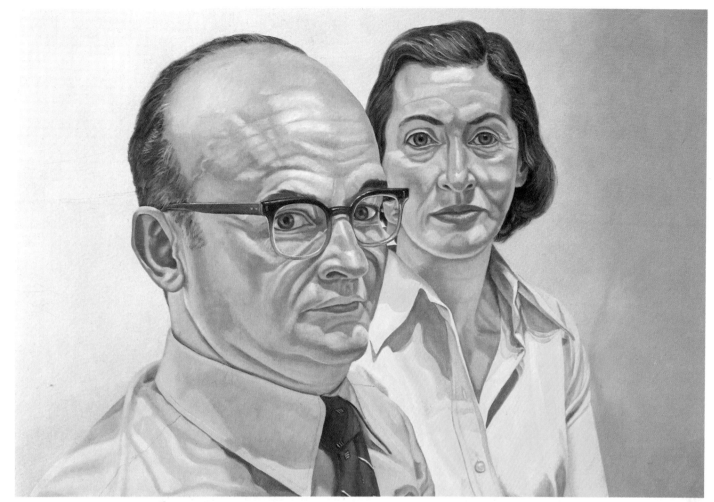

JEROME AND PONNIE WEINER, 1975, oil, 28″ × 40″ (71 × 102 cm)

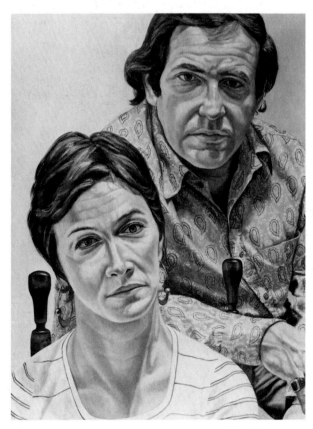

MARTIN AND NANCY MELTZER, 1973, oil, 40″ ×
30″ (102 × 76 cm)

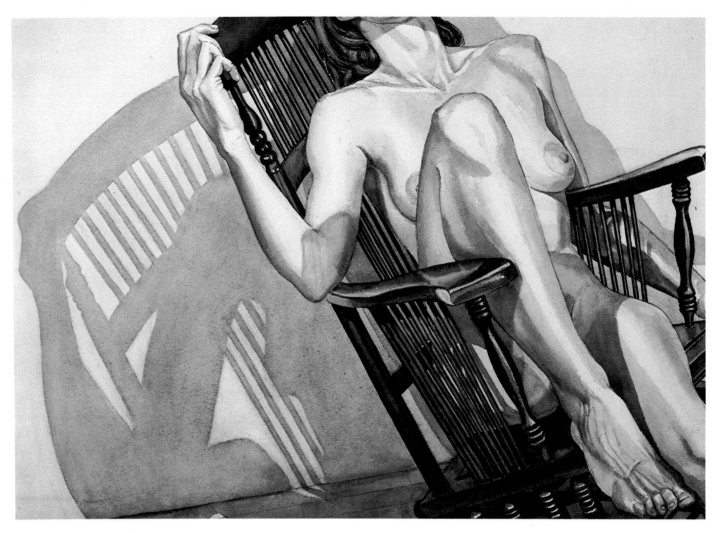

FEMALE MODEL ON PLATFORM ROCKER, 1977, watercolor, 29½″ × 41″ (75 × 104 cm)

While Pearlstein regards each of his works— oil painting, drawing, watercolor, or print— as independent and self-contained, sometimes a composition is complicated enough to be worth developing in other media as well. This was the case with the watercolor of Female Model on Platform Rocker, *which was Pearlstein's earliest use of this image.*

NUDE WITH ROCKER, 1977, color lithograph, 3¼″ × 33¾″ (59 × 86 cm)

FEMALE MODEL ON PLATFORM ROCKER, 1978, oil, 72″ × 96″ (183 × 244 cm)

Part Four
WATERCOLOR WORKSHOP

In recent years watercolor has come to play an increasingly important role in Pearlstein's work, both for its own sake and in relation to his aquatint etchings. He had always done wash drawings, but the majority of his studies of rocks, ruins, and figures of the 1950s and 1960s were monochromatic. Since the middle 1970s his involvement has been with fully chromatic watercolor, on an increasingly larger scale. For Pearlstein, the clarity and brilliance of watercolor are a large part of its appeal, but it is a more difficult medium to handle than oil. Whereas oil can be subtle and allows greater control in the shading and blending of color areas, watercolor does not allow such delicately controlled manipulation. Therefore Pearlstein works with the medium by building up transparent layers of washes.

For his watercolor pigments, Pearlstein prefers the kind packaged in pans for their transparency; colors in tubes tend toward opacity. His watercolor palette is necessarily different from his oil palette. Watercolor washes are different after drying, becoming lighter in value and duller in intensity. And the same pigments respond differently when ground in oil or ground in gum arabic. For example, he uses Naples yellow for oils, but it is opaque and there is no watercolor equivalent. In watercolor he depends on the white of the paper for the lightest tones in modeling and uses thin yellow ocher washes to achieve the effect of Naples yellow. Pearlstein will use alizarin crimson for watercolor but not for oil, where the strong dye color crimson stains every other color it touches. As a watercolor, alizarin crimson minds its own business.

When he starts a new project, Pearlstein's first decision is the medium—oil or watercolor. Since the two processes differ in technique but the basic aesthetic issues remain the same, his choice is subjective and often depends on the colors of the studio situation. His next decision is the composition, on which he spends as much time as necessary. Pearlstein believes that the movements of the poses must come from the models themselves and he accepts the poses they find. But he moves around them, studying the configuration from different angles until he finds his composition. He also accepts their suggestions about props and drapes. In spite of the objectivtiy with which he tries to render the forms of human bodies, Pearlstein is concerned about his models as people, not as objects. Over the years he has learned which postures are characteristic of each model, and he likes to combine a model who can take complicated, condensed poses with one who is more comfortable in an extended position. This lends interesting formal movements to his compositions and allows him to find the complications, spatial tensions, and unusual, even awkward, juxtapositions that fascinate him. Once the poses are established, he marks the models' positions with pieces of tape, choosing a color that will distinguish the marks from those of other works in progress.

Pearlstein begins a watercolor immediately with a line drawing, brushed on with a thin wash of color, to establish the compostion. He does the line drawing with particular care and precision, committing himself to his decisions thoughtfully, because it is especially difficult to make changes in watercolor. This almost contemplative attitude demands a slowing down of the working process and allows the elements of composition to dominate his mind. The slowness of the watercolor medium is part of its attraction for Pearlstein. It permits closer observation and enables him to create a more controlled, precise painting of the objects through the statement of the play of light on the forms. He has found that patterned textiles force him to take even more time to observe and record with accuracy, and intricately woven rugs and ornately flowered kimonos appear regularly in his watercolors, as well as in his oil paintings. The kimonos he purchases to use as props are selected for the clarity of their designs.

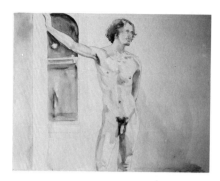

STANDING MALE MODEL, 1972, wash, 22" × 30" (56 × 176 cm)

When the drawing group began to set the models in longer poses, Pearlstein found himself working more slowly and paying increased attention to developing the modeling and creating the physical setting of the figures, instead of concentrating on the bodies alone. Standing Male Model was one of the first drawings that indicated his move in this direction. His shift to the full chromatic range of watercolor was thus a logical extension of the tendency, in the monochromatic wash drawings, to create a totally realized space for the figures.

The initial line drawing for a watercolor is made with a finely pointed #2 or #3 sable brush and a thin wash of raw umber, chosen because it will blend in with the final colors. The paper, usually a 20" × 41" (51 × 104 cm) or 41" × 60" (104 × 152 cm) sheet of Arches 300- or 400-pound weight, is clipped to a board on his easel and tilted slightly. He likes the heavy paper for its rough surface and ready response to both painting and scrubbing.

After the line drawing has been worked out—this can take several work sessions of three or four hours—Pearlstein uses a finely pointed #6, #7, or #8 sable brush to apply the washes. He does not wet the paper but leaves it dry, moistening an area when necessary to apply a smooth wash. The washes are usually the medium-dark values of the flesh tones, which he develops one area at a time in order to keep the hues from becoming muddy. The colors selected for the flesh tones depend on the models; he is careful to maintain the distinctions between their different complexions.

As in his oil paintings, Pearlstein develops the surroundings of the model with as much attention to detail as the figure itself. When he can no longer work on an area without muddying the colors, he moves on to another section, allowing the first washes to dry and adjusting the easel in order to bring another portion of the painting within easy reach; he himself remains in the same spot throughout the painting process. To create highlights, Pearlstein washes out color if it has spread beyond its intended boundaries or dried with edges that are too harsh. He wipes the paper to be lightened with wet paper towels or cotton tips for small areas or edges. If necessary, he uses soft sponges to wash out color from large areas or to dampen the paper with clean water to let a color spread evenly. To deepen tones, he adds successive layers of washes until the desired colors and values are achieved.

Pearlstein likes to think about painting either before he does it or after he does it, but not while working on it, when the internal logic of recording what he has chosen to compose must be allowed to speak. He is often startled, on completing a painting, to see what impression dominates. Sometimes the finished painting will seem to have a strict geometric plan or strong rhythmic patterns where none were consciously intended. At other times, sharp perspective angles, chosen for other reasons, will seem to make the forms defy gravity. He enjoys this after-curiosity about what he has done.

Pearlstein's method of painting landscapes in watercolor differs from his studio practice because of the changing conditions of light and weather. Under the fixed artificial light of the studio, the colors of forms and the way they catch light and shadow can be dealt with as a coherent entity, but outdoors, on location, the constantly shifting quality of light, as well as the movement of the sun, creates separate problems. Pearlstein approaches these problems as systematically as possible. He first concentrates on a drawing, done in raw umber watercolor, that is a precise outline of every definable form in his field of vision. He then paints in the local color of each of these forms and its surroundings. At this stage, because the changing direction of sunlight radically alters the appearance of the scene, he will work on the painting for only a couple of hours a day, returning at the same time the next day, if required, to continue. Grappling with a unified feeling of sun and shadow comes last. In this final stage, large areas are brushed over with thin washes of color—sometimes Paynes gray or raw sienna—to provide a sense of the atmospheric conditions prevailing during the last hour of work.

Pearlstein's methods of adapting some of these landscapes for aquatint etching are discussed in Part Five. The working sequence that follows illustrates how he paints a watercolor from the model in the studio.

MODEL SEATED ON BAMBOO CHAIR

Each photograph represents a four-hour posing session on successive weeks.

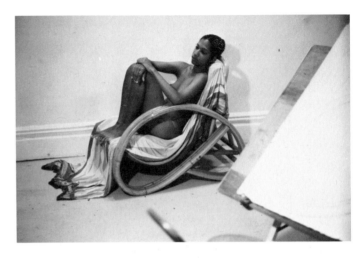

The studio situation: Pearlstein's folding chair at the drawing table and the model posing on drape in bamboo chair.

The line drawing is made with Japanese white hogs' hair brushes, which, in Pearlstein's experience, hold a fine point longer and better than the brown. For the drawing, he uses raw umber from a tube and then switches to pan watercolors for their greater transparency.

Pearlstein starts putting in the color of the figure, beginning with the right arm and breast and continuing, part by part, to the torso, legs, and face, including the shadows cast by the arms of the chair.

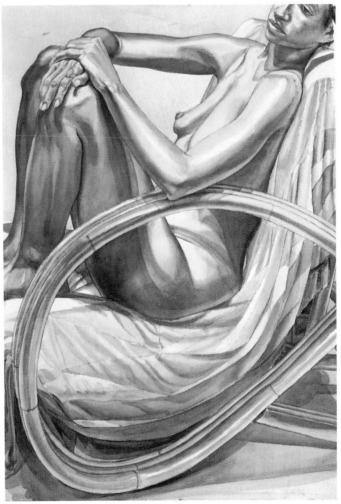

In the finished watercolor, the face and foot have been completed and all the shadows, on the model, drapery, and floor, have been intensified.

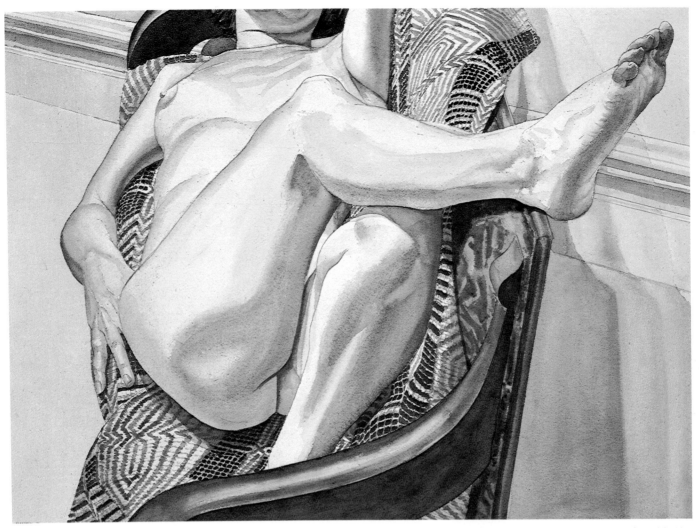

FEMALE MODEL ON RED AND BLACK AMERICAN BEDSPREAD, 1976, watercolor, 29½″ × 41″ (75 × 104 cm)

Pearlstein began to make watercolors in the late 1970s. One reason for his interest in watercolor was his experience in printmaking. Through color lithography, which, like watercolor, involves problems of paper absorbency and the layering of colors, he discovered that a little more care spent in the elaboration of the drawing resulted in a more refined, less expressionistic image. The broadness of watercolor, however, makes continuous modeling in a consistent light difficult, and so the artist must delineate areas of color that will make sense of the forms from an appropriate distance. In Pearlstein's watercolors, contours and modeling that are painterly from a close view are firm from farther away, and the washes, all soaked into the paper, unify the scene with a powerful sense of atmospheric space.

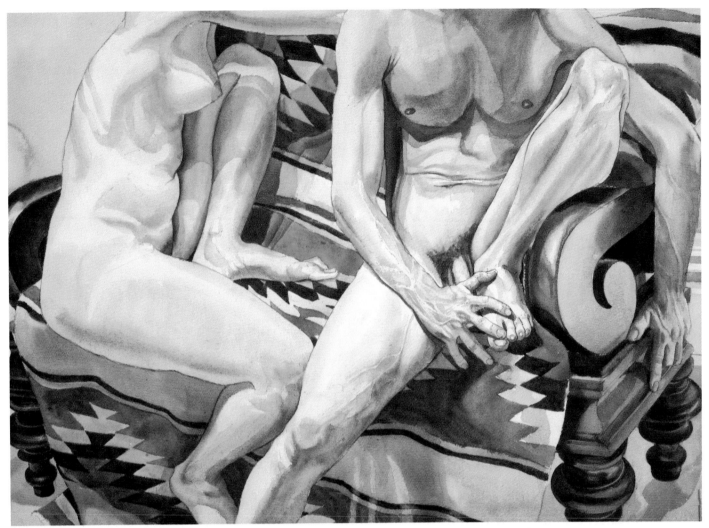

MALE AND FEMALE MODELS ON GREEK REVIVAL SOFA, 1976, watercolor, 29½″ × 41″ (75 × 104 cm),

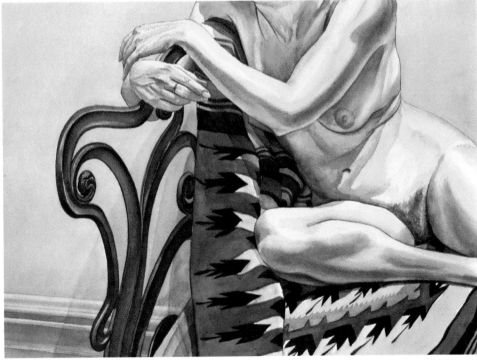

FEMALE MODEL ON IRON BENCH WITH MEXICAN BLANKET, 1976, watercolor, 29½″ × 41″ (75 × 104 cm)

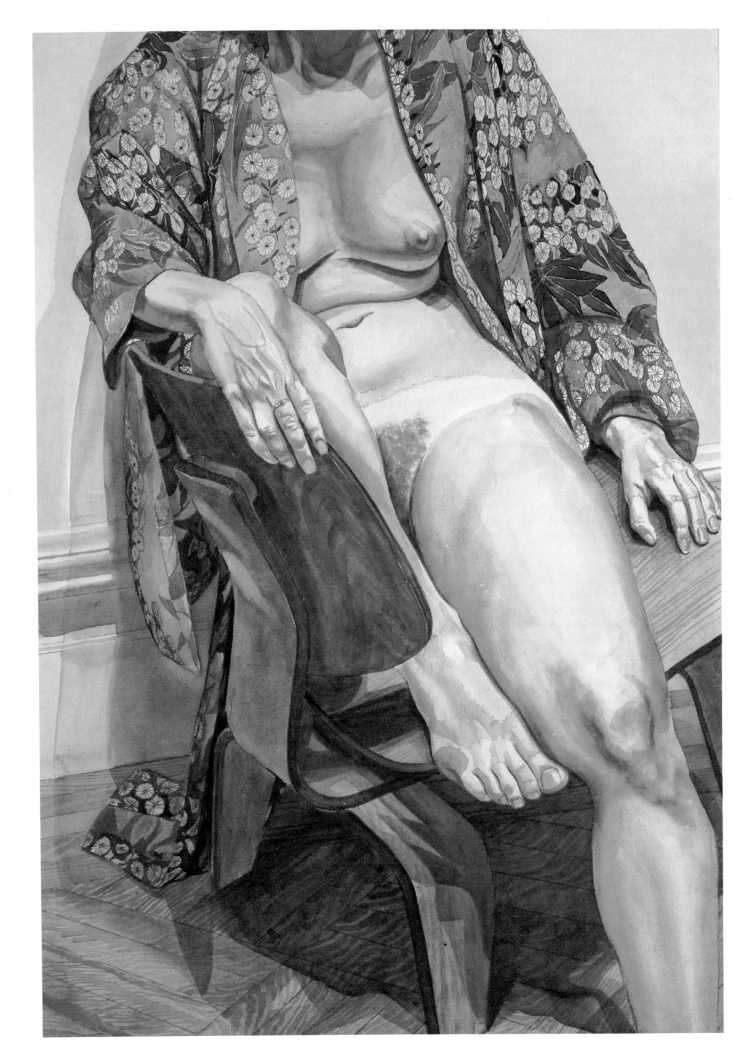

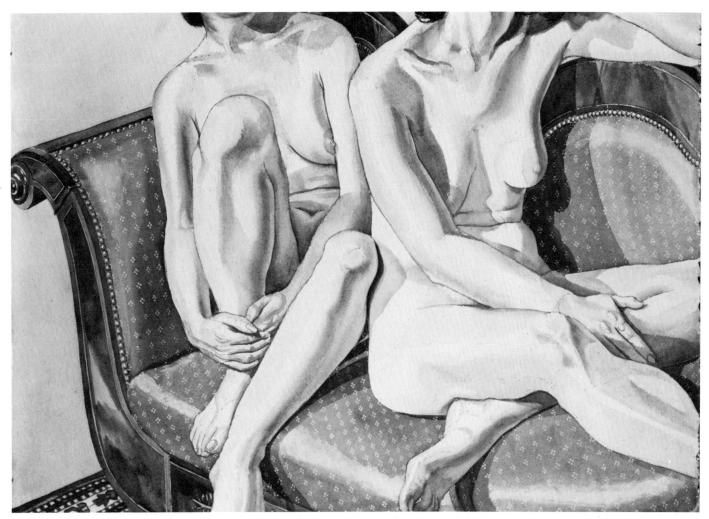

TWO FEMALE MODELS ON REGENCY SOFA, 1976, watercolor, 29½" × 41" (75 × 104 cm)

Pearlstein's earlier watercolors used the same furniture and textiles as the oils, but since the media differ, so do the effects. The luminosity of watercolor is created by light reflecting from the white paper through the transparent layers of colored washes. In watercolor, more than in oil, the warmth of the washes softens the glare of the studio lights and strongly projects the contrast of flesh, objects, and shadows, heightening the illusion of the image because the picture plane, in the untouched paper, is still visible.

MODEL IN FLOWERED KIMONO SEATED IN EAMES CHAIR, 1978, watercolor, 41" × 29½" (104 × 75 cm)

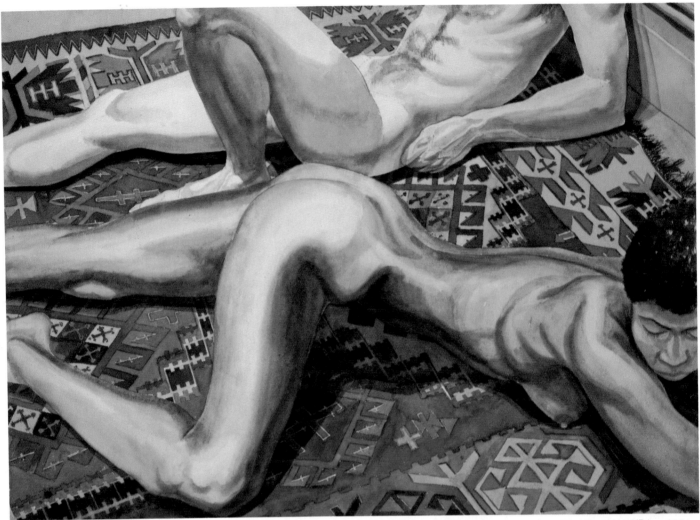

Male and Female Models on Kilim Rug, 1978, watercolor, 29¼″ × 41½″ (74 × 105 cm)

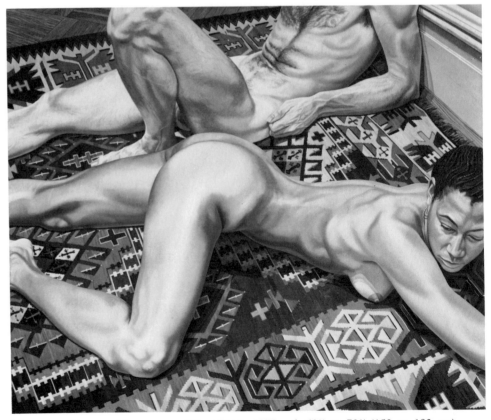

Male and Female Models on Kilim Rug, 1978, oil, 60″ × 72″ (152 × 183 cm)

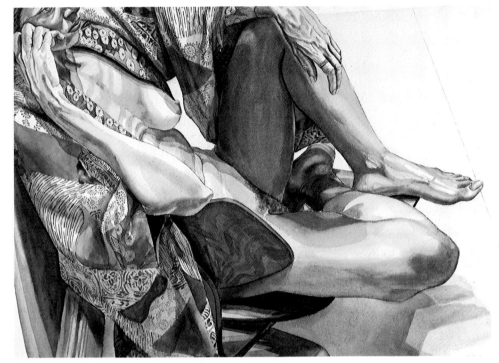

FEMALE MODEL IN KIMONO, 1978, watercolor, 29½″ × 41″ (75 × 104 cm)

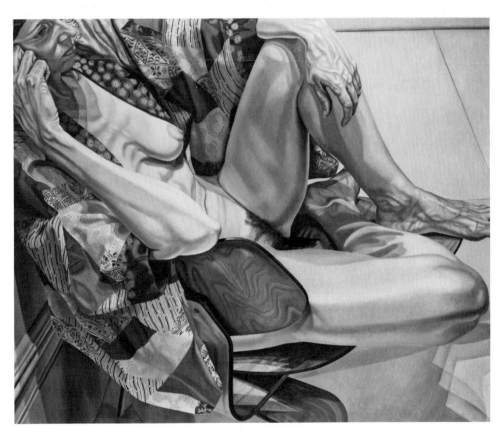

MODEL IN KIMONO ON EAMES CHAIR, 1980, oil, 60″ × 72″ (152 × 183 cm)

The complicated compositions and designs of the two watercolors were too compelling to be left in that medium alone. Pearlstein re-created them as large oil paintings.

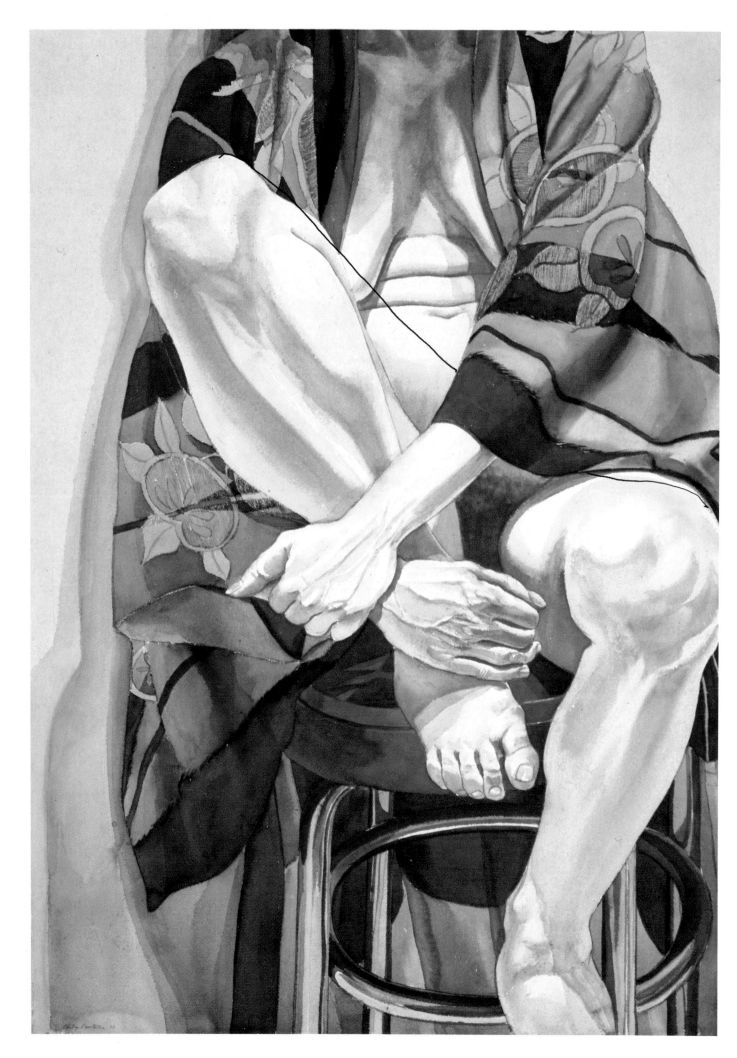

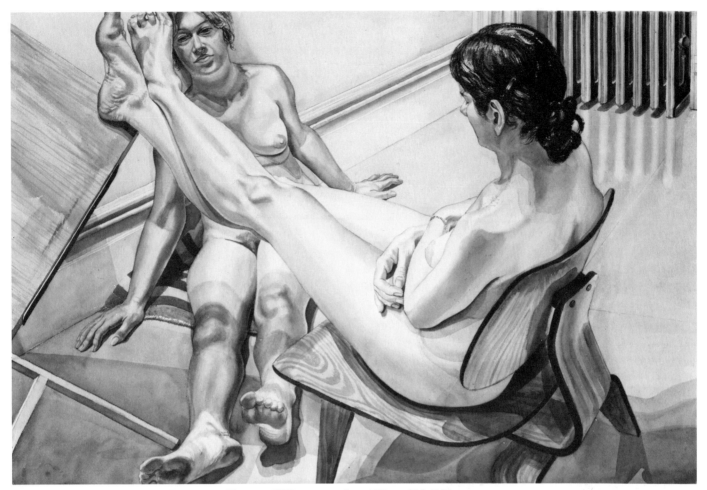

TWO FEMALE MODELS WITH DRAWING TABLE, 1979, watercolor, 40" × 59" (102 × 150 cm)

In Two Female Models with Drawing Table, *the ingenious triangular configurations of table, limbs, and baseboard on the left are stabilized on the right by the verticals of the radiator and its reflection on the floor. This was one of a number of very large watercolors that Pearlstein painted in 1978 and 1979. The size of the paper, twice that of the earlier watercolors, was conditioned by the limits of ease of handling and framing. Painting on an almost vertical surface, Pearlstein felt like a Renaissance fresco painter, carefully concentrating on one section at a time. As in the large oil paintings of the same years, the life-size format gave Pearlstein room to move around in the disposition of the larger forms and in the elaboration of detail.*

FEMALE MODEL IN PLUM COLORED KIMONO SEATED ON CHROME STOOL, 1979, watercolor, 41" × 29" (104 × 74 cm)

Moving closer to the subjects caused the accessories to loom even larger as compositional elements. The model in the kimono is shown in a knotty, condensed pose, parallel to the surface and with her body carefully distinguished from the equally important fabric of the robe. Cropped at the shoulders, left knee, and foot, the partly clothed body pushes toward the viewer with tremendous vigor.

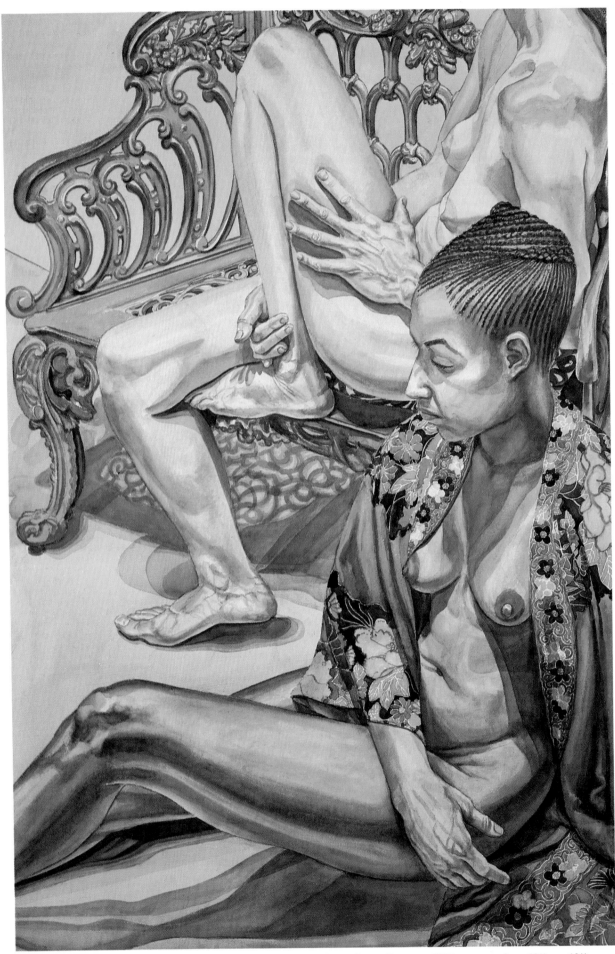

TWO MODELS WITH KIMONO AND CAST-IRON BENCH, 1981, watercolor, 60″ × 40″
(152 × 102 cm)

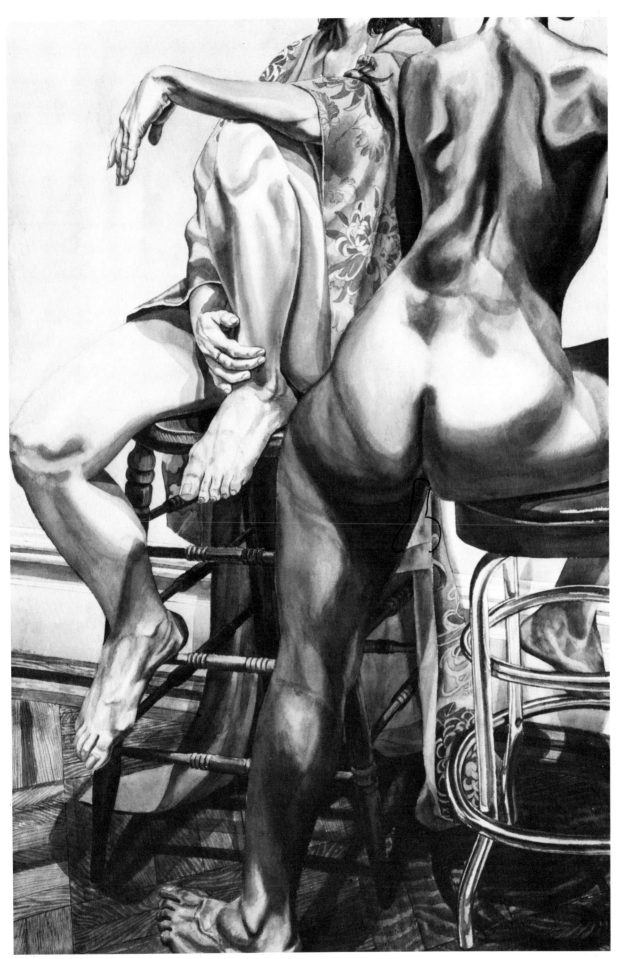

TWO FEMALE MODELS ON CHROME AND WOODEN STOOLS, 1979, watercolor, 59″ ×
40″ (150 × 102 cm)

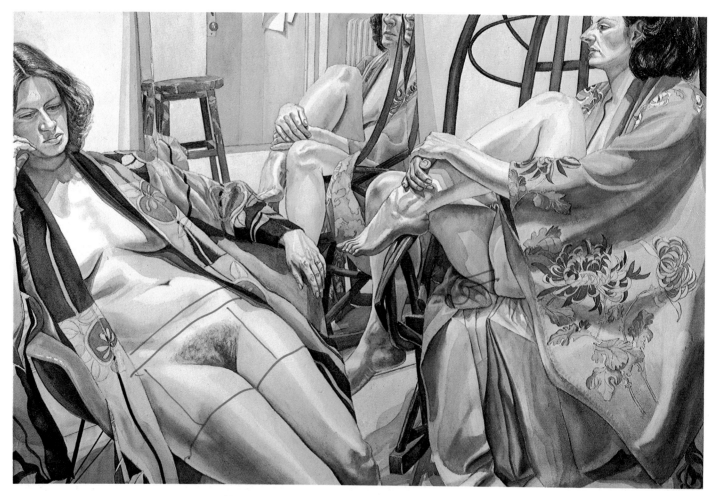

Two Female Models in Kimonos with Mirror, 1980, watercolor, 40″ × 59″ (102 × 150 cm)

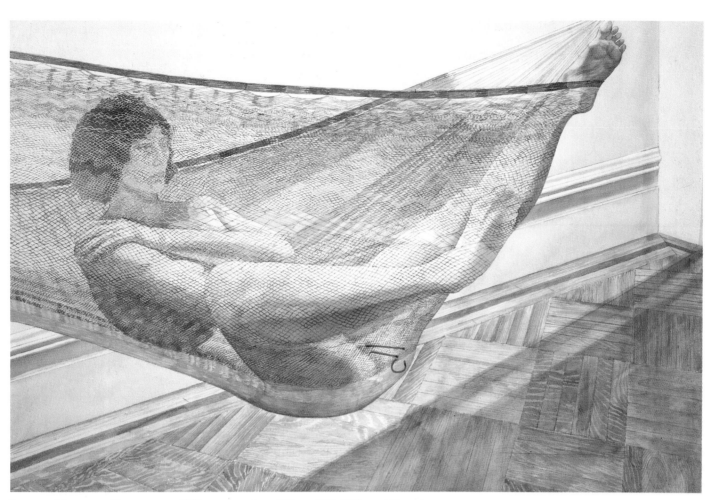

Female Model in Hammock, 1979, watercolor, 40″ × 59″ (102 × 150 cm)

In their scale and apparent clarity, Pearlstein's large watercolors subtly undermine the viewer's associations to the medium. The size seems to involve confrontation, but the tender rendering of fine net and cascades of falling drapery recall the fluency and sense of intimacy traditionally linked to the technique.

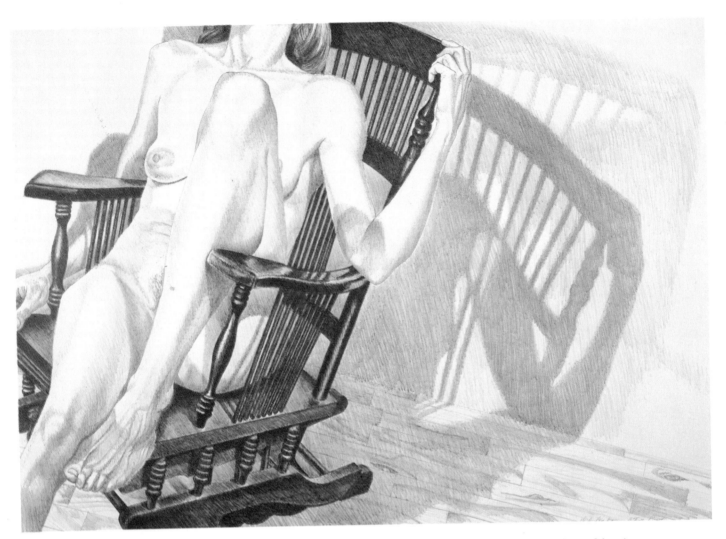

NUDE WITH ROCKER, 1977, color lithograph, 3¼" × 33¾" (59 × 86 cm)

When Philip Pearlstein developed the subject of his watercolor Female Model on Platform Rocker *as a color lithograph, he contrasted the rocker and the shadows with the body of the model more strongly. The oil painting, done the following year, took Pearlstein's interest in the chair and shadows even further.*

FEMALE MODEL ON PLATFORM ROCKER, 1977, watercolor, 29½" × 41" (75 × 104 cm)

FEMALE MODEL ON PLATFORM ROCKER, 1978, oil, 72" × 96" (183 × 244 cm)

Part Five
PRINTMAKING WORKSHOP

P earlstein began doing lithographs in 1968 when, as an instructor, he was allowed the use of the graphic workshop at Pratt Institute. He was fascinated by the technique, seeing a challenge in the application of his own artistic concerns to a new and complex medium.

The lithographic process is dependent upon the mutual repulsion of grease and water. Its inventor, Aloys Senefelder, used a printing surface of a slab of limestone, which is porous and water-resistant; today treated metal plates of zinc or aluminum are often substituted because they are lighter and easier to handle than limestone. The drawing can be made on the stone or plate in two ways, both of which are capable of producing a variety of tones. An image that is essentially linear can be created by drawing on the stone with a greasy lithographic pencil, or the image can be brushed on with tusche, a greasy liquid that creates a more painterly feeling approximating that of a wash drawing. The pencil or tusche media are absorbed into the pores of the stone, and a solution of gum arabic and nitric acid, called an etch, is applied to the surface to stabilize the image. The stone is dampened with water and inked with a roller, the greasy ink being repelled by the untouched areas but retained by the marks of the greasy drawing. Moistened paper is placed over the inked stone and both are passed through a press to transfer the image.

Pearlstein has worked on stones primarily when he has been a guest artist at various art schools. In his own studio he prefers the more maneuverable aluminum plates because he draws directly from the model. A limestone slab must remain horizontal, but an aluminum plate can be placed on an easel in front of the model and moved as needed to work on different areas of the drawing. As in his painting, Pearlstein tries to maintain the same vantage point during the making of the drawing, marking the positions of the models and himself with pieces of tape on the floor so they can return to their respective positions after rest breaks and in subsequent sessions.

Once the primary or key color drawing is complete, Pearlstein sends the plate to a master printer who etches the key plate, transfers the image to the plates that will be printed in colors, and pulls trial proofs. Then Pearlstein re-poses the models in order to draw the colored areas required on each plate, using the transferred image as a guide. Sometimes he paints on the proof itself to try out colors before working on the new plates. Since the final effect of the lithograph depends on overlapping colors, he may require several trial proofs before he is satisfied that all the drawings are complete.

Pearlstein has used both grease pencils and tusche to draw his lithographs but generally prefers pencil—Korn #3 or #4—because it is easier to control and allows him to achieve a more graceful rendering of his composition. Tusche does allow for transparent wash effects but they must be done at the first pass of the brush and are not easily refined. He holds the lithographic pencil lightly and moves it rapidly in diagonal strokes over the surface of the plate. The drawing is built up over a long period of time using the same stroking gesture. As each stroke leaves a deposit of grease on the surface, the modeling from light to dark is accomplished by repeated stroking to build up a dense network of lines.

Although drawing directly from life onto a lithographic stone or plate does have immediacy, the final result is still separated from the initial drawing by the intermediate stages of the printing process. It is this technical complexity that Pearlstein finds challenging. The final print is more difficult to control and there are risks involved. Sometimes unpredictable mishaps occur during production, as

happened with two of the Pratt lithographs. When the printing of the lithographs was interrupted at the end of a working day, the plates, in the usual shop procedure, were "closed," that is, coated with gum to prevent deterioration of the zinc through oxidation. When the printing was resumed, the plates inexplicably printed darker than the proofs that were pulled before closing. This was a chemical accident beyond the printer's control. In one of the prints, the resulting contrast in modeling between the figure and the shadows was much stronger than intended. The edition was abandoned and only artist's proofs were pulled. On the second print, however, the darker modeling was consistent throughout. Pearlstein accepted the accident and settled for a smaller edition.

Pearlstein began aquatint etching around 1970. Although he had long been a collector of the prints of Goya, the first master of the aquatint process, the initial impetus for Pearlstein's involvement in etching was a Christmas gift of a prepared etching plate from a friend, the painter Robert Birmelin.

In etching, the artist uses a fine needle to draw on a metal plate, usually copper, which has been covered with an acid-resistant, hard ground. The plate is "bitten," that is, placed in an acid bath for various periods, depending on the value of the tones desired. The acid eats into the exposed lines of the drawing, making them deep and enabling them to hold ink. After the ground is removed, the plate is inked, the excess ink is wiped from the unetched areas, and the plate and paper are passed through a press in the usual way. Etching is essentially a linear technique; tonal areas and shadows are conveyed by different schemes of cross-hatching and by successive bitings of the lines in desired places to cause them to print darker, since more deeply etched lines will hold more ink.

Aquatint, which is often combined with line etching, is a tonal method. A copper plate is prepared by dusting it with a fine layer of pulverized rosin. When the plate is heated, the rosin melts slightly and adheres to the surface. In biting the plate, the acid eats the exposed metal around the particles of rosin, leaving a uniform texture of tiny raised mounds that can be manipulated for tonal effects. When a treated but unworked aquatint plate is inked and put through the press, it prints an all-over gray tone because of the distribution of the raised particles of rosin. The artist forms the image by working the plate in both directions from this middle tone. If the artist wants areas to print darker, the rest of the plate is covered with stop-out, an acid-proof varnish, and the plate returned to subsequent acid baths. This etches the exposed areas more deeply. Areas can also be darkened by working them with spiked wheels, called roulettes, which gouge the surface and allow these areas to hold more ink. Tonal areas can be made to print lighter by reducing the rosin mounds with sandpaper or a burnisher so that the areas will retain less ink.

Pearlstein also uses the sugar-lift technique. With this method, he draws on a plain metal or an aquatinted plate with a brush dipped in a solution of sugar, ink, and water. When the drawing is fully developed, the whole plate is varnished with a hard ground. After the varnish has dried, the plate is immersed in water until the sugared areas and lines dissolve, swell, and break away the varnish, baring the surface. In biting, the exposed lines are etched into the plate. Since both the syrup and the varnish are applied with a brush, the result produced by this method can be more calligraphic and painterly than the the usual line etching. In his recent prints, Pearlstein uses a combination of all three techniques, line etching, aquatint, and sugar-lift. As with lithography, he likes the additional complexities derived from printing more than one color on more than one plate.

Since the late 1970s the subjects of Pearlstein's aquatints have broadened to include landscapes. Unlike the lithographs and etchings he draws directly from the model, the landscape aquatints must be done indirectly from watercolor paintings made on the spot because of the technical complexities of the graphic process. To translate the watercolor into a print, Pearlstein makes a pencil tracing of the watercolor on a sheet of mylar plastic, carefully recording the outline of every shape and tonal variation. The plastic is turned over and retraced with carbon paper onto copper plates, one for each of the colors of the final print. The plastic is turned over so that the reversed image on the plates will match the image of the watercolor as viewed in a mirror. In working on the plates, Pearlstein uses this mirror image as his model. Generally, he uses four plates for the color separations of a landscape etching; the combination of colors will vary depending on the scene. After the initial line drawing is etched onto the first plate, it is transferred to the others by the printer, who then gives each plate a new aquatint ground. At this point, Pearlstein begins to put in the tones on each, one section at a time, working from the reversed watercolor image. In order to develop the tones, the stopped-out plates are bitten for set periods on a time scale to produce lighter or darker results.

Throughout this complicated process, Pearlstein works closely with the master printer, but they have no definite idea of what effect the bitings will have, nor of the appearance of the print, until the first full-color proof is pulled. After Pearlstein compares the first proof to his original watercolor, he makes both large-scale and minute corrections in the plates, as well as in the color and transparencies of the inks, to achieve the final combination of color and tone. For most of his landscape etchings Pearlstein finds it necessary to pull as many as five proofs, each one representing further reworking of the plates and changes in the color and application of the inks, until the impression comes together correctly. The working sequence on the following pages show various stages during the making of one of Pearlstein's landscape etchings, *Monument Valley*, from the original watercolor to the completed artist's proof.

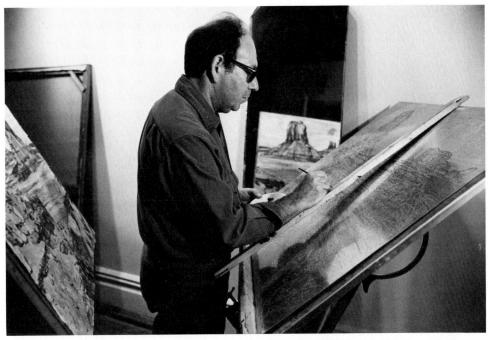

Pearlstein at work on one of the plates for his aquatint etching Monument Valley, *which is shown in detail in the working sequence on pages 148–149. His original watercolor, mounted behind him on an easel, is reflected in reverse in the mirror so that he can use it as the model for the plate.*

1. Pearlstein based his complex color etching of Monument Valley on a large watercolor he had painted on location in 1976.

2. The painting's clearly defined color areas lent themselves well to the aquatint process. Pearlstein decided to do the etching on four copper plates: brown, blue and green (in different areas on one plate), gray, and red.

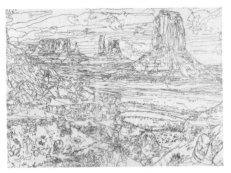

3. The first step was to make a tracing of the contours of each color area on a sheet of mylar plastic (mylar is inert and does not shrink or stretch).

4. Next the image was traced in reverse so that it would print correctly. Pearlstein used white carbon paper to transfer the tracings to the appropriate plates.

5. Beginning with the brown plate, Pearlstein prepared the plates for etching. Viewing the image of the watercolor (left) reversed in the mirror (center), he painted acid-resistant stop-out over the large areas he did not wish to expose to the acid bath.

6. Each bite is a combination of the strength of the acid solution and the amount of time the plate is immersed in it. The brown plate was stopped out to expose areas for a no. 3 bite to produce the middle tones.

7. The white tracing is still visible on the gray plate, which has been painted with stop-out to expose areas that will be given a no. 1 bite, the lightest bite.

8. The areas containing the next level of tones are left exposed for a no. 2 bite on the gray plate.

9. Darker areas of the gray plate are left exposed for a no. 3 bite.

10. The darkest areas of the gray plate are left exposed for its last bite, a no. 4.

11. This is the red plate. The exposed shapes, which will receive a no. 1 bite, will print over areas of the brown plate.

12. A combination proof revealed that the etching had a harsh quality at this stage.

MONUMENT VALLEY

13. A working proof of the brown plate was marked for further development of the tones in areas of the foreground and middleground.

14. This working proof shows the brown plate almost completed; all that remained to be added at this stage were the darkest accents.

15. Lift ground was used on the brown plate for the strong accents, which would receive a deep bite. Then stop-out coating was painted over the entire plate and it was soaked in water until the sugary lift ground had dissolved and exposed the lines to be bitten.

16. A proof showed that the brown plate had failed. The acid had crept in under the stop-out coating, producing vertical lines. Pearlstein had to retrace the drawing on to a new plate and repeat the entire etching procedure for the brown plate.

17. This was to be a final proof showing how the finished aquatint would look, but the colors were too dark and opaque. More transparent inks were used for the actual printing.

18. The completed aquatint shows all four plates, including the combined blue and green plate on which the colors were inked by hand for the sky and grass.

Seated Nude *was the first of six lithographs done at Pratt Institute in 1968. It is the most developed, as shown by the distinct cast shadows on the breasts and upper torso and by the extraordinary delicacy of the fingers of the left hand. The greater sense of volume in the torso, as opposed to the left leg, resulted from the body of the seated model trapping the ceiling studio lights from more than one direction. The summarily handled overall modeling indicates that Pearlstein was using the lithographic crayon rapidly, as he used the pencil in his drawings.*

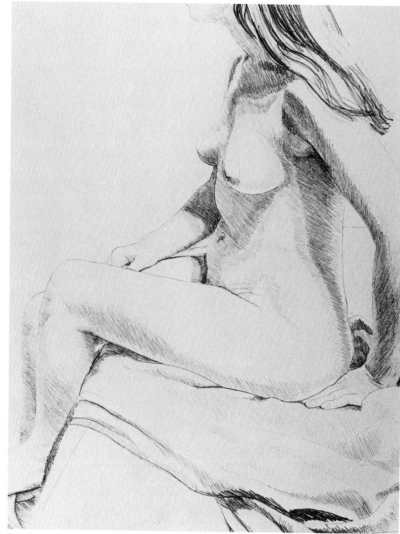

SEATED NUDE, 1968, lithograph, 23½″ × 18″ (60 × 6 cm)

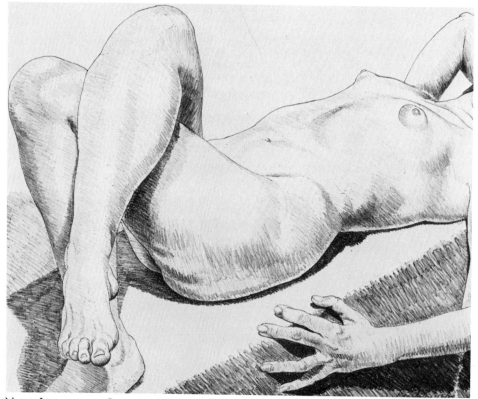

NUDE LYING WITH CROSSED LEGS, 1969, lithograph, 18″ × 22½″ (46 × 7 cm)

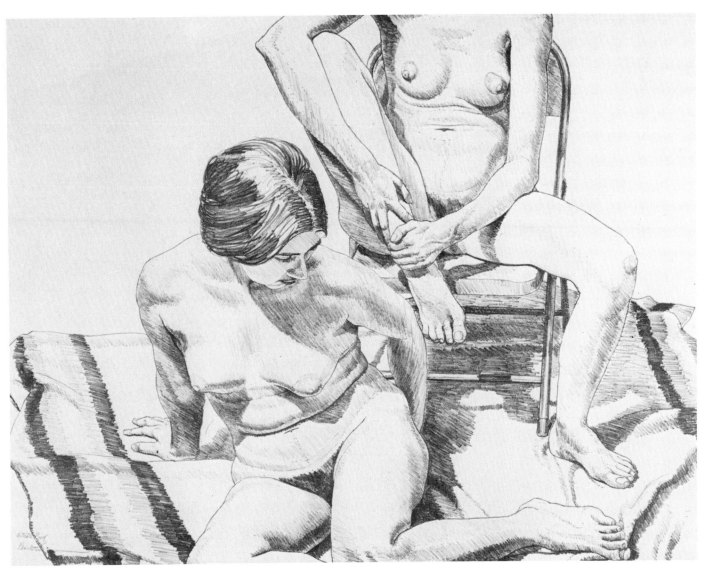

TWO NUDES, 1969, lithograph, 22½" × 9" (57 × 4 cm)

Pearlstein's next three lithographs were done as part of a lithography teaching project in the art department of the University of South Florida at Tampa. Printed in brown ink on buff-colored paper, they are more developed in chiaroscuro than his earlier prints, giving a full range of tones that completely describe the volumes of the forms in space. This subtlety of tone was a direct reflection of the fully worked-out figure drawings in pencil that Pearlstein had recently resumed. At the same time, the lithographs began more closely to resemble his paintings of the period, with closely seen, tightly cropped bodies in taut, complex compositions, high points of view, and a greater emphasis on rugs, blankets, and the shapes and spaces of furniture contrasted with the figures. The space of the chair in Two Nudes is as tangible as the bodies, which echo each other in the slant of the lower figure against the right arm and leg of the upper.

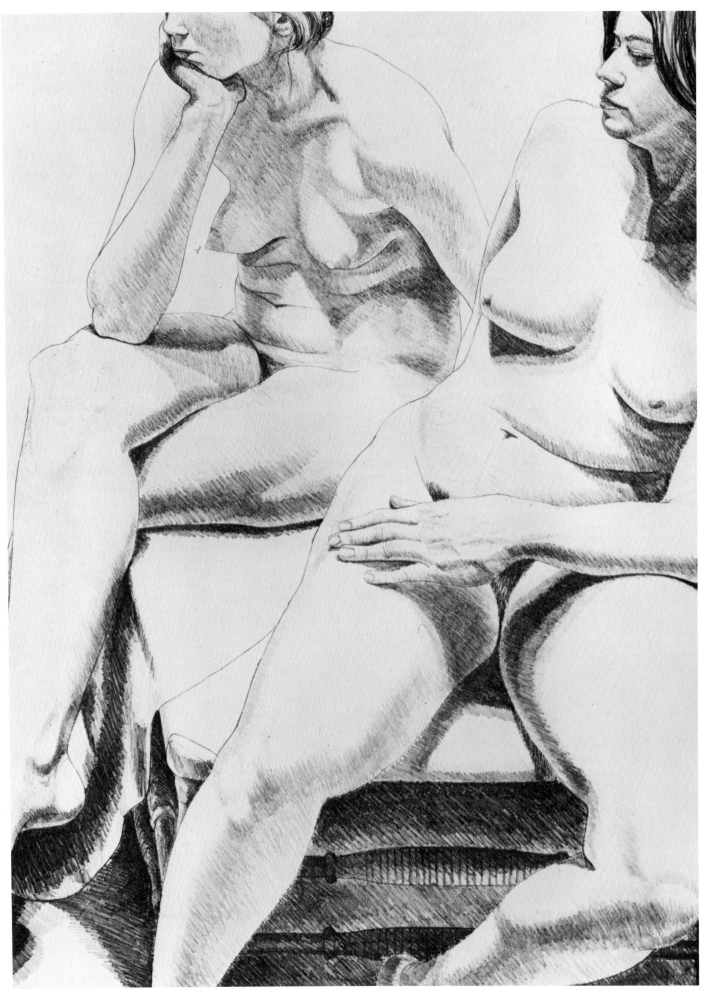

Two Female Figures, 1970, lithograph, 30″ × 22″ (76 × 56 cm)

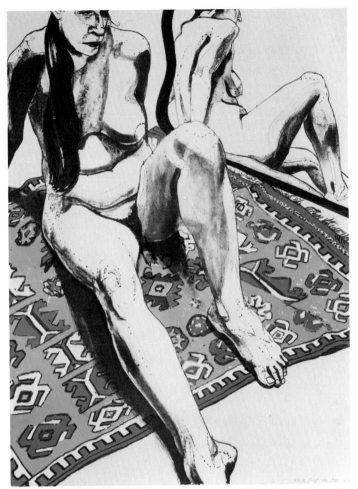

FIGURE SEATED ON RUG WITH MIRROR, 1970, color lithograph, 30″ × 22″ (76 × 56 cm)

FIGURE LYING ON RUG, 1970, color lithograph, 30″ × 22″ (76 × 56 cm)

These prints are from the suite Six Lithographs Drawn from Life, printed at the Nova Scotia College of Art and Design, Halifax, as part of a teaching project in lithography. The two color lithographs of the set were painted in tusche on four plates inked in red, yellow, blue, and brown, with the colors reserved for the dense designs of the rugs. Figure Lying on Rug is especially skillful in its manipulation of the plane of the blank paper. The barely modulated body of the model, a more or less empty surface, is set against the rich tactility of the blue rug and bulges out from the rug in a hypnotic reversal of the usual figure and ground relationship. Pearlstein based the composition of the lithograph Two Female Figures on an earlier horizontal painting. In the print he moved closer, compressing the apparent space between the figures and sharply cropping the bodies on all sides.

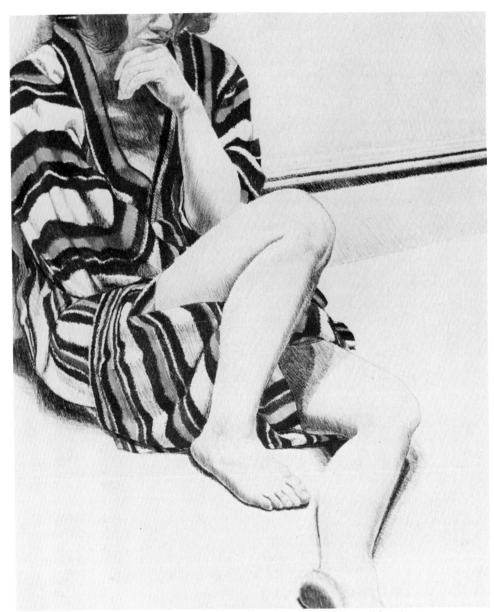

GIRL IN STRIPED ROBE, 1972, color lithograph, 27″ × 22″ (69 × 56 cm)

Because of the planimetric nature of lithography, Pearlstein is able to exploit spatial effects more easily in prints than in paintings. In Girl in Striped Robe the high point of view opens the right angle of wall and floor, allowing the body of the model to act as a bridge between them in a series of diagonals on the surface. A similar composition was used in Ellen in Tutu. It shows Pearlstein's younger daughter in an uncharacteristically pensive mood, seated slightly off-center on the edge of a folding chair, with the natural-looking awkwardness of her left foot and ankle reminiscent of Degas. A great deal of the charm of this print comes from the finely drawn rendering of the gauzy layers of tulle in the ballerina's costume. The print was done on two plates, a dark brown and a pink on buff paper.

ELLEN IN TUTU, 1972, color lithograph, 22¼″ × 34″ (64 × 86 cm)

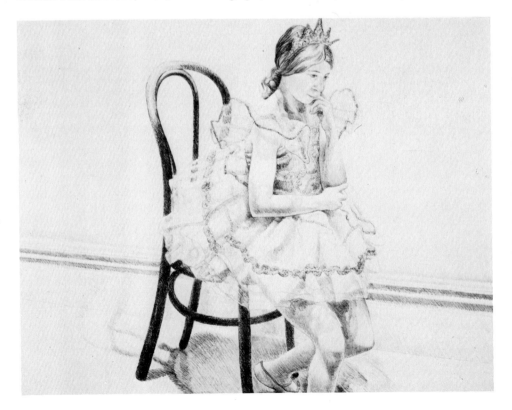

154

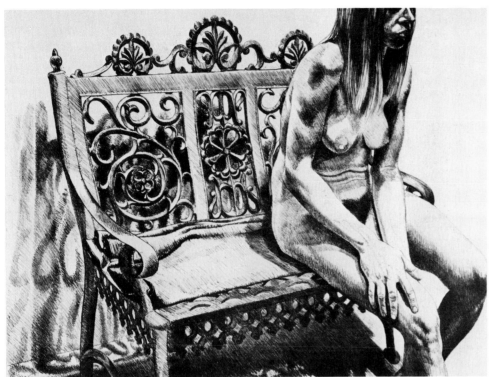

GIRL ON IRON BENCH, 1972, lithograph, 24″ × 32¼″ (61 × 82 cm)

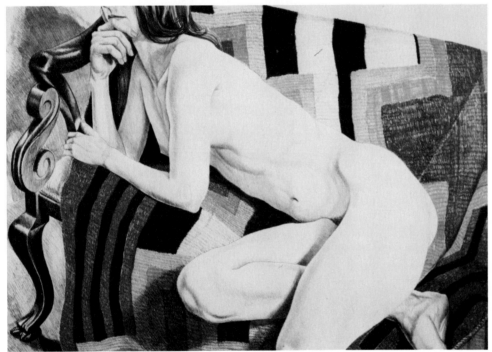

NUDE ON CHIEF'S BLANKET, 1978, color lithograph, 28″ × 40″ (71 ×102 cm)

Girl on Iron Bench *and* Nude on Chief's Blanket *show the two extremes of Pearlstein's activity as a lithographer—rich chiaroscuro on the one hand, and flat modeling on the other. Girl on Iron Bench was potentially one of the most complexly shadowed of Pearlstein's single-color lithographs, but it was never printed in a full edition. Satisfactory proofs were pulled, but the aluminum plate clogged after it was inked for printing. Pearlstein liked the subject enough, however, to return to it in a later color lithograph, drawing the plates again from the same model. The strong design of the blanket, in Nude on Chief's Blanket, pushes the barely articulated body of the diagonal model toward the surface and obscures the receding sofa.*

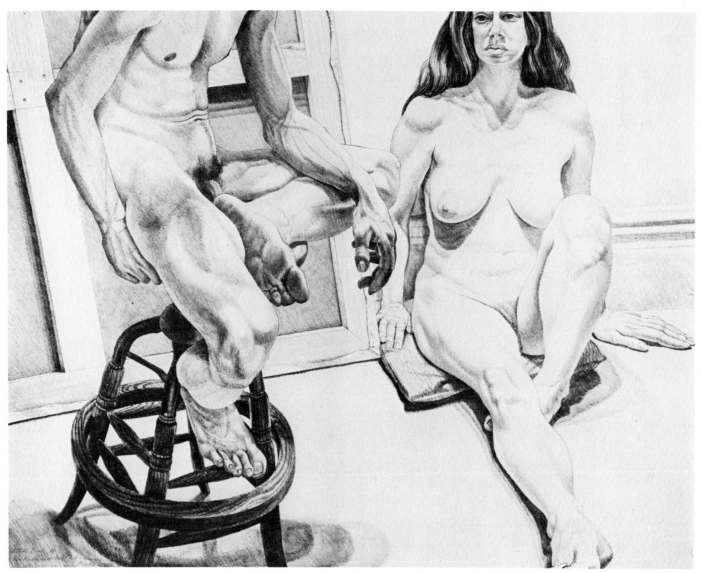

Two Nudes with Oak Stool and Canvas, 1976, lithograph, 29″ × 36½″ (74 × 93 cm)

The furniture, rugs, and draperies that became increasingly important in Pearlstein's paintings of the late 1960s also appeared in the lithographs of the 1970s. With the stretched canvas acting as a foil for the lines of the models' bodies, Two Nudes with Oak Stool and Canvas marks the first introduction of studio objects into Pearlstein's prints.

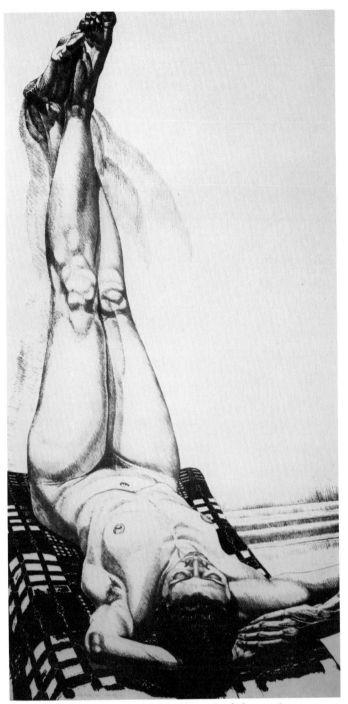

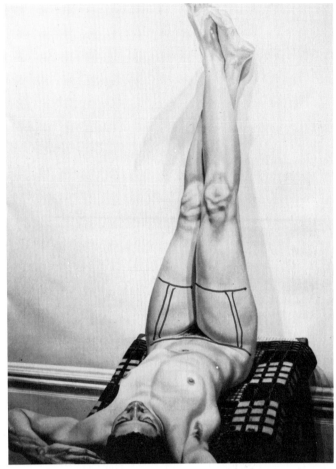

FEMALE MODEL, LEGS UP, 1975, oil, 72″ × 54″ (183 × 317 cm)

FEMALE NUDE WITH LEGS UP, 1976, color lithograph,
72″ × 36″ (183 × 91 cm)

The painting was the source for the oversize color lithograph. In the painting the view is to the
left and slightly back, revealing the model's head, left arm, and the wall to the right. Thus, an
almost right-angle niche of space is physically maintained. In the lithograph, drawn from the
model on 8′ × 4′ (244 × 122 cm) aluminum plates, Pearlstein emphasized the vertical format
of the paper by moving the sides closer and eliminating the floor under the bench. Because the
rendering of the blanket stops short of the lower edge of the paper, the blank area at the
bottom is assimilated into the unshadowed parts of the wall and the surface of the print
appears to buckle like an accordion pleat.

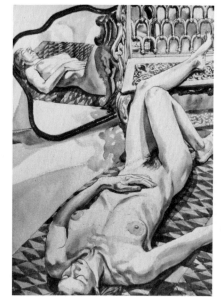

FEMALE MODEL WITH MIRROR,
RUG AND IRON BENCH, 1973, wash,
30½″ × 20″ (77 × 51 cm)

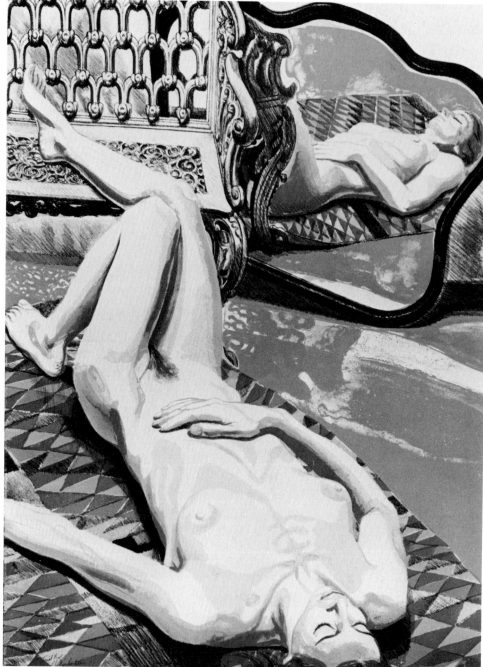

NUDE WITH IRON BENCH AND MIRROR, 1978, color lithograph, 30″ × 22½″ (76 × 57 cm)

Pearlstein's use of mirrors is similar to Ingres'. The mirror serves both to enclose the space and to extend it, functioning as a physical barrier to the eye that also contains another version of what we are seeing. Also as in an Ingres painting, the image in the mirror is not always easily reconcilable with what is in front of it. With its rich combination of textures and surfaces, Nude with Iron Bench and Mirror *is one of Pearlstein's most sumptuous lithographs. The time gap between the drawing and the print was caused by plate failures and difficulties in coordinating the seven colors. The making of the print went on, literally, for years, and in the meantime Pearlstein, unhappy with the results of tusche, turned to the aquatint process.*

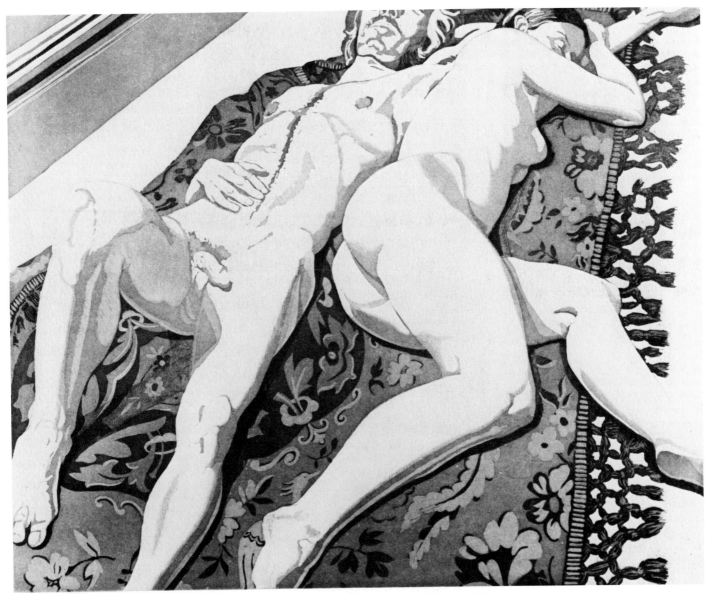

MALE AND FEMALE NUDES ON SPANISH RUG, aquatint and line etching, 17½″ × 21¾″
(45 × 55 cm)

This was Pearlstein's third etching. From this point, he began to exploit fully the linear and
tonal possibilities of the medium. Here only the outlines of the figures were etched in line by
the stop-out process. Both the rug and the modeling of the bodies were done in aquatint.

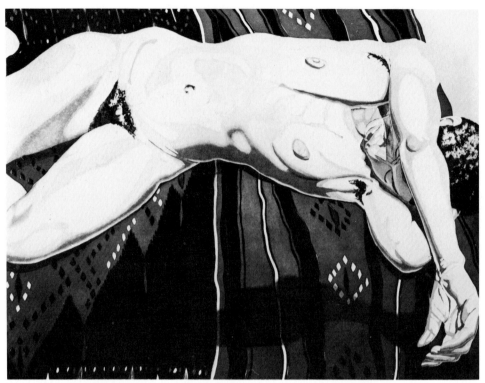

Nude Lying on Black and Red Blanket, 1974, color aquatint and line etching, 22¼″ × 29″ (57 × 74 cm)

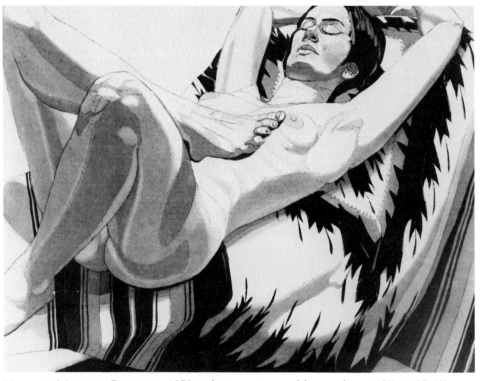

Nude on Mexican Blanket, 1972, color aquatint and line etching, 18″ × 27½″ (46 × 70 cm)

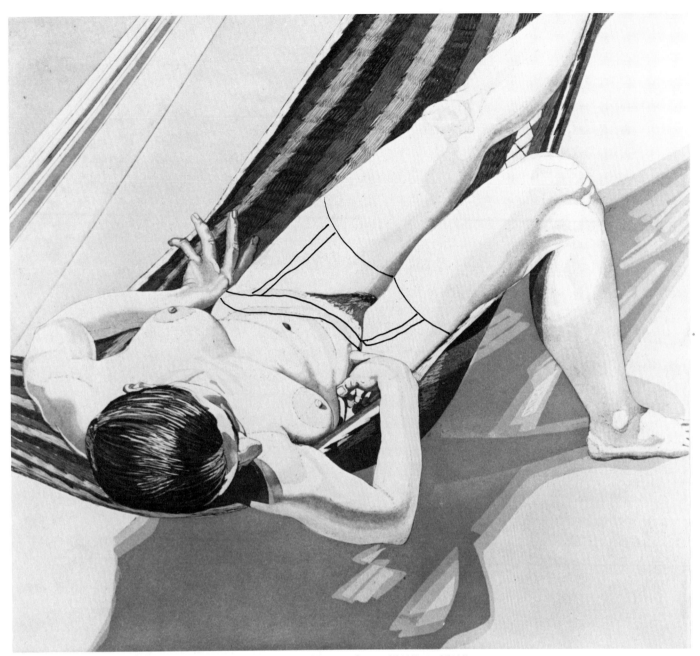

NUDE ON STRIPED HAMMOCK, 1974, color aquatint and line etching, 23½" × 25½"
(60 × 65 cm)

Pearlstein's work with etching continued with the addition of color in 1972. Each color usually
requires a separate plate, but small areas that do not adjoin may be on the same plate and
inked individually. Despite the large area modeling of the thighs and calves, the result of
burnishing the sharp edges of the stop-out process, Nude on Mexican Blanket is a particularly
satisfying composition; the limbs of the relaxed model vigorously connect with the bold design of
the blanket in an intricate series of interrelated triangles.

Nude on Striped Hammock is a masterpiece of diagonal construction in which the
insistent, but different, oblique angles of baseboard, hammock, body, and shadows on the green
floor are countered by the reverse directions of the right arm and lower leg. One of the most
remarkable images was the result of an unforeseen occurrence. The background of Nude Lying
on Black and Red Blanket printed too lightly, and so the red, black, and green plates were
re-inked and printed again on the same paper to reinforce the colors, a common printing
practice. The double pressing hardened the contours of the model's body, causing her to appear
to float very slightly above the blanket rather than sinking into it. Pearlstein would have
darkened the figure's lower contour, but the plates had already been steel-faced for durability
in printing. In any case, as a student of Dada, he liked the unexpected levitational quality and
the entire edition was printed that way.

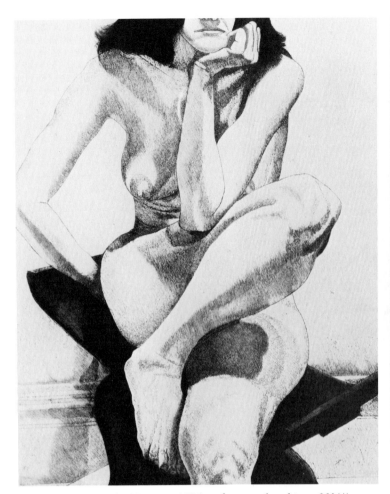

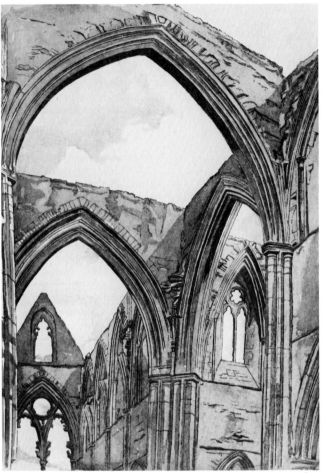

NUDE ON DAHOMEY STOOL, 1976, soft-ground etching, 23¾″ × 19¼″ (60 × 49 cm)

TINTERN ABBEY, 1979, color aquatint and lift ground etching with roulette work, 29¾″ × 39½″ (76 × 100 cm)

In 1976 Pearlstein tried soft-ground etching. As the name implies, in this process a soft layer of etching ground mixed with tallow is applied to the plate. The artist draws with a pencil or stylus on a sheet of thin paper laid over the plate. When the paper is removed, the ground adheres to the lines drawn on it, leaving the metal exposed for a biting in acid. The technique produces a soft textured line, very similar to that obtained by the crayon or chalk in lithography. In Nude on Dahomey Stool, the strong angles of the convoluted limbs, worthy of a Michelangelo Sibyl, work against the dark diagonal of the bench. The composition is extremely dynamic, exploding toward the edges, especially because Pearlstein concentrated the pose by cropping the bottom at the knee.

One reason for Pearlstein's strong involvement with aquatint is his pleasure in triumphing over complicated technical procedures. He is also aware that, with extra work, the medium,with its stubborn flexibility, can be stretched just a little bit further than it has been in the past. This attitude has marked all his aquatints since the late 1970s. The extra effort includes a great deal of tedious burnishing to soften the hard edges of stopped-out shapes and to render the translucency of successive cast shadows. In addition, the artist has to work within the physical limitations of aquatint. For example, if more than four plates are used, the last plate in printing tends to pull the color off the previously printed paper. Therefore, if more than four colors are desired, they must be coordinated so that two different colors can be inked in two separate areas on the same plate.

The additional labor involved in aquatint produces a tonal and chromatic richness that comes close to rivaling the similar qualities of watercolor. The wonderfully luminous Models in the Studio shows this expanded tonality in the shadows on the seated figure and on the arms and buttocks of the prone model. The color, too, is more extensive, five colors on four plates, with the blue of the rug repeated in the seated model's cushion and the yellow of the rug in the highlights on the chair.

Tintern Abbey was one of a suite of five etchings, Ruins and Landscapes, published by 724 Prints and Multi-Editions Press, New York. Although Pearlstein prefers to work from direct observation, the complex process of aquatint did not permit him to create the plates on location, and this etching was derived from a watercolor. In painting the watercolor, Pearlstein was restricted in his choice of vantage point on the site because of the danger of falling masonry.

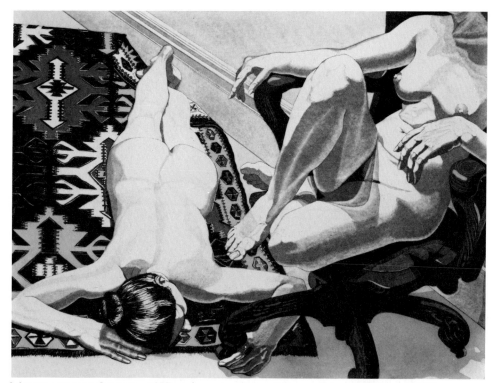

MODELS IN THE STUDIO, 1977, color aquatint and line etching, 39½″ × 29½″ (57 × 75 cm)

The technical skills acquired in producing the aquatints of figures have enabled Pearlstein, since the late 1970s, to move in another direction: prints of landscapes. The connection came from his increasing interest in watercolor as a medium that combined speed of manipulation with the capacity of transparent layers of washes to create light, a quality also found in the aquatint process. Since the landscape watercolors, from which the prints are made, are done on the site, Pearlstein does not have the luxury of time that he has in his studio. They are done quickly, usually in one or two full days of work.

Pearlstein paints the watercolors with the characteristics of the printing process in mind, that is, the layers of tonal aquatint, from light to dark, arrived at in separate stages. As is his habit, the first step is a line drawing of the subject. The drawing usually takes half of the total time spent on the watercolor. After that, Pearlstein begins to lay in the color, working as closely as he can to what he sees at any given time. This means that, at this point, transient light effects are ignored in favor of generalized local color. A consistent light can be created in the last hours of painting because of the transparency of the watercolor washes. Thus, the landscapes usually end up with the shadows of late afternoon.

MUMMY CAVE RUINS AT CANYON DE CHELLY, 1980, color aquatint and lift ground etching with roulette work, 40½″ × 28¾″ (103 × 73 cm)

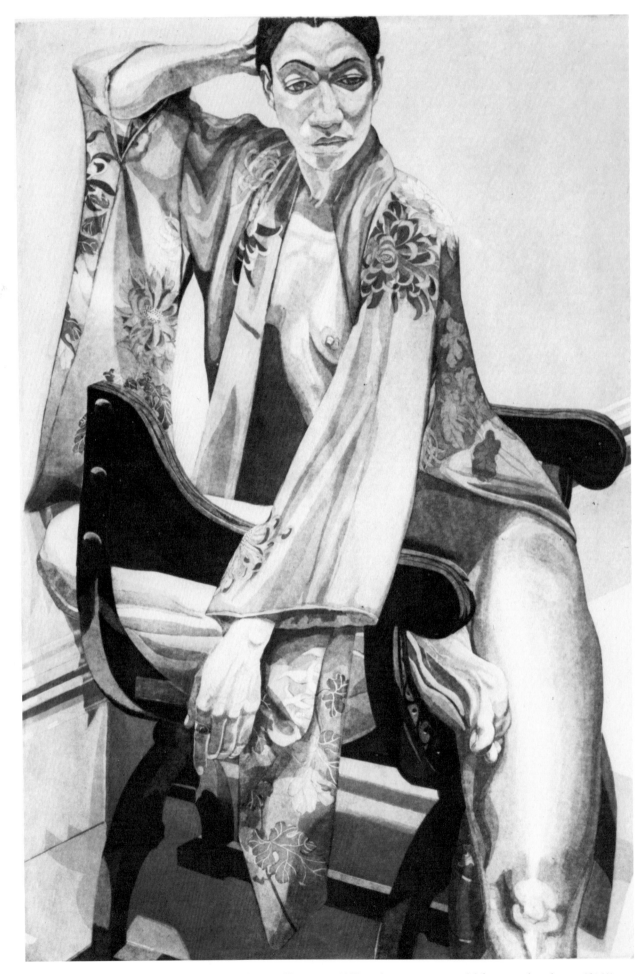

Model with Green Kimono, 1979, color aquatint and lift ground etching, 40¼″ × 27¼″ (102 × 69 cm)

NOTES

1. Leland Wallin, "The Evolution of Philip Pearlstein: Part 1," *Art International*, XXIII, no. 3-4, Summer 1979, p. 65f.

2. Paul Cummings, *Artists in Their Own Words: Interviews by Paul Cummings*, New York, 1979, p. 156.

3. Cummings, pp. 158f.

4. Lawrence Alloway, editor, *Landscape Views: Report of a Symposium at Montclair State College*, Montclair, New Jersey, 1978, p. 15.

5. Cummings, pp. 159f.

6. Sanford Sivitz Shaman, "An Interview with Philip Pearlstein," *Art in America*, vol. 69, no. 7, September 1981, p. 213.

7. Cummings p. 160.

8. Wallin, p. 65.

9. Pat Mainardi, "Philip Pearlstein: Old Master of the New Realists," *Art News*, vol. 75, no. 9, November 1976, p. 74.

10. "Figure Paintings Today Are Not Made in Heaven," *Art News*, vol. 61, no. 4, Summer 1962, pp. 9, 51f.

11. Philip Pearlstein, "Figure Paintings Today Are Not Made in Heaven," *Art News*, vol. 61, no. 4, Summer 1962, p. 39.

12. Pearlstein, p. 52.

13. Pearlstein, p. 52.

14. Mainardi, p. 74.

15. Vol. 37, no. 7, April 1963, pp. 46–49.

16. Shaman, p. 124.

17. Cummings, p. 171

18. Shaman, p. 126.

19. Hilton Kramer, "Three Portraits Upgrade the Genre; Philip Pearlstein Stars in Frumkin Show," *The New York Times*, April 30, 1966.

Selected Bibliography

By Philip Pearlstein

"Concept of New Realism, A." In *Real, Really Real, Superreal: Directions in Contemporary American Realism*. San Antonio, Texas: San Antonio Museum Association, San Antonio Museum of Art, 1981, pp. 37–40.

"Critics and Artists." *Art Journal*, vol. 37, no. 2 (Winter 1977–1978): pp. 15lf.

"Eyes, Highs, and Egos." *Allan Frumkin Gallery Newsletter*, no. 3 (Spring 1977), pp. 5, 4.

"Figure Paintings Today Are Not Made in Heaven." *Art News*, vol. 61, no. 3 (Summer 1962). p. 39ff.

"Futurism and Some Other Corrupt Forms." *Art News*, vol. 60, no. 4 (Summer 1961), pp. 30–33, 57–58.

"Hello and Good-bye, Francis Picabia." *Art News*, vol. 69, no. 5 (Sept. 1970), pp. 52–54, 72–76.

"Jacques Callot: He Knew What He Wanted." *Art in America*, vol. 63, no. 6 (Nov.–Dec. 1975), pp. 42f.

"Kinds of Realism." Questionnaire. *Allan Frumkin Gallery Newsletter*, no. 7 (Winter 1979), pp. 1–7.

"Letter from Philip Pearlstein, A." *Print Collector's Newsletter*, no. 4 (Sept.–Oct. 1973), p. 82.

"Present Concerns in Studio Teaching." *Art Journal*, vol. 42, no. 1 (Spring 1982), p. 35.

"The Private Myth." *Art News*, vol. 60, no. 5 (Sept. 1961), pp. 42, 61.

"The Process Is My Goal." *The New York Times*, 31 October 1976.

"Realist in an Abstract World, A." Unpublished typescript, 1977.

"The Romantic Self-Image is Gone." In "Sensibility of the Sixties" by Barbara Rose and Irving Sandler. *Art in America*, vol. 55, no. 1 (Jan.–Feb. 1967), p. 53.

"Statement, A." In *Philip Pearlstein: Zeichnungen und Aquarelle, Die Druckgraphik* by Alexander Dückers. Berlin-Dahlem: Staatliche Museen Preussischer Kulturbesitz, Kupferstichkabinett, 1972.

"The Symbolic Language of Francis Picabia" *Arts*, vol. 30, no. 4 (Jan. 1956), pp. 37–43.

"When Paintings Were Made in Heaven." *Art in America*, vol. 70, no. 2 (Feb. 1982), pp. 84–95.

"Whose Painting Is It Anyway?" *Arts Yearbook 7*, 1964, pp. 129–132.

"Why I Paint the Way I Do." *The New York Times*, 22 August 1971.

About Philip Pearlstein

Adrian, Dennis. "The Prints of Philip Pearlstein." *Print Collector's Newsletter*, vol. 4, no. 3 (Jul.–Aug. 1973): pp. 49–52.

Alloway, Lawrence, ed. *Landscape Views: Report of a Symposium at Montclair State College*. Montclair, New Jersey, 1978.

Auping, Michael. *Philip Pearlstein: Paintings and Watercolors*. Sarasota, Florida: John and Mable Ringling Museum of Art, 1981.

Bard, Joellen. "Tenth Street Days: An Interview with Charles Cajori and Lois Dodd." *Arts* vol. 52, no. 4 (Dec. 1977), pp. 98–103.

Cummings, Paul. *Artists in Their Own Words: Interviews by Paul Cummings*. New York: St. Martin's Press, 1979.

Dückers, Alexander. *Philip Pearlstein: Zeichnungen und Aquarelle, Die Druckgraphik*. Berlin-Dahlem: Staatliche Museen Preussischer Kulturbesitz, Kupferstichkabinett, 1972.

Field, Richard S. *Philip Pearlstein: Prints, Drawings, Paintings*. Middletown, Conn.: Davison Art Center, Center for the Arts Galleries, Wesleyan University, 1979. Similar essay published in *The Lithographs and Etchings of Philip Pearlstein* (see Landwehr, William C.).

Georgia Museum of Art. *Philip Pearlstein*. Essay by Linda Nochlin. Athens: The University of Georgia, 1970. Same essay published in *Art News* (see Nochlin, Linda).

Goldman, Judith. *American Prints: Process and Proofs*. New York: Whitney Museum of American Art, 1981

Goodyear, Jr., Frank H. *Contemporary American Realism Since 1960*. Philadelphia: Pennsylvania academy of the Fine Arts, 1981.

Hadler, Mona, and Viola, Jerome. *Brooklyn College Art Department, Past and Present: 1942–1977*. New York: Davis and Long Company and Robert Schoelkopf Gallery, 1977.

Hayden, Herrera. "Pearlstein: Portraits at Face Value." *Art in America*, vol. 63, no. 1 (Jan.-Feb. 1975), pp. 46f.

Hills, Patricia, and Tarbell, Roberta K. *The Figurative Tradition and the Whitney Museum of American Art*. New York: The Whitney Museum of American Art, 1980.

Kahmen, Volker. *Erotic Art Today*. Translated by Peter Newmark. Boston: New York Graphic Society, 1972.

Kramer, Hilton. "Three Portraits Upgrade the Genre: Philip Pearlstein Stars in Frumkin Show." *The New York Times*, 30 April 1966.

Landwehr, William C. *The Lithographs and Etchings of Philip Pearlstein*. Catalogue essay by Richard S. Field. Springfield, Mo.: Springfield Art Museum, 1978.

Mainardi, Pat. "Philip Pearlstein: Old Master of the New Realists." *Art News*, vol. 75, no. 9 (Nov. 1976), pp. 72-75.

Meyer, Susan E., ed. *20 Figure Painters and How They Work*. New York: Watson-Guptill Publications, 1979.

Midgette, Willard F. "Philip Pearlstein: The Naked Truth." *Art News*, vol. 66, no. 6 (Oct. 1967), pp. 54-55, 75-78.

Monte, James K. *22 Realists*. New York: The Whitney Museum of American Art, 1970.

Nochlin, Linda. "The Ugly American." *Art News*, vol. 69 (1970), pp. 55-57, 65-70.

"Pearlstein Watercolors Shown in April." *Allan Frumkin Gallery Newsletter*, no. 10 (Spring 1980), p. 5.

Perreault, John. "Philip Pearlstein—Naked Nudes." *The Soho Weekly News*, 20 April 1978.

"Realism vs Existentialism." *Allan Frumkin Gallery Newsletter*, no. 5 (Spring 1978), pp. 4, 5, 6.

San Antonio Museum Association. *Real, Really Real, Superreal: Directions in Contemporary American Realism*. San Antonio, Texas: San Antonio Museum of Art, 1981.

Schwartz, Ellen. "A Conversation with Philip Pearlstein." *Art in America*, vol. 59, no. 5 (Sept.-Oct. 1971), pp. 50-57.

Shaman, Sanford Sivitz. "An Interview with Philip Pearlstein." *Art in America*, vol. 69, no. 7 (Sept. 1981), pp. 120-126, 213-215.

Stokes, Charlotte. *Return of Realism, Part One: Four from the Allen Frumkin Gallery*. Rochester, Michigan: Meadow Brook Art Gallery, Oakland University, 1978.

Susser, Jill "Philip Pearlstein: The Figure as Still Life." *American Artist*, vol. 37 (Feb. 1973), pp. 38-43.

Tillim, Sidney. "Month in Review," *Arts*, vol. 37, no. 7 (April 1963), pp. 46-49.

———. "Philip Pearlstein and the New Philistinism." *Artforum*, vol. 4, no. 9 (May 1966), pp. 21-23.

Viola, Jerome. *Philip Pearlstein: Landscape Aquatints, 1978-1980*. New York: Brooke Alexander, Inc., 1981.

Wallin, Leland. "The Evolution of Philip Pearlstein: Part I." *Art International* 23/3-4 (Summer 1979), pp. 62-67.

———. "The Evolution of Philip Pearlstein: Part II." *Art International* 23/5-6 (Sept. 1979), pp. 54-61.

Index

Editor: *Betty Vera*
Graphic Production: *Ellen Greene*